R

INTRODUCTION BY
ROBERT ROSENBLUM
CATALOGUE TEXTS BY
LOWERY STOKES SIMS
AND
LISA M. MESSINGER

The Landscape in Twentieth-Century American Art

SELECTIONS FROM

THE METROPOLITAN MUSEUM OF ART

THE AMERICAN FEDERATION OF ARTS

RIZZOLI, NEW YORK

First published in the United States of America in 1991
by Rizzoli International Publications, Inc.
300 Park Avenue South, New York, NY 10010
and The American Federation of Arts
41 E. 65 Street, New York, NY 10021

Library of Congress Cataloging-in-Publication Data
Metropolitan Museum of Art (New York, N.Y.)
 The landscape in twentieth-century American art:
selections from the Metropolitan Museum of Art/
introduction by Robert Rosenblum; catalogue texts by
Lowery Stokes Sims and Lisa M. Messinger.
 p. cm.
 Published in conjunction with an exhibition organized
by the Metropolitan Museum of Art and the American
Federation of Arts.
 Includes bibliographical references and index.
 ISBN 0-8478-1303-7. — ISBN 0-917418-93-X (pbk.)
 1. Landscape painting, American—Exhibitions. 2.
Landscape painting—20th century—United States—
Exhibitions. 3. Metropolitan Museum of Art (New York,
N.Y.)—Exhibitions. I. Rosenblum, Robert. II. Sims,
Lowery Stokes. III. Messinger, Lisa Mintz. IV. American
Federation of Arts. V. Title. VI. Title: Landscape in
20th-century American art.
 ND1351.6.M48 1991 90-46829
 758'.1'09730747471—dc20 CIP

Publication Coordinators: Michaelyn Mitchell
 and Dorothy R. Caeser

Designer: Nai Chang

Editor: Stephanie Salomon

Photography: Courtesy of the Photograph Studio,
 The Metropolitan Museum of Art

Composition: Graphics Arts Composition, Philadelphia

Printer: Dai Nippon Printing Company, Tokyo, Japan

Frontispiece:
Detail from Marjorie Portnow's *Cambridge Corn,* 1981
Oil on canvas, 16 × 30 in. (40.6 × 76.2 cm)
Gift of Dr. and Mrs. Robert E. Carroll, 1983, 1983.191.2

This catalogue has been published in conjunction with *The
Landscape in Twentieth-Century American Art: Selections from
The Metropolitan Museum of Art,* an exhibition organized by
The Metropolitan Museum of Art and the American
Federation of Arts. The exhibition is a project of ART
ACCESS, a program of the AFA with major support from the
Lila Wallace-Reader's Digest Fund. The national tour and
catalogue have been made possible by a grant from the
Metropolitan Life Foundation. Additional support has been
provided by the national patrons of the AFA.

Exhibition Tour Philbrook Museum of Art
Tulsa, Oklahoma
April 14–June 9, 1991

Center for the Fine Arts
Miami, Florida
June 29–August 24, 1991

Joslyn Art Museum
Omaha, Nebraska
September 14–November 10, 1991

Tampa Museum of Art
Tampa, Florida
December 14, 1991–February 8, 1992

Greenville County Museum of Art
Greenville, South Carolina
March 17–May 10, 1992

Madison Art Center
Madison, Wisconsin
June 6–August 2, 1992

Grand Rapids Art Museum
Grand Rapids, Michigan
September 11–November 8, 1992

Metropolitan Life Foundation is delighted to support this
important and richly diverse presentation of work from the
Metropolitan Museum of Art. The exhibition and catalogue
offer a unique opportunity to view a central theme in
American art of this century. We are glad to be able to share
these treasures from one of the world's great museums with
our friends across the country. —Robert G. Schwartz,
Chairman, President and Chief Executive Officer,
Metropolitan Life Insurance Company

Founded in 1909, the American Federation of Arts is a
nonprofit educational organization that serves the visual arts
community. Its primary activity is the organization of
exhibition and film programs that travel throughout the
United States and abroad. Other services range from
management training to reduced-rate programs in fine-arts
insurance and transportation.

CONTENTS

ACKNOWLEDGMENTS

The Landscape in Twentieth-Century American Art is the fifth exhibition in an ongoing collaborative program of the Metropolitan Museum of Art and the American Federation of Arts designed to share the museum's vast resources with other institutions around the country. The sixty superb examples represented in this publication and presented in the traveling exhibition illustrate the various ways in which landscape has been employed as subject matter by artists of this century. We are delighted that these works and the curatorial concept that unifies them are being given national exposure.

For their contributions to both the exhibition and this publication, we wish to acknowledge a number of staff members in the Metropolitan's department of twentieth-century art: William S. Lieberman, chairman; Lowery Stokes Sims, associate curator; Lisa M. Messinger, assistant curator; Ida Balboul, research associate; John Buchanan, registrar, Herbert M. Moskowitz, senior associate registrar; Lucy Belloli, conservator; and Brenda Mitchell, former graduate intern.

We wish to thank the members of the AFA staff whose efforts have been important to the realization of this project: J. David Farmer, director of exhibitions; P. Andrew Spahr, senior exhibition coordinator; Michaelyn Mitchell, head of publications; Dorothy R. Caeser, interim publications coordinator; Susan J. Brady, director of development and public affairs; and Jillian W. Slonim, public information and promotion director. We also want to acknowledge the contribution of former AFA director Myrna Smoot.

Robert Rosenblum's perceptive essay constitutes a significant contribution, for which we wish to express our gratitude.

Last, we want to thank the Metropolitan Life Foundation for their very generous support without which the project would not have been possible; and the national patrons of the AFA, who have designated this project as the national patron exhibition of 1991. Additional support has been provided by the Lila Wallace-Reader's Digest Fund through their contribution to the AFA's program, ART ACCESS.

PHILIPPE DE MONTEBELLO
Director
The Metropolitan Museum of Art

SERENA RATTAZZI
Director
The American Federation of Arts

American Landscape Painting: An Endangered Species?

For many of the greatest painters of the nineteenth century, on both sides of the Atlantic, landscape as a theme rose to undreamed-of heights grand enough to absorb almost every serious vantage point. In Europe, Turner, contemplating a site in the Alps, could conjure up the history of the ancient world as well as a glimpse of divinity; and Cézanne, scrutinizing a mountain in his native Provence, could invest it with the importance of an eternal deity, worthy of ritual worship. When we think in the instance of Cézanne how the meadows, coasts, and forests of France could trigger responses ranging from escapist rural fantasies and regional documentation to the sunshot splendors and mysteries of ephemeral color, we begin to glimpse the awesome variety and vitality that nature held for the keenest nineteenth-century eyes and intellects. In America, too, landscape could inspire the grandest of epics or provoke transient spectacles and reveries. With American scenery, Thomas Cole could convey the full cycles of life and death, whether of the ages of man or the rise and fall of civilization; Frederic Church could inspire thoughts not only of Darwinian and biblical origins, but also of the primordial realities of the American landscape itself; Martin Johnson Heade and John Frederick Kensett could make us think that it was on American shores that God said, "Let there be light!"; Winslow Homer could grasp the pounding of surf on rock to remind a growingly urbanized and industrial nation of the elemental hardship and mysteries of Americans pitted against an often malevolent nature; and Childe Hassam, John Twachtman, and others who followed in the seductive footsteps of Monet could translate the more cultivated pastures and gardens of New England into a language of delectation alien to the landscape's Puritan roots.

But it must be said quickly and sadly that in the twentieth century,

7

this noble story, like the landscape itself, has become so threatened that a survey of the theme might produce the spectacle of an endangered species of painting on a continent where recent environmentalists have apocalyptically proclaimed the end of nature. Looked at from this angle, the present selection of some sixty American landscape paintings, ranging in time from 1907 to 1987 and in style from topographic documentation to primordial abstraction, can mirror both the fable and the reality of the distance between Longfellow's "forest primeval" and a continent that we are simultaneously destroying and preserving as the prospect of extinction looms over the horizon of the twenty-first century.

A heroic, optimistic introduction to this wilting, pessimistic theme is found in Jonas Lie's *The Conquerors* of 1913 (cat. no. 2), one in a series of twenty-seven paintings that documented modern man's triumphant conquest of planet earth, updating the cutting of the Suez Canal in the 1860s to an even greater triumph, the building of the Panama Canal. This decade-long campaign concluded in the summer of 1914, at ironically the very same time as the opening shots of four years of international warfare introduced an unprecedented destruction of man and nature. Lie's painting, with its awesome vista, scaled to the vision of a giant who could stride across oceans and continents, still offers full gusts of nineteenth-century confidence in the forward march of modern technology with its capacity to conquer the hugest impediments of geography. But even if this faith in progress now seems a nostalgic vestige of another era, the message of a fierce determination that could rend asunder the earth and the waters was to survive at The Metropolitan Museum of Art in a surprising way since Lie's was one of the American paintings most admired by the young Barnett Newman, who might almost be thought of as transforming the cutting of the canal into his own abstract language of a heroic force cleaving a void worthy of the Book of Genesis.

Pushed to a further extreme, this harnessing of nature could become a virtual substitute for it. *Water,* the elemental title of Charles Sheeler's painting (cat. no. 31), hardly prepares us for a totally dehydrated view of machine-age architecture in a barren landscape. Like Lie's *The Conquerors,* this painting was meant to record another conquest of man over nature, in this case a portion of a dam at the Tennessee Valley Authority; and the date, 1945, is equally ironic, given its coincidence with the most horrendous milestone in American technology, the dropping of a bomb capable of ending the century's second world war as well as of annihilating landscape as we know it. Compared to Lie's muscular power, Sheeler's vision of water transformed into abstract energy now has for us a sinister character, as if it were the site of a nuclear plant that had totally usurped the natural realm of earth, grass, and water. Indeed, strange

rumblings on the dark side of modern technology could occasionally appear in the interwar period, as in Doris Lee's eccentric fantasy of 1936, *Catastrophe* (cat. no. 16), both documentary and hallucinatory in character, of a zeppelin exploding in midair over New York and its waterways as parachuting survivors desperately leap toward the rescue crews and numbed spectators on the thin strip below.

But in general, such cataclysmic visions of nature turned inside out (a vision shared by many European surrealists on the eve of World War II) were alien to the American landscapes of the earlier decades of the twentieth century, which tended to perpetuate, though often with diminishing conviction, assumptions inherited from the nineteenth century. For example, the ghost of Winslow Homer, insofar as it haunted the most remote reaches of that already remote state, Maine, could be felt in the work of artists as different as Rockwell Kent and John Marin. For Kent, his virtual exile on Monhegan Island in a cabin he built himself while eking out a living as a jack-of-all-rugged-trades (lobster fisherman, well-driller, carpenter) was a realization of an archetypal American myth. But in 1907, the date of a bitterly cold winter landscape in which Kent's primitive, utilitarian dwelling is pitted against the snow, *Winter—Monhegan Island* (cat. no. 29), the reality of that myth seems far more out of sync with the facts of contemporary America than it did a century earlier. In fact, at exactly the same time in 1907, one of the pioneer American modernists, John Marin, was sojourning in Europe, even exhibiting in Paris at the Salon des Indépendants and the Salon d'Automne. Marin's growing espousal of the rejuvenating foreign modernities of fauvism, cubism, and futurism was quickly put to use with subjects that seemed the antithesis of the timeless American landscape: views of lower Manhattan, the Brooklyn Bridge, the docks at Weehawken, New Jersey. But in a polarity often repeated by American artists of the early twentieth century, he soon reverted to unspoiled territory, in his case, Homer's Maine. There, beginning in 1914, he would apply his own salty version of European modernism to the heaving energies of the Maine coast and landscape, capturing, as in *Off Cape Split, Maine* (cat. no. 28), the belated romantic metaphor of surf beating against rock in his own dynamic shorthand, which weds the lessons of modern urban explosiveness, gleaned from Europe, with the archaic power that could still be found on the American continent, if one was willing to travel farther and farther away from the cities.

John Marin's wedding of a transatlantic, avant-garde vocabulary and raw American truths offered a blend far more potent than many related efforts to bring the pictorial news from Paris back home. Eugene Speicher's *Morning Light* of about 1907 (cat. no. 3) or William Glackens's *The Green Car* of 1910 (cat. no. 11), judged by the real European model, seem polite and provincial variants of late impres-

sionism, just as Andrew Dasburg's *Road to Lamy* of 1923 (cat. no. 13) may now seem a quaintly naïve adaptation of the dirt roads of Cézanne's Provence to their American counterparts near Santa Fe. Dasburg's choice of site, however, was typical of a seesawing balance between modern art, on the one hand, and a timeless, primal landscape, on the other—a balance typical of many American artists who emerged in the shadow of European modernism. Of these, the most famous may be Georgia O'Keeffe, who in the 1920s painted some of the most celebrated hymns to Manhattan's skyscraper culture but who also immersed herself in an almost extraterrestrial landscape, the prehistoric terrain of New Mexico, where her decades-long residence made her more and more a refugee from the rapidly changing patterns of twentieth-century art and life. In her *Red and Yellow Cliffs* of 1940 (cat. no. 4), O'Keeffe continues to explore, in an on-site, documentary way, the kind of primordial landscape sublimities recorded in the West by generations of nineteenth-century painters, an awesome immensity so untouched by civilization that we expect dinosaur fossils, if not dinosaurs, at every step. But more and more, as with Gauguin's group in Brittany, this search for primitive soil was allied to communal, avant-garde spirits who would willfully seek out the other side of the modern coin. So it was that O'Keeffe followed in the footsteps of other artists who had colonized parts of New Mexico, particularly Taos and Santa Fe. Of these, Ernest Blumenschein was a pioneer, and his view of the Taos Valley of 1933 (cat. no. 5) helps to place O'Keeffe's far better-known work in a broader context of those many sophisticated connoisseurs of primitive American landscape who offered escape from the pollutions of the urban world. For many artists of these years, such locales were the equivalent of national parks, sanctuaries of nature where—following the more adventurous nineteenth-century explorations of a Moran or a Bierstadt—natural, perhaps even supernatural, truth and beauty might be found. Marsden Hartley's own itinerary was symptomatic of this familiar dialogue. Born in Maine, a state whose landscape he painted both before and after his European sojourns, he also had been to New Mexico in 1918–19, memories of which he carried back to Paris. In that city, at the end of 1924, he painted from his mind's eye a cemetery in New Mexico (cat. no. 55), a sacred site that seems in part a meditation on the fundamental relationship of man to nature and in part a highly personal translation of Cézanne contemplating Mont Sainte-Victoire. And as a belatedly poignant reminder of this ongoing dialogue between modern city and ancient landscape, between European modernism and American experience, there is a 1952 view of the Pacific Coast by Max Weber (cat. no. 6), whom some know best as a feisty young cubo-futurist who painted the New York subway at rush hour. This almost generic American colli-

sion of savage rock and ocean, painted by a seventy-one-year-old artist, might be Maine as well as California. Like John Marin's seascapes, it fuses indigenous scenery with distant memories of Cézanne's seismographic capturing of the internal rumblings of water and earth.

To be sure, not all artists had a taste for the strong, primeval stuff of nature that could be found on this continent. Even in Maine, on Matinicus Island, not far from where Rockwell Kent had lived like an archaic settler, George Bellows could depict a domesticated landscape that had more the flavor of a summer vacation than an arctic expedition (cat. no. 18). All across the country, artists explored a symbiotic relationship between the abiding facts of American nature and an agrarian way of life that, sometimes only decades old, might nevertheless look as timeless as the landscape itself. Such visions of rural felicity, deeply rooted in romantic myths about the goodness of the simple country life, far from the temptations of the vice-ridden city, and often supported by the examples of European masters like Brueghel, were common in the interwar period, when well-known regionalists like John Steuart Curry and Thomas Hart Benton, or lesser-known ones like Paul Starrett Sample and Frederic Grant, created soothing illusions that human life was most harmonious when closest to the soil. It was a viewpoint abundantly propagated in acres of nineteenth-century paintings on both sides of the Atlantic, but given a new American twist in the isolationist decade of the 1930s, an era of depression when documentary photographers like Dorothea Lange and Walker Evans recorded appalling truths about American farm life that were totally suppressed from these painted fantasies. Whether we look at Benton's cotton pickers (cat. no. 20) or Grant's homesteader (cat. no. 21), the figures in these landscapes are as happily and inevitably rooted in the earth as plants or trees. Sometimes, the scale of these rural visions is breathtakingly expansive, as in Curry's *Wisconsin Landscape* (cat. no. 22), where all the world seems to be America, from sea to shining sea, whereas elsewhere, as in the folkloric simplicity of Sample's narrative, *Janitor's Holiday* (cat. no. 40), we seem to be viewing a dollhouse-scale microcosm of immaculate preservation, a precious fly in amber to be protected from the raging realities outside its preserve.

Indeed, in only a matter of years, under the shadow of World War II, these now old-fashioned visions of American landscape's "peace and plenty" seemed deeply threatened, subject to unexpected mutations. Often, the topographic reality of landscape was turned into private mirages that, under the liberating influence of European surrealism, could transport us to domains of memory or imagination. Begun in the middle of the war in 1943 and completed about ten years later, Edwin Dickinson's *Ruin at Daphne* (cat. no. 46) was a slow

compilation of international tourist souvenirs, fusing ruins of ancient civilizations in a theme grimly appropriate to the documentable truths of the actual wartime destruction of venerable European sites and the poignant aftermath of historical rubble. More homespun, but equally desolate, are two paintings by artists who steadfastly rejected the lure of European modernism while nevertheless managing to cast a surrealist or, perhaps better said, neoromantic aura of dream and longing upon the commonplaces of America. In Walter Stuempfig's *Thunderstorm II* of 1948 (cat. no. 32), the setting is as ordinary as Cape May on the New Jersey coast out of season. But an enigmatic drama is stirred up by the darkening sky, the endless horizon of the sea, and the lonely and dwarfed figures who seem perilously placed at the brink of an engulfing, threatening nature. A pregnant woman in profile who faces the expanse of ocean; a frail little boy who confronts us head-on as we approach this barren scene; a quartet of figures in a moored rowboat—this strange cast generates a scenario that hovers between a record of the ramshackle world of those who live out their lives by the sea and a more ambitious drama of human destiny that would echo such venerable romantic allegories as, say, Thomas Cole's *Voyage of Life.* No less haunting as a strangely specific but equally evocative narrative is Carroll Cloar's *The Lightning that Struck Rufo Barcliff* of 1955 (cat. no. 41). By recreating from memory, decades after the fact, a traumatic event that occurred during his Arkansas childhood of a friend who was killed by a lightning bolt while chopping wood, Cloar again turns the commonplace into the sinister. The tidy, meticulous rendering of a forest of leafless trees and two tiny woodchoppers recalls the painstaking, ingenuous manner of a folk artist, establishing a surprising visual environment for the deathly tendrils of lightning that instantly fell Rufo Barcliff as he, in turn, is trying to fell a tree. Although in its quaint and naïve look (as well as in its medium, tempera on composition board) this little work may evoke an Italian primitive painting that would depict, for instance, the myth of Niobe's children struck dead by the gods in a malevolent heaven, it also shares, in a regional, true-to-life way, the international rumblings of disaster that could be sensed throughout the mid-years of a century darkened by global war.

These messages of cosmic gloom increased during the domain of European surrealism, many of whose most important practitioners sought refuge from the approaching war on American shores, where they continued to pursue their imaginary voyages into submarine or extraterrestrial realms. The presence in the United States of Yves Tanguy, who had arrived at the outbreak of the war in 1939 and then married the American painter Kay Sage, triggered a strange expansion of the metaphor of landscape to convey anxieties and mysteries both universal and personal. The pair of mid-1950s landscape fanta-

sies by Tanguy and Sage (cat. nos. 47, 48) provides a strangely complementary couple. In both, the doom-laden ambience of a cloud-covered dreamscape extending to nowhere projects the mood of apocalypse, a graveyard of man-made architecture as well as the fossil remains of things that lived eons ago. At the same time, the two works may reflect private sorrows, Tanguy's painting having been completed the year before his death in 1955 and Sage's painting having been executed in the first year of her widowhood.

Such oblique and multiple associations were common in the period darkened by the war. In another painting of surrealist persuasion, Leon Kelly's *Vista at the Edge of the Sea* of 1940 (cat. no. 56), a different view of the apocalypse is offered. Instead of the Tanguy-Sage stillness of death and memory, we find a fiery combustion of oceanic danger, thrashing with subliminal references to voracious animals of the deep at war with one another and with nature. Kelly's deep plunge into a primordial violence offers an insufficiently known moment in the fascinating history of the absorption of European surrealism in the 1940s by Americans of Arshile Gorky's generation, and one that has many counterparts in the almost cosmological vision of landscape that marked the origins of many abstract expressionists. Typical is Clyfford Still's untitled canvas of 1946 (cat. no. 57), which pushes the geological marvels literally depicted by artists like Georgia O'Keeffe and Ernest Blumenschein to mythic beginnings rooted, nevertheless, in the specific character of the American landscape of the West, where Still was raised. With its strange cartographic shapes that seem to evolve like coastlines and mountains, Still's canvas thrusts us into imaginative realms concerned with the very beginnings of earth and sea, a viewpoint precociously prefigured in this selection in a seldom seen canvas of 1933 by the sculptor David Smith, *Seashell and Map* (cat. no. 54).

From such abstract distillations of what often resemble the four elements—earth, fire, air, water—there might have been a point of no return. Indeed, the triumph of abstract expressionism in the 1950s, heralded on both sides of the Atlantic, seemed to slam the door on all but the most allusive suggestions of landscape, which for masters like Still, Mark Rothko, or Jackson Pollock meant the conjuring up of universals, not the specifics of time and place. To be sure, this kind of vision had various progeny, especially in the 1980s, when many artists, at a time when the end of the second millennium grew closer, began to imagine a world that existed long before human habitation. A small group of paintings here may stand for that mood, of which the closest to the abstract expressionist inheritance is Tod Wizon's *Above (for Steven Schmidt)* of 1986 (cat. no. 60), in which a vertiginous overhead view, inspired by a visit to Joshua Tree National Monument, California, discloses a cosmic turmoil of organic mat-

ter, an updating of the convulsive configurations of Gorky and Pollock. Louisa Chase's *Pink Cave* of 1983 (cat. no. 53) also takes us to awesome geological territory, a mutation of Still's abstractions into a more legible language that might provide a setting for an ancient saga. And often these primitive landscapes are inhabited by wild animals living in a world where the human race has lost control. In Leonard Koscianski's *Wild Dogs* of 1982 (cat. no. 51), the two canines attack each other ferociously, as if the species once domesticated by mankind had reverted to its savage origins. Such a descent down the ladder of civilization is also felt in John Alexander's *Red Goat* of 1983 (cat. no. 52), where we are first submerged in a primordial jungle, inspired by the actual swamps of the Texas-Louisiana area the artist knew from childhood, and then are suddenly confronted, within this camouflaging bramble, by the stare of a goat, who seems as startled by us as we are by him.

Yet for artists, the abiding attraction of painting not only things imagined behind closed eyes but also things seen simply and quietly with eyes wide open has yielded, since the heyday of abstract expressionism, a steady and almost self-consciously understated tradition of putting on canvas the most uneventful felicities of the American landscape. Dozens of artists went about cultivating their private visual gardens, documenting—with what often amounted to a strong-willed rejection of the kinds of pictorial innovation familiar to modern art—the most ordinary here and now, a view from the porch, a brisk walk in the snow-covered woods, a bend in a sunny rural road. One generation of painters after another illustrates this point. For instance, while summering on Great Spruce Island in the 1960s, Fairfield Porter (born in 1907) ignored the drama that earlier American painters had found in the meeting of rock and water on the coasts of Maine and replaced it with a genteel, soft-spoken account of nothing but the modest visual facts of an ordinary sight in an ordinary American vacation (cat. no. 33). In the same state, Neil Welliver (born in 1929), who since the 1960s has made Maine his permanent residence, also brings up to date the experience of unpolluted nature earlier found there by such masters as Winslow Homer, John Marin, and Marsden Hartley. In *The Birches* of 1977 (cat. no. 7), the dense but pristine beauty of a forest of trees that cast blue shadows on early snow and provide a brambly scrim for a remote mountain view is recorded in a cool, empirical manner, framing, as in a casual snapshot, nothing but the specific truths that happen to fall within the visual range of a perfectly square, five-by-five-foot canvas. In another escape from the city, Jane Freilicher (born in 1924) offers a different seasonal moment from a country retreat, an autumnal view of the low-lying fields that reach to the ocean near Water Mill in eastern Long Island (cat. no. 24), the kind of view that might have been

translated as a glimmer of the divinity, were it painted in the mid-nineteenth century by an American luminist like Martin Johnson Heade, but which here seems to avoid such old-fashioned poetry. In *Fair Hills* (cat. no. 45), Willard Dixon (born in 1942) moves us to the other side of the continent, to California's Marin County, where the ordinary scene of a woman in shorts walking her dog along the bend of a road in a landscape whose Garden of Eden lushness might once have thrilled the likes of Frederic Church to high-minded evangelical rhetoric. Here, however, it is underplayed as the usual background to a prosaic moment in the life of a posh community's privileged resident.

But if these artists stubbornly cling to the straightforward, no-nonsense look of a welcoming countryside in a country where the very concept of nature is being challenged from all sides, others often put an ironic spin on these commonplace appearances. Duncan Hannah's *Out of Doors* (cat. no. 36), for instance, may at first seem an anachronistic cliché, a picture-postcard idea of rural happiness whose stagy, shopworn pleasures are constantly avoided by the more detached and candid vision of artists like Porter and Freilicher, who both paint more ordinary comforts of life out of doors. But in fact, Hannah's painting is not what it seems. Based on a photograph from an *Illustrated London News* of 1949, the painting emanates haunting layers of nostalgic memory—a buried time capsule. Recreated in colored pigment from a glossy black-and-white reproduction, the original image is preserved as if it were a flickering recollection of a remote rural myth that had in fact expired decades ago.

A creeping eeriness, in the manner of a subliminal message at the start of a sophisticated science-fiction film, can also be intuited in many of Mark Innerst's diminutive landscapes, whose very smallness can turn the most ordinary patch of land and road into a magically ominous setting. When that everyday scene is then doubled, as it is in his *Pennsylvania* of 1983 (cat. no. 9), the mystery escalates, especially after we observe, as if in the documentation of an unexplained, otherworldly event, that the path of light in these two glimpses of the same dull vignette of the American roadside changes abruptly from one framed view to the other. We seem to have evidence from what look like two related, but disconnected movie stills that something bizarre may happen to our peaceful landscape, a glimmer of anxiety in what at first appears as low-keyed snapshots of nothing at all. That the hanging of these two little paintings is flexible—they may be seen side by side or one above the other—adds to their aura of unsolved mystery, as if they were two minuscule pieces of evidence in a puzzle of potentially cosmic dimensions.

Such ghosts that hover below our perceptions of a disappearing historical and geographical past can also be seen in terms of a more

raucous humor that would contrast new facts and old fantasies. John Tweddle's *Vision from Oklahoma* (cat. no. 49) runs a home-spun collision course between a cowboy on a bucking bronco, the very symbol of the brawny, macho conquest of the American West, and a corny, folkloric message turned inside out by the more timely, marginal decorations that mix dollar signs, bombers, oil wells, and automobile exhaust in a comic-strip display of new American realities versus old American fictions.

In fact, these days artists find no end of ways to unbalance and complicate our inherited views of the American landscape, as if they were groping to define the drastic changes around us. Of these, one of the most surprising is Yvonne Jacquette's vision (cat. no. 25) of an unpolluted corner of our nation, the town of Belfast, Maine, depicted with a miniature perfection and purity that recall the immaculate, agrarian American life of the 1930s imagined by artists like Paul Sample (cat. no. 40) and Grant Wood and that might provide the generic setting for Thornton Wilder's *Our Town* (1938). But the angle of vision has changed crazily, for we are looking straight down from an airplane, Jacquette's favorite vantage point for both city and country views. Accommodating the unfamiliar look of maplike plots of land and abstract textures of grass and forest, as experienced from an aerial view, she depicts the earth below with the uncommon effect of stippled, closely woven paint patterns that turn reality into a flat tapestry whose scale is at once diminutive and vast. The increasingly trite bird's-eye view of a romantic past has been replaced by a routine sight for most of us in the late twentieth century, framed by the nearest window on our next flight. Seeing the Grand Canyon or a New England village from 30,000 feet, we realize that we are living in a time when the venerable traditions of American landscape painting are being transformed by strange new ideas and images we must count on artists to tell us about.

America the Beautiful

During the late eighteenth and early nineteenth centuries, the first stirrings of our national identity coincided with the promulgation of philosophical currents that sought to immerse man in a pantheistic celebration of nature. The concept of the sublime—the feeling of awe in the presence of the grandeur of God and his creations in nature—became a national creed. Internationally, the special quality of America's topography was recognized as well. Few nations have inspired such pronouncements as these: "Have mountains, and waves, and skies, no significance but what we consciously give them when we employ them as emblems of our thoughts?"[1] Or, "Il n'y a de vieux en Amérique que les bois. [The only thing that is old in America is its forests]."[2] And finally, "In the Beginning, all the world was America."[3]

The paintings in this section celebrate the diversity of landscapes that may be found in the United States from the Northeast to the Southwest, from the mountains to the marshlands, from the east coast to the west. As a group, they exemplify the most typical and the most enduring appreciation of this land. However, within the context of twentieth-century thought they also present specific contemporary concerns and reflect the destiny of the landscape in the face of the onslaught of industrial exploitation.

In *The Conquerors* (cat. no. 2), Jonas Lie challenges our notions of the sublime. His chronicle of the building of the Panama Canal (one of twenty-seven paintings on the subject) depicts a blasphemy. Here man asserts his hegemony over nature, one in which nature is to be subdued, not revered. Mark Innerst's *Pennsylvania* (cat. no. 9), executed seven decades later, shows a mysterious light beaming down on an otherwise ordinary scene. This is not the alternately encroaching and waning light that accompanies the daily passage of time, but an intrusive apparition that we would guess to be, if not extraterrestrial, at least atypical.

Louis Eilshemius's *Landscape, Binghamton, New York* (cat. no. 1),

Ernest Blumenschein's *Taos Valley* (cat. no. 5), and Georgia O'Keeffe's *Red and Yellow Cliffs* (cat. no. 4) celebrate the specificities of the topography in New York State and New Mexico. The O'Keeffe, the most recent in terms of date, shows a slice of nature so framed that the overall design of the crenulations of the mountainside and the subtle tonalities of the light washing over the rocks tend to predominate rather than restrict our sense of topographical rendering. Even Gabor Peterdi's *The Big Wetland I* (cat. no. 8) and Neil Welliver's *The Birches* (cat. no. 7) engage abstract concerns in spite of the realist styles of both artists. In the former, the grasses of the Long Island marshlands can be seen as mimicking the more overall tracks of the drips and strokes of abstract expressionist painting from the 1960s. A similar abstract effect is achieved by Welliver, who creates a network of birch trees and branches in the foreground of his painting. Max Weber's *Pacific Coast* (cat. no. 6) was executed at the height of the abstract expressionist era. Although the style is reminiscent of Weber's figural work from the 1920s and 1930s, it conveys a more articulated surface generally associated with gestural abstraction.

L.S.S.

NOTES

1. Kynaston McShine, ed., *The Natural Paradise: Painting in America, 1800–1950* (New York: The Museum of Modern Art, 1976), 72.
2. Ibid., 89.
3. Ibid., frontispiece.

1
LOUIS MICHEL EILSHEMIUS
1864–1941

The career of Louis Eilshemius is a fascinating study in the paradoxes and anomalies that often characterize the progress of an artist's reputation, subject as it may be to the vagaries of fashion and time. In fact, it may be asserted that Eilshemius had two distinct artistic careers, painting in two different styles.

The first phase of Eilshemius's artistic development was located well within the nineteenth century. His parents were well-to-do, and as a child he traveled widely and was educated first in Geneva and then in Dresden. After studying agriculture at Cornell University, Eilshemius began his artistic training, studying first at the Art Students League of New York, then at the Académie Julian in Paris. During the 1880s and 1890s, Eilshemius's work primarily consisted of landscapes that show the influence of the French Barbizon painters, particularly Corot.

After he returned from Paris in 1888, Eilshemius

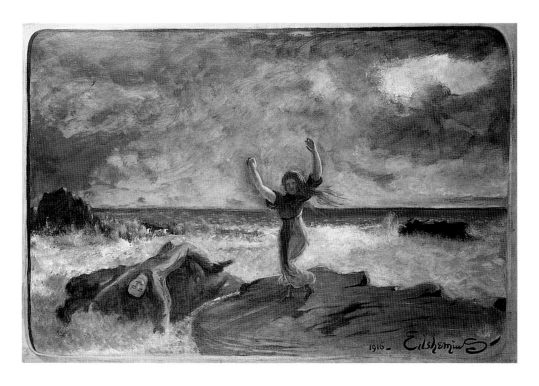

Figure 1
Tragedy of the Sea, 1916
Oil on cardboard, 40½ × 61¼ in. (102.9 × 155.6 cm)
Bequest of Miss Adelaide Milton de Groot (1876–1967), 1967
67.187.160

pursued an eclectic career—painting, writing poetry and novels, and serving as the editor of various art magazines. He continued to travel in Europe and North Africa, and in 1901 he made a trip to Samoa and the South Seas. His painting, however, did not receive the recognition he sought. Gradually his art evolved into a more "primitive" or "naïve" style, and by the turn of the century figures became more prominent. His subject matter became more grounded in the imagination, although often inspired by memories of specific places and events. He became preoccupied with themes of tragedy—as seen in *Tragedy of the Sea* (fig. 1), which is also in the collection of the Metropolitan Museum. It may be tempting to ascribe these stylistic changes to Eilshemius's psychological conflicts, given his frustration in gaining recognition for his work. However, they are also an indication of Albert Pinkham Ryder's influence on Eilshemius's later work.

Eilshemius finally received the attention he sought after his later paintings were seen in the 1917 exhibition of the Society of Independent Artists in New York, the first of its kind. Although *Landscape, Binghamton, New York* was painted in 1907, after Eilshemius had begun his stylistic transformation, the painting still shows the "plein-air" light and atmosphere of the artist's nineteenth-century landscape works. But the handling of the paint reveals the more expressionistic quality of the brushwork of his later oeuvre. The view is of the Susquehanna Valley and Mount Prospect in the distance seen from the Lookout, a spot in Ross Park in Binghamton.[1]

Eilshemius stopped painting altogether in 1921. During the last twenty years of his life, however, he finally achieved the respect he so desired. He enjoyed the support and patronage of such preeminent collectors as Duncan Phillips and Katherine S. Dreier; he had his first one-man exhibition at the Société Anonyme in 1920; and his work was acquired by art institutions as well. The Metropolitan Museum of Art's collection includes more than ten examples of his work. Perhaps the most significant contribution to Eilshemius's posthumous reputation has been the interest of Roy Neuberger, who acquired more than 150 examples of the artist's work, which are now in the collection of the Neuberger Museum at the State University of New York at Purchase.

L.S.S

NOTES

1. Doreen Bolger Burke, *American Paintings in the Metropolitan Museum of Art, vol. III: A Catalogue of Works by Artists Born Between 1846 and 1864* (New York: The Metropolitan Museum of Art, 1980), 460.

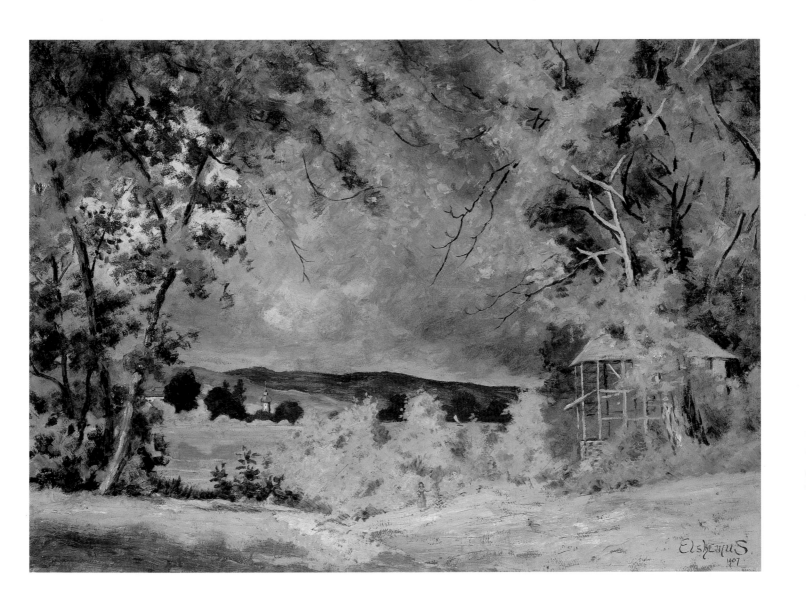

Landscape, Binghamton, New York, 1907
Oil on masonite
26¼ × 37¾ in. (66.7 × 95.9 cm)
George A. Hearn Fund, 1934
34.157

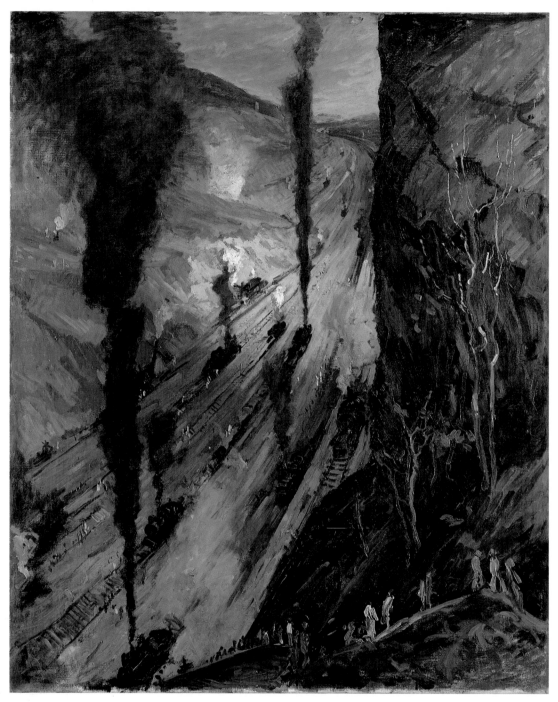

The Conquerors (Culebra Cut, Panama Canal), 1913
Oil on canvas
59¾ × 49⅞ in. (151.8 × 126.7 cm)
George A. Hearn Fund, 1914
14.18

2
JONAS LIE
1880–1940

The Conquerors (Culebra Cut, Panama Canal) is one in a series of twenty-seven paintings by Jonas Lie chronicling the excavation of the Panama Canal. The canal, the focus of much international news during the 1980s, created as much political controversy as did the digging of the Suez Canal, completed in 1869.

Lie began depicting the building of the canal in 1910, some three years after the commencement of construction. The entire series records the progress from initial planning to ultimate completion. (The canal was informally opened on August 15, 1914, and formally by presidential proclamation on July 12, 1915.) At a 1914 exhibition of Lie's paintings at the Buffalo Fine Arts Academy (now known as the Albright-Knox Art Gallery), the artist was commended for his success in interpreting the "epic quality of the profound genius and the conquering labor that had gone into the building of the Panama Canal" and for presenting "the greatest work of labor we have attempted as a nation."[1] The scene depicted in *The Conquerors* is located at the Culebra Cut (now known as the Galliard Cut)—the point where the canal crosses the Continental Divide of North America, approximately ten miles in from Panama City on the Caribbean coast. (The entire canal is some forty miles in length from coast to coast.)

Although the subject is definitely twentieth-century in approach and concept, the painting's composition relates more to eighteenth- and nineteenth-century notions of the sublime—man overwhelmed by, and in awe of, the grandeur of nature. Lie has exploited the dramatic perspective of the descent from the cliffs' dizzying heights to the water bed's low trough, being dug up by workers located at the center of the painting. We are reminded of the puny size of man within the context of nature when we start to discern the figures climbing up and down the promontory at the lower right of the composition. But the relationship between man and nature has changed dramatically. The smoke from the machines that cut and burrow through the landscape indicates that man is no longer respectful of the land, but is determined to manipulate and exploit it to his own advantage. The audacity of cutting through a land mass in order to achieve convenient access between two oceans would seem to be almost heretical within the philosophical context of earlier landscape traditions. By recording this event, Lie's Panama Canal series could be counted among similar documentation in twentieth-century American art such as George Bellows's depiction of digging tunnels under the Hudson River during the building of Pennsylvania Station in 1907, and Lewis Hines's photographs of the completion of the Empire State Building in 1931.

A native of Norway, Emil Carl Jonas Lie emigrated to the United States in 1893 after spending a year in Paris. While supporting himself as a designer in a cotton print factory in New York, he studied at night at the National Academy of Design and the Art Students League. He exhibited at the 1913 Armory Show and received the Carnegie Prize from the National Academy of Design in 1927. He served as president of this organization from 1934 until his death in 1940. Twelve of the remaining twenty-six paintings in the Panama Canal series are in the collection of the West Point Museum.

L.S.S

NOTES

1. *Catalogue of an Exhibition of Paintings of the Panama Canal by Jonas Lie* (Buffalo: Buffalo Fine Arts Academy, Albright Art Gallery, 1914), preface.

3
EUGENE SPEICHER
1883–1962

Eugene Speicher's reputation was established by his commissioned portrait paintings of the 1920s and 1930s, which were executed in a flattering, realist mode. After 1926 the artist continued to paint portraits, though no longer commissioned, as well as landscapes and flower arrangements. Several fine examples of Speicher's mature style are represented in the Metropolitan Museum's collection, including *The Mountaineer*, 1929, and *Deep Lake, Canada*, 1933 (fig. 2).

Morning Light, however, is of a much earlier date.

In its use of pale tonalities and broken brushwork, it is clearly inspired by impressionism. The light is greatly diffused as it filters through the early morning fog that hovers over the countryside. The locale depicted may be Woodstock, New York, a still-popular artists' colony at the foothills of the Catskill Mountains. Around 1907 Speicher bought a summer home in Woodstock and established a yearly pattern of spending seven months in the country and five months in New York City.

Born in Buffalo, New York, Speicher studied art

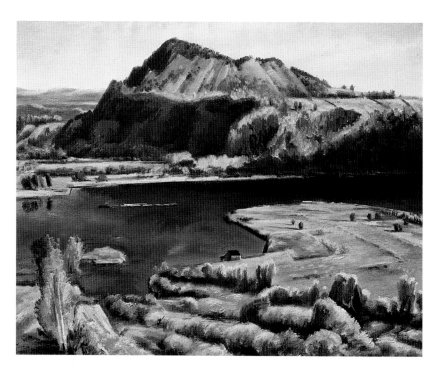

Figure 2
Deep Lake, Canada, 1933
Oil on canvas, 27 × 35 in. (68.6 × 89.9 cm)
George A. Hearn Fund, 1934
34.39

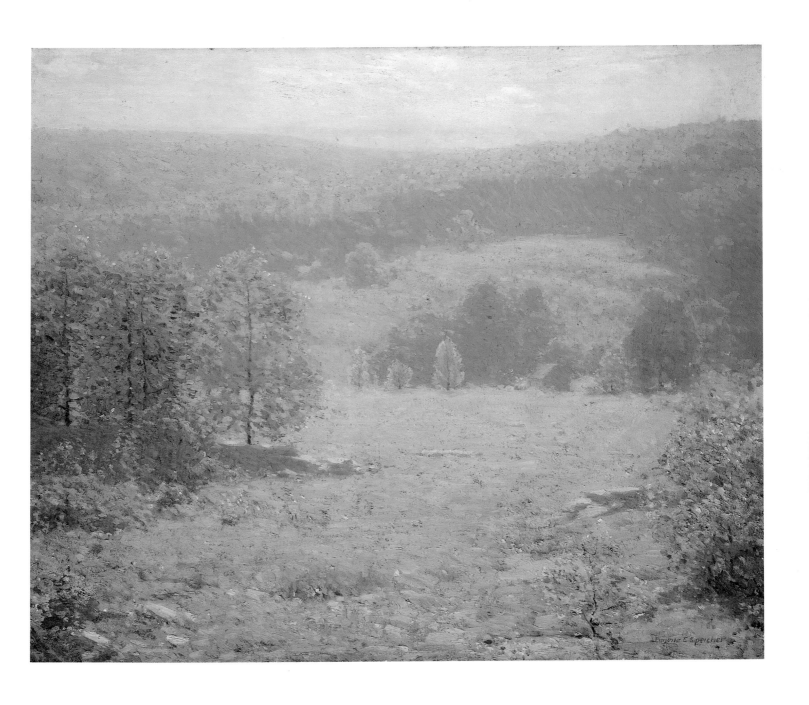

Morning Light, c. 1907
Oil on canvas
27¼ × 34⅛ in. (69.2 × 86.7 cm)
George A. Hearn Fund, 1912
12.105.5

in his hometown at the Albright Art School from 1902 to 1906 before attending classes at the Art Students League of New York on a scholarship between 1907 and 1908. At the League, Speicher met the young artist Georgia O'Keeffe and painted her portrait. Both of them took classes with William Merritt Chase, whose earlier impressionist work may have influenced Speicher's painting at that time. One year later, in 1909, Speicher began studying with Robert Henri (leader of The Eight, a group of artists who drew their subjects from city life), and his style and palette changed dramatically toward broader brushstrokes and darker colors. A trip to Europe in 1910, where he saw the work of Velázquez and Frans Hals, reinforced these tendencies and set the course for his mature development as an artist.

In 1945, many years after painting *Morning Light,* Speicher wrote "My Credo," which aptly expresses the qualities evident in this very early work: "My look and feel of the thing I am painting: my imagining and thinking about it, is what I try to express, be it a portrait, a figure, a landscape or a bouquet of flowers. Something that is not merely original and short-lived but which is supported by fundamental principles of art as well. It must be at once vital and subtle, well made and fresh in spirit. Something that will be a tonic to stir the imagination, a pleasure to the eye and reflect my sense of quality in life. Above all it must have rare flavor and strong grace, be warm, simple and well ordered."[1]

L.M.M.

NOTES
1. "My Credo" in *Eugene Speicher*, Eugene Speicher (New York: American Artists Group, 1945).

4
GEORGIA O'KEEFFE
1887–1986

For Georgia O'Keeffe, the natural landscape became her primary subject matter very early in the artist's long career. By the early 1920s she was prolifically painting images of Lake George, New York, located 150 miles due north of New York City in the Adirondack Mountains. Between 1918 and 1928, O'Keeffe and Alfred Stieglitz, the gallery owner and photographer whom she married in 1924, spent every summer there at the Stieglitz family home. Her paintings of Lake George range in style from highly abstract to very realistic. They focus on both the panoramic features of the landscape—the mountains, lakes, and rolling hills—as well as on individual trees, flowers, and barns (fig. 3). These specific objects were often painted at close range without including their surroundings.

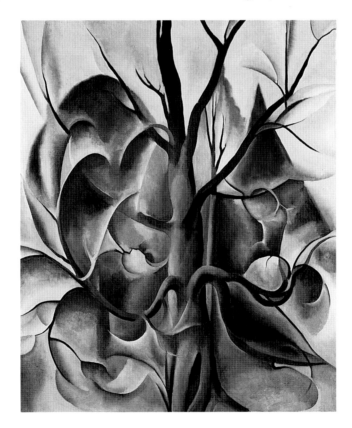

Figure 3
Grey Tree, Lake George, 1925
Oil on canvas, 36 × 30 in. (91.4 × 76.2 cm)
Alfred Stieglitz Collection, Bequest of Georgia O'Keeffe, 1986
1987.377.2

In 1929, O'Keeffe went to New Mexico for the first time and became enthralled with the vastly different terrain. No longer inspired by the lush green countryside of upstate New York, she became an annual visitor to New Mexico, eventually living there permanently from 1949 until her death in 1986. O'Keeffe found an eternal beauty represented in the bleached animal bones in the desert and in the unusual earthtones and formations of the mountainous southwestern landscape. She painted such scenes over and over again, often in series of four or five canvases. Nowhere does the human figure intrude upon the setting. Neither are there extraneous details; every object is honed to its essential shape and line, functioning as direct, almost spiritual, communications between the artist and the land.

O'Keeffe painted *Red and Yellow Cliffs* in the summer of 1940. The work is a luminous view of the striated cliffs behind the artist's adobe house at Ghost Ranch, near Abiquiu, New Mexico, which she humorously referred to as her "backyard."

O'Keeffe conveys the physical enormity of these seven-hundred-foot-high cliffs by her close, ground-level perspective. The cliffs, and the reddish hills below them, occupy the entire canvas, with only a small strip of blue sky visible in the upper left. The picture space is rather shallow and compressed. Three successive layers move our eye back in space. In the foreground are bare slopes dotted with green juniper bushes and piñon trees; in the middle are the rounded, creviced red hills; and finally, in the background, the imposing wall of rock. The brightness of the desert light is particularly evident in the upper yellow stripes, which almost seem to dissolve in the glow.

O'Keeffe was an important member of the Stieglitz circle in New York from the late 1910s to 1940s, but her personal reticence and need for isolation when working kept her somewhat apart from the group. When she traveled to New Mexico, she once again placed herself on the outside of the flourishing art communities of Taos and Santa Fe.

L.M.M.

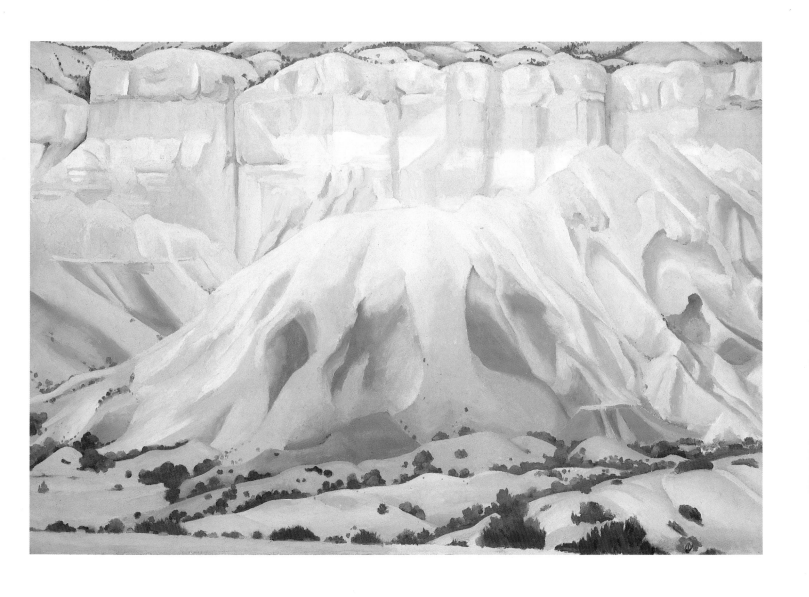

Red and Yellow Cliffs, 1940
Oil on canvas
24 × 36 in. (61 × 91.4 cm)
Alfred Stieglitz Collection, Bequest of Georgia O'Keeffe, 1986
1987.377.4

5
ERNEST BLUMENSCHEIN
1874–1960

For many artists, writers, and photographers in the early twentieth century, the American Southwest held forth the promise of unspoiled terrain, an "exotic" native culture, and fresh subject matter, vastly different from that found in the East or Midwest.

After first hearing about New Mexico from a fellow art student in Paris, Ernest Blumenschein made a brief trip to Taos early in 1898 on an illustration assignment from *McClure's* magazine. Taken with the city, he returned there later that year for a more extended stay and visited again in 1901. Between 1910 and 1919, when he settled there permanently, Blumenschein made annual painting trips to Taos.

Along with Joseph Henry Sharp and Bert Phillips, with whom he founded the Taos Society of Artists in 1912, Blumenschein is considered among the first generation of artists to arrive in New Mexico between the late 1890s and 1917. Trained in traditional art academies both in Europe and America, Blumenschein evolved a conservative style that nevertheless displays a flair for dramatic color and unusual perspectives. Younger artists like Andrew Dasburg, Marsden Hartley, and Georgia O'Keeffe (whose paintings of the Southwest are included in this publication; see cat. nos. 13, 55, and 4) are considered second-generation artists, and their work reflects a modern approach toward the expressive use of abstraction.

Besides painting the Indians in their native dress, artists in both generations sought to capture the impressive physical characteristics of the landscape, in particular the unusual clarity of light, the enormous scale of the geographical formations, and the sense of seemingly endless open space.

In *Taos Valley*, Blumenschein captures the extremes of the terrain: high, jagged mountains looming over low, flat plains. Although painted in 1933, this work closely recalls a scene that Blumenschein saw some thirty-five years before as he caught sight of Taos for the first time: "The morning was sparkling and stimulating. The beautiful Sangre de Cristo range to my left was quite different in character from the Colorado mountains. Stretching away from the foot of the range was a vast plateau cut by the Rio Grande and by lesser gorges in which were located small villages of flat-roofed adobe houses built around a church and a plaza, all fitting into the color scheme of the tawny surroundings. . . . The color, the effective character of the landscape, the drama of the vast spaces, the superb beauty and serenity of the hills, stirred me deeply. . . . New Mexico inspired me to a profound degree."[1]

Here, two mountain ranges dominate the foreground and background of the painting. They are treated in a sculptural manner that emphasizes their mass as well as their faceted, crystalline surfaces. The valley below is dotted with tiny adobe houses, while above, a storm is brewing in an overcast sky. The artist's reverence for the wild, majestic beauty of this landscape is clearly evident.

L.M.M.

NOTES

1. Ernest Blumenschein quoted in *Pioneer Artists of Taos*, Laura M. Bickerstaff (Denver: Old West Publishing Co., 1983), 31.

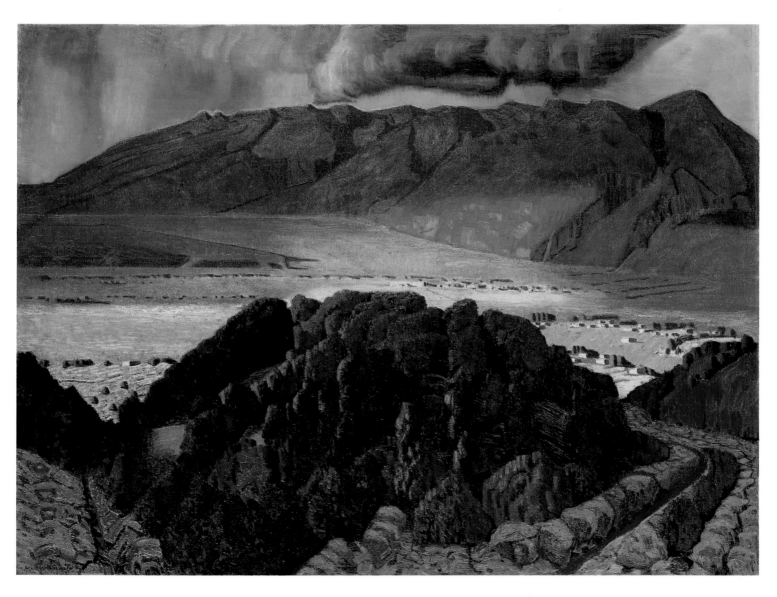

Taos Valley, 1933
Oil on canvas
25 × 35 in. (63.5 × 88.9 cm)
George A. Hearn Fund, 1934
34.61

6
MAX WEBER
1881–1961

Despite a career that spanned more than fifty years, Max Weber is most noted for his early abstractions, inspired by both the cubists and futurists, of figures, still lifes, and cityscapes that he created in New York between 1910 and 1915 upon his return from Paris. Tightly composed and visually dynamic, these paintings and drawings were in the forefront of radical American modernism and reflected his first-hand knowledge of Picasso, Braque, Matisse, and Rousseau, all of whom he had met a few years earlier, between 1906 and 1908. Weber's associates in Paris also included the American painters and sculptors who formed the New Society of American Artists (see cat. no. 10) under the leadership of Edward Steichen. In 1910, Weber exhibited with this group in New York at Alfred Stieglitz's avant-garde gallery "291" in the Younger American Painters exhibition, and the following year he had a one-man show there that marked the end of his short-lived friendship with Stieglitz.

By 1920 Weber's work underwent a permanent change in style and subject matter that seemed to signal a retreat from his more boldly innovative beginnings. His handling of paint became loose and brushy, almost expressionistic. His work became more narrative, focusing almost exclusively on figures and themes from Jewish life. Therefore, a small, lyrical landscape like *Pacific Coast* is unexpected, although pure landscapes, devoid of human figures or man-made intrusions, can be found periodically throughout his oeuvre.

Pacific Coast is the largest of at least three versions of this composition that Weber painted in 1952. Filling almost the entire canvas is a close-up view of a steep, craggy cliff in California. The wider panoramas presented in two horizontal companion pieces reveal that the cliffs are actually part of a coastal scene. While the ocean is not specifically painted in this version, it is alluded to in the artist's pervasive use of blue and green tonalities. The oil paint is broadly applied to the canvas in thin, overlapping washes of color. The formation of the rocks is defined by quick, jagged lines that dart across the canvas, rather than by modeling. This technique suggests affinities with the calligraphic, gestural brushwork of the abstract expressionists, particularly that of Clyfford Still and Mark Tobey, both of whose work gained prominence in the 1940s and 1950s. The overall effect of *Pacific Coast* is ethereal, even mystical, recalling the spiritual quality of Oriental art. It is a marvelous reaffirmation of life by an artist in the last years of his career.

L.M.M.

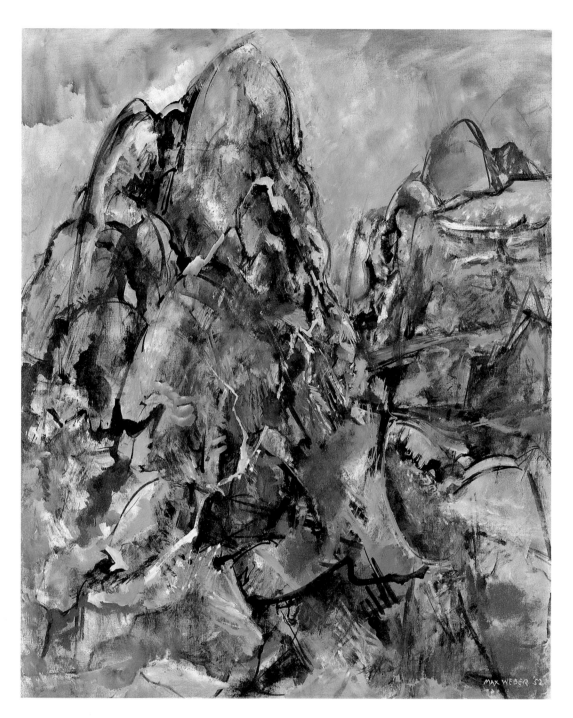

Pacific Coast, 1952
Oil on canvas
36 × 30 in. (91.4 × 76.2 cm)
Gift of Joy S. Weber, 1985
1985.453

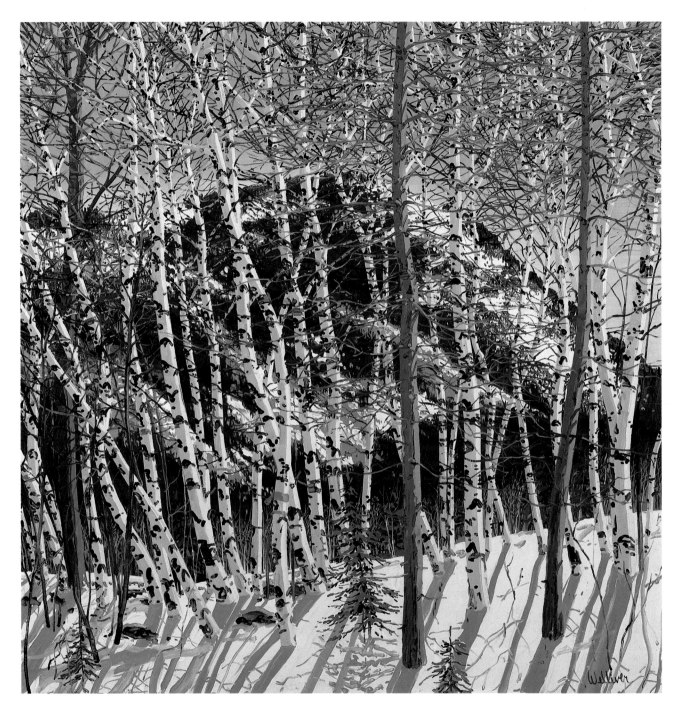

The Birches, 1977
Oil on canvas
60 × 60 in. (152.4 × 152.4 cm)
Gift of Dr. and Mrs. Robert E. Carroll, 1979
1979.138.2

7
NEIL WELLIVER
born 1929

The beautiful woods of Maine, where Neil Welliver lives, have been the primary source of inspiration for his art for more than twenty years. Raised in Pennsylvania, Welliver first came to Maine in 1961 in search of a place to paint landscapes. He stayed with his friend, the artist Alex Katz, and finding it ideal, purchased a large farm.

The Birches reflects Welliver's meticulous style of realist painting that is based on direct observation over a period of several days, without the benefit of photography. Often the setting is already familiar to the artist, but has gone unnoticed before. "What interests me is to walk into the woods and turn in any direction and suddenly see something that strikes me, something that's absolutely staggering. When I do, I hang out there, going back, walking and walking through the same area again and again....I find the woods inexhaustible, overwhelming, really....There's something devastating about walking through a spot you've been through fifty times and suddenly seeing it. It forces itself on you. That's an incredible experience that is difficult, if not impossible, to make sense of."[1]

Like the painters of the nineteenth-century American landscape tradition that preceded him, Welliver paints idyllic landscapes that focus on the beauty of nature. However, unlike these artists, Welliver's settings are not grandiose or sublime. Rather his pictures are realistic renderings of quiet, unspoiled landscapes, without people, often bathed in light.

Starting with two-foot-square oil sketches made on the spot, Welliver works out the composition in charcoal sketches until a final arrangement is created. Then a large, full-scale drawing is made and transferred onto the canvas by perforating the drawing with holes and dabbing through some dry pigment. The result is a general outline from which the artist begins to paint.

Welliver's painting process is as disciplined as his preparatory work, and highly unusual. Beginning at the top of a canvas, he works his way across and down without ever going back. "The way I paint is totally focused and intense and complete—every mark is a form that's not going to be covered up later. I don't go over it. I go down the canvas to the bottom and out, and that's it."[2] To complete a painting takes anywhere from four to five weeks. This mastery of painting technique is fully evident when we look at the incredibly complex detailing in *The Birches.*

The scene depicted is of Hatchet Mountain in Maine, viewed from the west. A thicket of slender white birch trees, defoliated for the winter, forms an open latticework fence that almost camouflages the large blue mountains in the background. A few other tall trees, whose barks have a green cast, and some small pine trees grow in between the birches. The overall density of the imagery negates a central focal point. The ground is covered with untrodden snow, striated with blue shadows cast by the cool winter light. The air fairly crackles with the frigid temperature. "In Maine there is an extraordinary clarity. You can look for a mile but objects seem right before your face....I'm interested in the character of the light—that northern flat light—where the sun doesn't get very high."[3] This is a painting that by its monumental scale and size invites the viewer to enter the scene.

L.M.M.

NOTES
1. Neil Welliver quoted in *Art of the Real,* ed. Mark Strand (New York: Clarkson N. Potter, 1983), 204 and 208.
2. Ibid., 217.
3. Ibid., 204.

8
GABOR PETERDI
born 1915

Landscape subjects were the first images to inspire the Hungarian-born artist Gabor Peterdi. At fifteen, he created paintings and drawings that earned him a one-man show in his native Budapest. After studying art at the Hungarian Academy for a year (1929), he moved to Rome in 1930, and the following year attended the Academie delle Belle Arti.

Disgusted by the rise of Fascism in Italy, Peterdi moved to Paris in 1931, remaining there until 1939. His work during these years centered on urban themes and often reflected the political tensions and violence in Europe prior to World War II. In Paris in 1934 he joined Stanley William Hayter's famous printmaking school, Atelier 17, where he learned intaglio techniques. From then on Peterdi produced, in addition to paintings, a body of graphic work for which he has become well known. After emigrating to the United States in 1939, he joined Hayter's school in New York City, where he met Jackson Pollock. That year he had a one-man show at the Julien Levy Gallery in New York City. Through the end of World War II Peterdi's work continued to depict images of violence and death.

It was his move in 1951 to Rowayton, Connecticut, in the southwestern part of the state that prompted his change to more optimistic themes and a return to landscape subjects. The artist said: "I believe in life, and it is this faith which compels me to express the creative powers of nature as a symbol of the triumph of life over destruction."[1] Paintings of the sea, the intricate weaving of tree branches and marshland grasses, and the visual relationship between land and sky has dominated his work of the past thirty years. In such pictures, done in series, Peterdi experiments with color and the effects of light and season. Although based on actual places, these paintings evoke the feeling of a particular environment without presenting it literally and stand as metaphors for human emotions.

Since 1977, Peterdi has found an inexhaustible inspiration in the wetland area that runs along the Long Island Sound near his home in Rowayton. The compositions in this series are similar, although the artist's point of view shifts slightly from painting to painting, thereby altering the placement of the horizon line. In *The Big Wetland I,* the viewer looks up at the distant landscape and thin strip of pale sky through a delicate mesh of tall grass. Peterdi makes us hear the rustling sound of those resilient blades blowing in the wind, and we sense the undercurrent of their gentle motion as evoked by his calligraphic brushstrokes. At times these lines are dense and agitated; at others they are thin and attenuated—a play of texture and density also found in Peterdi's prints. The overall impression of the painting is highly abstract, although these linear elements are held in check by a rigid understructure of horizontal bands. Such spontaneous brushwork reminds us of the rigorous strokes and drips of the abstract expressionists, many of whom Peterdi knew in the 1940s.

For the artist, these landscapes evolved spontaneously, "triggered by contact both physical and emotional with the subject. Once I start working I let the painting take over and tell me how it wants to be painted. I want the painting to have autonomy and not to be an illustration of a literary idea."[2] They are the result of his quest "to reconcile poetry and geometry."[3]

L.M.M.

NOTES
1. Gabor Peterdi quoted in *Gabor Peterdi: Paintings*, Burt Chernow (New York: Taplinger Publishing Co., 1982), 11.
2. Gabor Peterdi, artist questionnaire in The Metropolitan Museum of Art, Department of 20th Century Art archives.
3. Ibid.

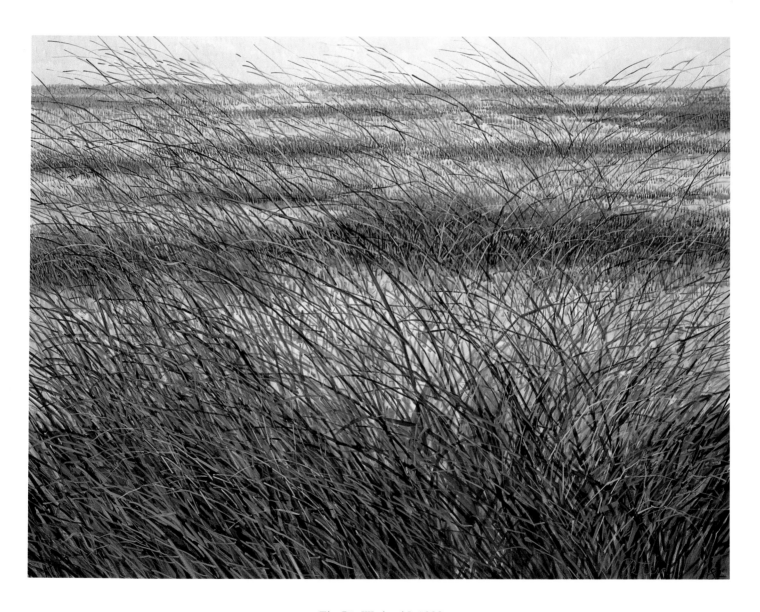

The Big Wetland I, 1982
Oil on canvas
60 × 80 in. (152.4 × 203.2 cm)
Gift of Mr. and Mrs. Warren Brandt, 1983
1983.39

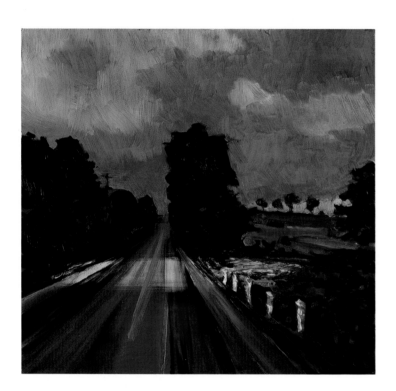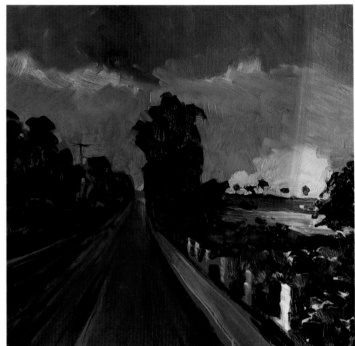

Pennsylvania, 1983
Oil on wood
Two panels, each 9¼ × 9¾ in. (23.5 × 24.8 cm)
Edith C. Blum Fund, 1983
1983.254a,b

9
MARK INNERST
born 1957

Mark Innerst was born in York, Pennsylvania, and received his Bachelor of Fine Arts from Kutztown State College, also in Pennsylvania. He currently works in New York City and Newfoundland, Pennsylvania.

The modestly scaled diptych landscapes of *Pennsylvania*—views of the same portion of a quiet rural road—may be installed either side by side or one above the other. This optional installation requirement does not mitigate the fact that these two paintings might be seen as serial stills of a running movie. Together they show movement, a change in time. The important variable is the placement of the celestial light that slices through the right-hand portion of one, and sets down horizontally across the road in the other. The preceding, intermediary, and subsequent moments in the movement of the light—if indeed it comes from the same source—have been eliminated, its source unspecified, thus intensifying the speculation about the narrative whole. Are we witnessing a passing atmospheric phenomenon? Or does the light emanate from an extraterrestrial vessel, the kind often sighted in isolated areas?

This lapse in information lends an air of mystery to an otherwise innocuous scene, rendered in such a way that the ordinary becomes extraordinary. Innerst adroitly exploits our appetite for anecdote, and our enjoyment of suspense, which has been fed by our movie culture. Given his use of a sequential format, it is not surprising that the artist has worked at producing storyboards for feature-length films. Innerst also addresses the dominance of photographic and filmic images in our society, and their effect on our perspective on the world around us by utilizing their narrative techniques within a painterly format. The gestural brushwork functions to "mask" or "veil" the expected sharp focus of the material, introducing an almost impressionistic, that is, atmospheric, look to the twin scenes. It is what Barry Blinderman has coined as "the Divine Light and the electronic sublime . . . [that is] . . . we behold nature through a series of technologically veiled snapshots."[1]

The frames are also a focal point of interest for the artist. They cause a curious disjunction between the space within the two panels in spite of the fact that they are meant to be installed in close proximity to one another. Innerst may be challenging the conceit of historicism in European painting, but the nuance is completely of the 1980s. The idea of art as commodity has never been more forthrightly declared, whether in a gallery, an auction house, or even a museum. Various artists have responded to this situation by asserting the value of paintings through the use of frame iconography with the presentation of frames either singly or in multiples as the main focus or subject matter. Whether cynical commentary or conceptual symbolism, this device potently chronicles the conflicts and divergent philosophies within the contemporary art world.

<div align="right">L.S.S.</div>

NOTES
1. Barry Blinderman, "Veil of the Soul," in *Mark Innerst: Landscape and Beyond: Paintings and Works on Paper, 1981–1987* (Normal, Ill.: University Galleries, Illinois State University, 1988), 10.

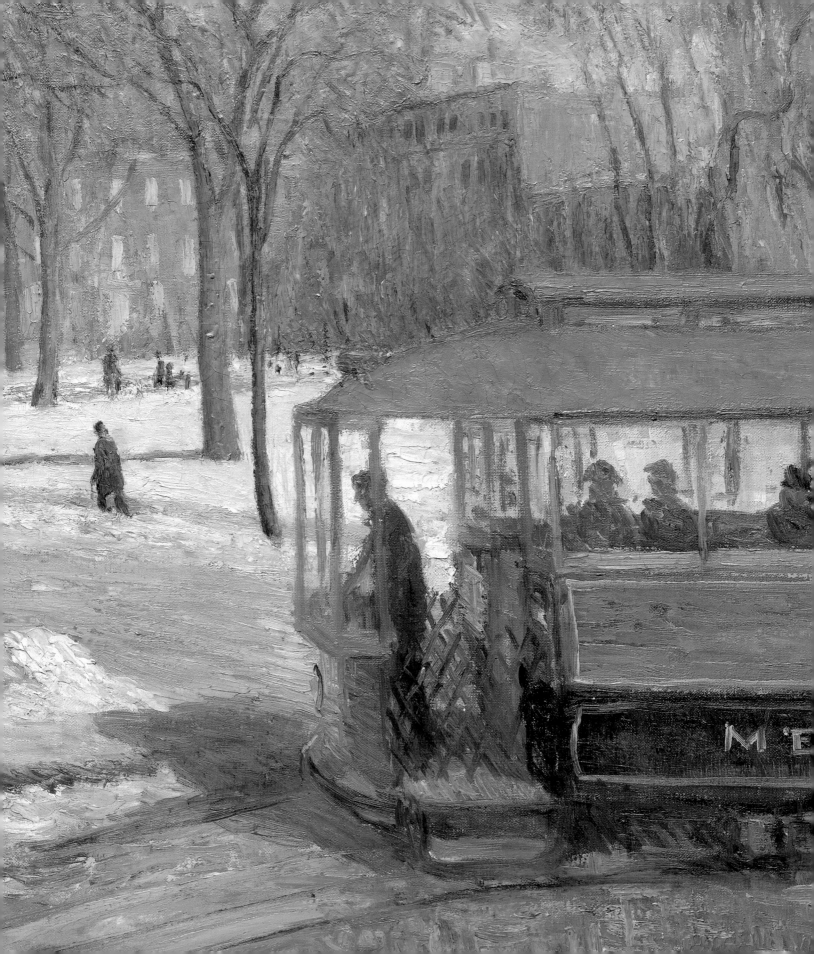

Town and Country

At the turn of the century, the physical distinctions between city and country were much less defined than they are today. In 1900, even large metropolitan centers like New York remained relatively rural with sizeable tracts of undeveloped land and low buildings. What seems to set these metropolitan and rural settings apart from each other is their degree of activity. At first glance, *The Green Car* (cat. no. 11)—William Glackens's view of Washington Square in New York City's Greenwich Village—is not so different from *The Church* (cat. no. 10)—Arthur B. Carles's painting of a country church located outside Paris. However, upon further study, we see that Glackens's painting is busy with people attending to their daily rounds, and the insertion of the green trolley car presents the machine that signals the beginning of a new era. Carles's bucolic painting of a church, on the other hand, is quiet and restful, undisturbed by human or mechanical motion. Only its composition and colors suggest a thoroughly modern vision.

Over the next few years, the face of the city changed rapidly and dramatically with the advent of the skyscraper. This change was expressed in the paintings of the 1920s and 1930s, which presented an ambiguous relationship between architecture and nature. Some artists, such as Edward Hopper and Doris Lee, focused on images of isolation or catastrophe within the city's vortex. Others, like Ogden Pleissner and Loren MacIver, present some hope of coexistence, akin to the way small gardens thrive within the backyard confines of townhouse buildings. In *Steeplechase* (cat. no. 14), Milton Avery's view of the beachfront amusement park at Coney Island, a glimpse of city leisure time is presented in a Depression-era painting. The large, simple shapes of the tents and roller coaster find sympathetic counterparts in the bulbous bodies of the sunbathers.

Like Avery's painting, *Road to Lamy* (cat. no. 13), Andrew Dasburg's picture of a deserted road in Santa Fe, New Mexico, shows an interdependent relationship between landscape and architecture. The adobe buildings grow naturally out of the red earth, their irregular, rocklike forms echoing the hulking shape of the surrounding mountains.

L.M.M.

41

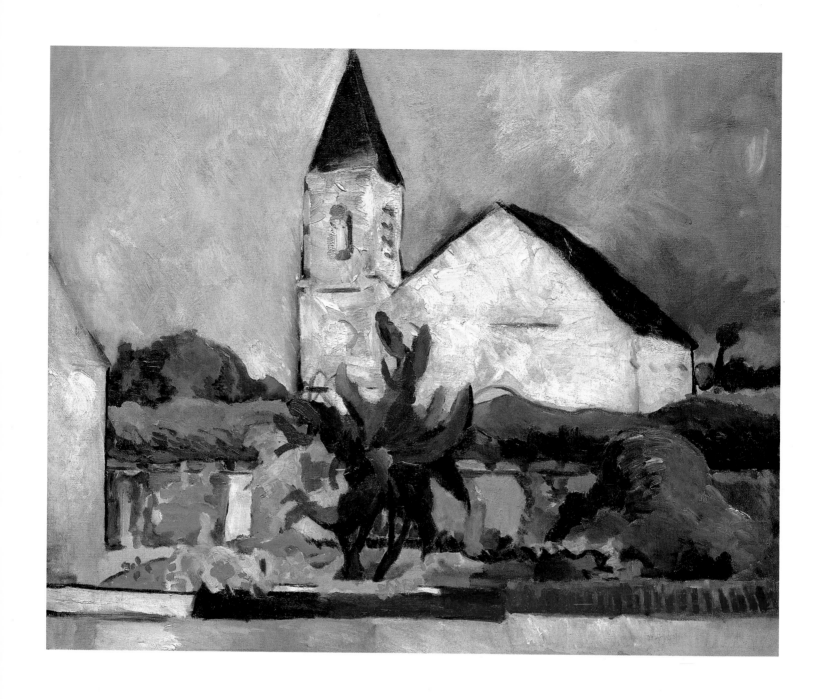

The Church, c. 1910
Oil on canvas
31 × 39 in. (78.7 × 99.1 cm)
Arthur Hoppock Hearn Fund, 1962
62.203

10
ARTHUR B. CARLES
1882–1952

During February 1908, a group of American artists in Paris, led by the painter-photographer Edward Steichen, formed the New Society of American Artists. Included in the group were such painters as Patrick Henry Bruce, John Marin, Alfred Maurer, Max Weber, and Arthur B. Carles, who was in Europe between June 1907 and November 1910 on a scholarship from the Pennsylvania Academy of the Fine Arts. Steichen had many connections with modern artists in Europe and America. Through him, Carles met the sculptors Auguste Rodin and Constantin Brancusi. He also knew Alfred Stieglitz in New York, with whom he had founded the "291" gallery. Stemming from this association, the New Society of American Artists was included in the "291" show, Younger American Painters, in 1910.

Among the Americans, Carles was one of the most profoundly influenced by Henri Matisse's paintings, which he saw in Paris. Matisse's expressionist use of unnatural color, thickly applied pigment, and light-filled surfaces found a sympathetic, if less vigorous, response in Carles's work of 1908–

10. *The Church*, a picture of a simple country church in Voulangis par Crécy-la-Chapelle-en-Brie, located about twenty-five miles east of Paris, is composed of light, line, and color, with almost no modeling or specific detailing. Like most of Carles's landscapes, this one does not contain people.

Carles spent the summer of 1908 in Voulangis, where Steichen also had a house, and made several drawings and paintings of this Romanesque chapel. In July 1909, Carles married Mercedes de Cordoba, a fashion illustrator whom he had met through Steichen. Considering the painting's subject and the time of year portrayed, it is interesting to speculate if the couple might have been married in this particular church. Whether or not this is the case, the painting was important to the artist since he chose to include it, as one of two, in the Armory Show in New York in 1913.

After another trip to Europe in 1912, Carles returned to Philadelphia. An avowed modernist and influential teacher, Carles's later work continued in the direction of ever-increasing abstraction.

L.M.M.

11
WILLIAM GLACKENS
1870–1938

William Glackens was a keen observer and able recorder of the rhythm and details that comprised daily life for urban dwellers in early twentieth-century America. From about 1891 to 1914, Glackens earned his living as an artist-reporter for several newspapers and magazines, first in his native Philadelphia, then in his adopted home of New York after 1896. His friend, the artist Everett Shinn, remarked that Glackens had an outstanding visual acuity that served him well: "His memory was amazing; one look on an assignment was much the same to him as taking an exhaustive book of that incident from a shelf where at his drawing board he opened it and translated it into pen lines."[1] This visual memory also served him well in his other career as a painter in which he was able to capture

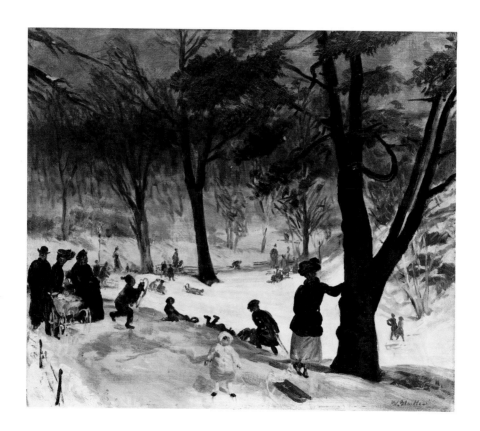

Figure 4
Central Park, Winter, c. 1905
Oil on canvas, 25 × 30 in. (63.5 × 76.2 cm)
George A. Hearn Fund, 1921
21.164

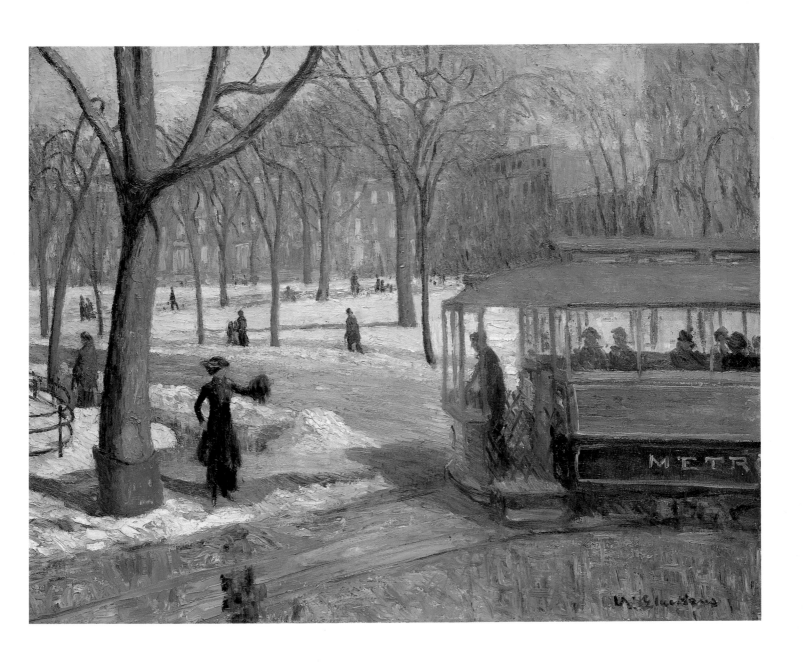

The Green Car, 1910
Oil on canvas
24 × 32 in. (61 × 81.3 cm)
Arthur Hoppock Hearn Fund, 1937
37.73

the smallest details of gesture and incident, thus endowing his canvases with a sense of spontaneity and life.

Glackens's early years in Philadelphia brought him into contact with the future art collector Albert C. Barnes, and with some of the artists who would come to be known as The Eight, including Robert Henri, John Sloan, Everett Shinn, and George Luks. He gained recognition for his paintings when they were exhibited in 1908 in The Eight's only exhibition, held at the Macbeth Gallery in Manhattan. The group (which also included Ernest Lawson, Maurice Prendergast, and Arthur B. Davies) shocked the public with their preference for painting contemporary urban scenes, rather than traditional academic subject matter. Of all the members, Glackens was most obviously influenced by impressionist paintings, which he had seen during trips to France in 1895–96 and 1906. He was particularly influenced by the feathery brushwork and high-keyed palette of Pierre-Auguste Renoir. In 1912 Albert Barnes sent him to Europe with $20,000 to purchase paintings for his collection (now in Merion, Pennsylvania). Among the works Glackens selected for Barnes were paintings by Renoir as well as by Edouard Manet, Edgar Degas, and Paul Cézanne. That same year Glackens painted a series of canvases depicting life around Washington Square, which no doubt reflected the influences of these French artists.

Since 1904 Glackens and his family had lived on Washington Square, by the park in New York City's bohemian Greenwich Village. In 1908, the year of The Eight's exhibition, they moved to an address on lower Fifth Avenue, and Glackens ac-quired a studio on the square, from which he painted *The Green Car*. In this painting, a green trolley car rounds the corner at the south side of the park on its way to pick up a lady standing by a tree at the curb. Dressed in long coat, hat, and muff, she signals to the conductor. Her pose and outfit recall another woman in one of Glackens's earlier paintings of New York, depicting sledders in snowy Central Park (fig. 4). Her face and figure, like those of other people in the picture, are indistinct, yet their actions hold a familiar ring. The park is dotted with small, dark figures, summarily painted, walking along the snowy paths, which are beginning to thaw. In viewing this carefully structured composition, our eye moves from front to back, following the route of the trolley and the converging pathways through the park until we reach the row of three-story brick buildings in the background. The overall effect of the picture is one of energy and movement enhanced by the consistently animated brushwork and bright mix of colors used throughout the composition. By 1910, Glackens's use of unusual color combinations—such as purple and orange—and his new interest in patterning, suggested the influence of another French artist, Pierre Bonnard.

For Glackens, New York City's still rather rural landscape of the early twentieth century provided an affirmation of the good life, which he himself was experiencing.

L.M.M.

NOTES
1. Everett Shinn quoted in *The Eight*, Mahonri Sharp Young (New York: Watson-Guptill Publications, 1973), 97; reprinted in *Recollections of The Eight*, Everett Shinn (Brooklyn: Brooklyn Museum Press, 1943).

12
EDWARD HOPPER
1882–1967

For many artists living in New York City in the early decades of the twentieth century, the rapidly changing cityscape provided a subject as stimulating and varied as any found in the natural landscape. The paintings by these artists recorded the transformation of the city from a genteel setting of low brownstones and trees, as in William Glackens's 1910 impressionistic view of Washington Square (cat. no. 11), to Doris Lee's horrific fantasy of 1936, depicting New York's harbor surrounded by tall skyscrapers, under siege by panicked parachuters (cat. no. 16). Somewhere in between, both in date and in feeling, is Edward Hopper's realistic painting of 1928, *From Williamsburg Bridge,* one of several memorable images of New York City that he painted around this time.

In this picture, Hopper focuses on the upper portions of four adjoining buildings, seen from the

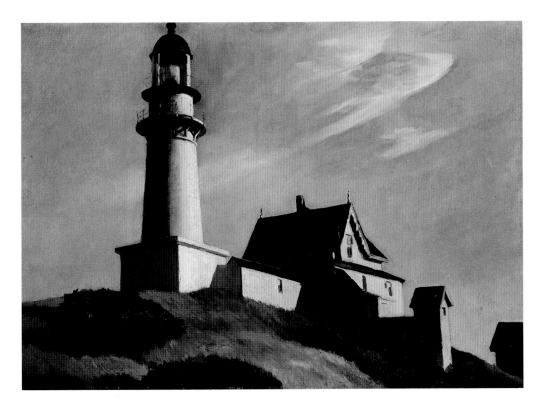

Figure 5
The Lighthouse at Two Lights, 1929
Oil on canvas, 29½ × 43¼ in. (74.9 × 109.9 cm)
Hugo Kastor Fund, 1962
62.95

47

vantage point of the Williamsburg Bridge. The bridge, which spans the East River, was completed in 1903 and links the lower east side of Manhattan with the borough of Brooklyn. The architectural styles of the buildings in this painting suggest the charm of New York at the beginning of the twentieth century, but the sense of social isolation that Hopper achieves seems much more contemporary. In the immediate foreground, he includes the handrail that runs along the pedestrian path of the bridge, sloping it upward to suggest the gentle rise of the structure. The presence of this physical impediment creates a psychological barrier for the viewer. Like Hopper, we too become passive but interested observers of this factual representation of city life. In the stark geometry of the buildings and the absence of extraneous detail and street activity, we almost miss the lone figure sitting at the open window of the tallest building.

Hopper made at least one drawing for this painting,[1] presumably on site, that reveals another chimney, pipe, fire escape, and grating that were eliminated in the final version for the sake of visual clarity and cohesion. Varying in height and degree of ornateness, Hopper's buildings have repetitious rows of windows, and the irregular, jigsaw patterns of the rooflines are set against the open sky. The bright daylight creates stark contrasts of light and dark on the structures, which lend the scene a sense of solidity.

Hopper's work as an illustrator between 1899 and 1924, and his early training from 1900 to 1906 at the New York School of Art with Robert Henri, an artist and leader of The Eight, led him to paint realistic scenes of urban and rural America. His paintings, however, unlike those of Henri and his followers, seem motionless and without noise. His favored subjects were not narrative vignettes or animated portraits, but rather solemn, carefully composed compositions that explored the effects of light on architectural subjects, as in *The Lighthouse at Two Lights* (fig. 5). In most of Hopper's works, the one or two figures present play a secondary role to their surroundings.

In 1928, the year he painted *From Williamsburg Bridge*, Hopper characterized the work of another American painter, Charles Burchfield, in terms that might well describe his own art: "From what is to the mediocre artist and unseeing layman the boredom of everyday existence in a provincial community, he has extracted a quality that we may call poetic, romantic, lyric, or what you will. By sympathy with the particular he has made it epic and universal."[2]

Five years later, in 1933, Burchfield wrote this entry for Hopper's retrospective exhibition at the Museum of Modern Art: "Hopper's viewpoint is essentially classic; he presents his subjects without sentiment, or propaganda, or theatrics. He is the pure painter, interested in his material for its own sake, and in the exploitation of his idea of form, color, and space division. In spite of his restraint, however, he achieves such a complete verity that you can read into his interpretations of houses and conceptions of New York life any human implications you wish; and in his landscapes there is an old primeval Earth feeling that bespeaks a strong emotion felt, even if held in abeyance."[3]

L.M.M.

NOTES

1. A drawing for *From Williamsburg Bridge* (1928, conté crayon on paper, 8½ × 11 in.) is in the collection of the Whitney Museum of American Art, New York, Josephine N. Hopper Bequest.
2. Edward Hopper, "Charles Burchfield: American," *The Arts* 14 (July 28): 6.
3. Charles Burchfield, "Edward Hopper—Classicist," in *Edward Hopper: Retrospective Exhibition*, Alfred H. Barr, Jr. (New York: Museum of Modern Art, 1933), 16.

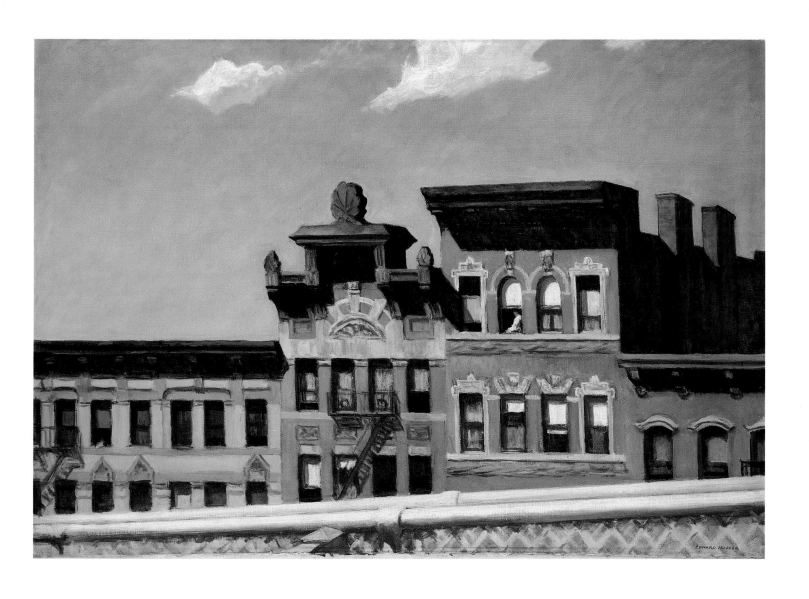

From Williamsburg Bridge, 1928
Oil on canvas
29 × 43 in. (73.7 × 109.2 cm)
George A. Hearn Fund, 1937
37.44

13
ANDREW MICHAEL DASBURG
1887–1979

The opening of the West to travelers from the East began in the 1880s when the Atcheson Topeka & Santa Fe Railroad made its first run between Kansas and New Mexico. Shortly thereafter, other railways laid tracks to California that also went through the Southwest. Cities like Santa Fe and Taos (located seventy-five miles north) soon became thriving artistic centers because of their relative accessibility to New Yorkers.

In 1918, Andrew Dasburg came to Santa Fe for the first time at the beckoning of Mabel Dodge, who had recently moved there from New York with her husband at the time, the artist Maurice Sterne. Known in New York for her art salon, Dodge in New Mexico continued to surround herself with interesting people by extending invitations to such artists as John Marin and Georgia O'Keeffe, and the writer D. H. Lawrence, among others. Dodge's telegram to Dasburg read: "It's a wonderful place. Must come. Am sending you tickets. Bring me a cook."[1] With German cook in tow, Dasburg and Robert Edwin Jones, the stage designer, made the journey from New York to Santa Fe. They stopped briefly in Lamy to change trains, then continued north to Embudo where a car met them for the drive to Dodge's house in Taos.

Dasburg's view of the dirt road leading from Santa Fe to Lamy was painted in the 1920s, several years after his initial visit to Mabel Dodge. Between 1920 and 1928, he was a regular part-time resident in Santa Fe, dividing his time between New Mexico, where he wintered, and Woodstock, New York, another artists' colony where he lived and taught the rest of the year. The deserted, dusty road, solid adobe buildings, and slender telephone poles depicted in this picture closely resemble photographs taken of Canyon Road, located near Dasburg's Santa Fe home. The tall telephone poles echo the shape of the many religious crosses that dot the New Mexico landscape. Like a religious procession, they lead our eye into the composition. Using a pictorial device that he learned from studying Cézanne's work during an earlier sojourn in Paris around 1909–10, Dasburg tilts the road upward toward the viewer, bringing the background closer.

When he moved permanently to Taos in 1933, Dasburg had already established his career as a modernist in such New York gallery shows and international exhibitions as the Armory Show of 1913 and the Forum Exhibition of 1916. During the 1920s, his style combined abstract and representational elements. Recognized as an accomplished scene painter, Dasburg soon rivaled Ernest Blumenschein as the dominant painter in the Taos art community.

L.M.M.

NOTES
1. Edna Robertson and Sarah Nestor, *Artists of the Canyons and Caminos: Santa Fe, The Early Years* (Salt Lake City: Gibbs M. Smith, 1976), 98.

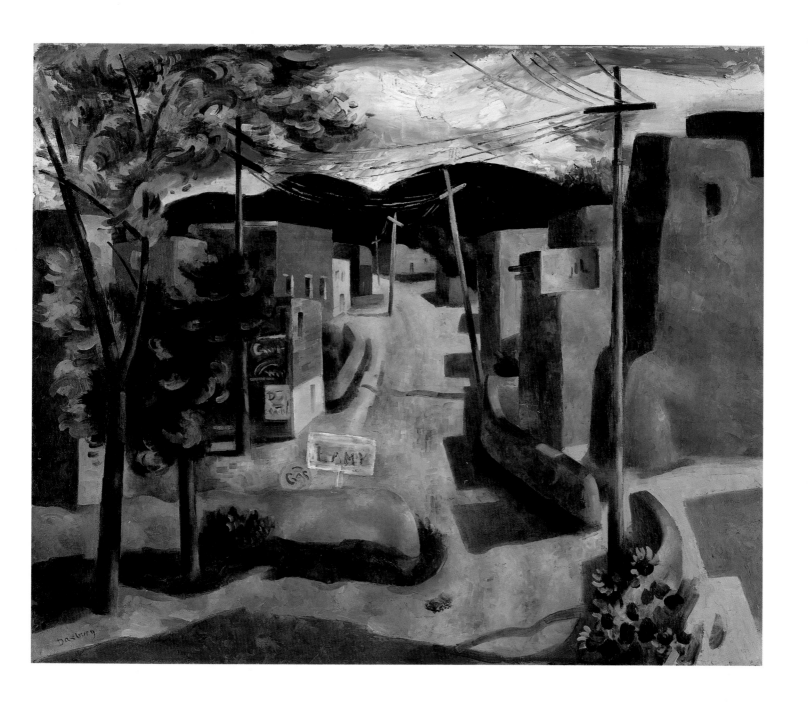

Road to Lamy, 1923
Oil on canvas
24 × 29½ in. (60.9 × 74.9 cm)
George A. Hearn Fund, 1951
51.19

14
MILTON AVERY
1885–1965

Weekend excursions to Coney Island were a favorite summer pastime for Milton Avery and his wife Sally, herself a painter. They were married in 1926 and had settled into a New York City studio by 1929. Sally Avery has reminisced: "The subway fare to Coney Island was five cents; with a dollar set aside and our sketchbooks in our knapsacks, we could spend a fascinating holiday at the beach. We reveled in the crowds . . . the wonderful smells of hot dogs and knishes. . . ."[1] But this depiction of the amusement park at the beach evokes a bittersweet memory: "We eyed the Steeplechase and Luna Park wistfully. The admission charge kept us out, but we listened to the barkers extolling the virtues of the bearded lady, the snake charmer, and the sword swallower—our free mini show. When the sun was going down we began to think of starting home. We still had enough left from our

dollar to get a hot chocolate. Then into the subway for the long ride back, full of sun and sand and ideas for future paintings."[2]

Avery's *Steeplechase* demonstrates the dramatic changes in his painting style that came about in the late 1920s. There are still resonances of the brooding palette of Albert Pinkham Ryder (the first strong influence on Avery) in the relatively dark values of black and brown. But the more recent impact of Henri Matisse (who received the Carnegie International Award in 1929, the year this painting was executed) can be glimpsed in the cursory, abbreviated rendering of the figures and forms in which the flow of the line has a primary role. While Avery still relies on a perspectival system to indicate a spatial progression in the composition, there is enough ambiguity in the positions and relationships of the foreground figures to indicate his eventual surrender of this spatial device and his growing reliance on color to define space.

Coney Island, located in Brooklyn on the Atlantic coast, has been a resort area since the 1840s when the first bathhouse and pavilion were erected. The development of amusement parks at the beach—of which the Steeplechase and Luna Park were the most famous—began around the turn of the century.[3] William Glackens's composition, *Crowd at the Seashore* (fig. 6), which is also in the Metropolitan Museum's collection, was completed around 1910. It is amusing to contrast the more daring bathing attire in Avery's work with the prudish cover-ups in Glackens's.

L.S.S.

Figure 6
Crowd at the Seashore, c. 1910
Oil on canvas, 25 × 30 in. (63.5 × 76.2 cm)
Bequest of Miss Adelaide Milton de Groot
(1876–1967), 1967, 67.187.126

NOTES
1. Sally Michel Avery, "A Family Album," *Art and Antiques* (January 1987): 65.
2. Ibid., 67.
3. Kathy Peiss, *Cheap Amusements: Working Women and Leisure in Turn-of-the-Century New York* (Philadelphia: Temple University Press, 1986), 115–38.

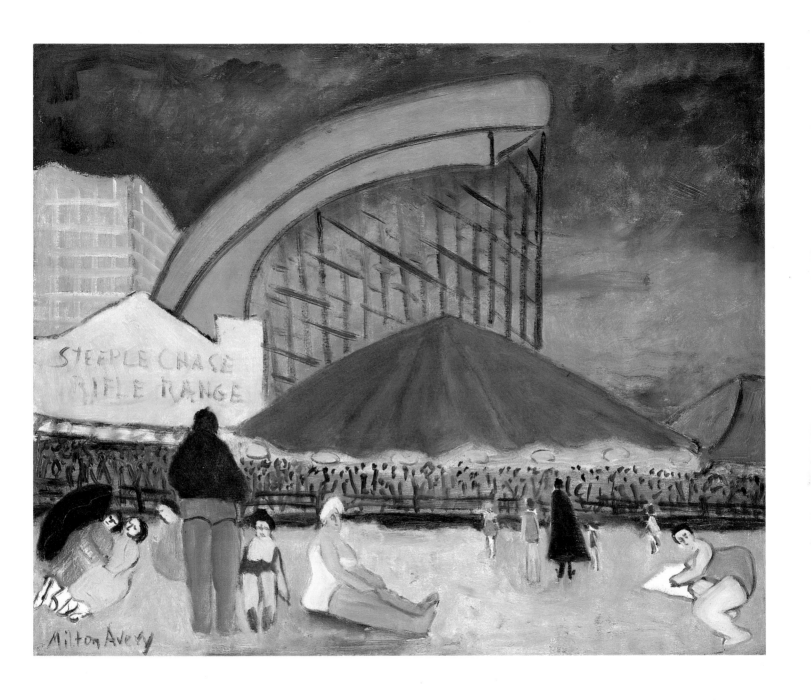

Steeplechase, 1929
Oil on canvas
32 × 40 in. (81.3 × 101.6 cm)
Gift of Sally M. Avery, 1984
1984.527

15
OGDEN MINTON PLEISSNER
1905–1983

This view of the contiguous backyards of a group of town houses in Brooklyn by Ogden Pleissner was acquired by the Metropolitan Museum when the artist was twenty-seven years old. Although we do not have specific information on the location, there is a familiar quality about the scene that could certainly be found in any urban residential area today.

Appropriately enough, Pleissner was born in Brooklyn. He studied at Manhattan's Art Students League where one of his instructors was George Bridgman, author of the well-known book on human anatomy for artists. During World War II, Pleissner served as an official artist for the United States Air Force, recording battle scenes in Italy and France. His paintings of the Normandy invasion appeared in *Life* magazine, and earned him special recognition by the Office of the President.

Pleissner's skills at observation and precise rendering were fine-tuned under the urgent conditions of wartime reporting. *Backyards, Brooklyn* is remarkable for its immediacy and attention to detail. The artist has carefully observed the manner in which the sunlight falls on the surface of the buildings. We can pinpoint the time of day as the late afternoon. Pleissner has also lavished great care on the rendering of the trees and vines at this moment in the early spring, particularly the dogwood tree that is in full bloom in the center of the composition.

In spite of the absence of any human figures, there is a feeling of intimacy in this scene, which contrasts with the more desolate air of another work in this publication, *From Williamsburg Bridge* (cat. no. 12), which is Edward Hopper's view of working-class housing executed four years earlier. Pleissner's heroic presentation of this ordinary local scene reflects the related interests of the artists of the regionalist school and the American scene movement in depicting the unsung aspects of American life and culture.

Pleissner was a member of many artistic organizations, notably the National Academy of Design and the American Watercolor Society. During the 1940s and 1950s he traveled all over the world, painting various scenes in oil and watercolor. Pleissner also spent several months each year working in the West, specifically around Dubois, Wyoming. His depictions of the mountain scenery, grain fields, and mining towns comprise a significant aspect of his oeuvre.

L.S.S.

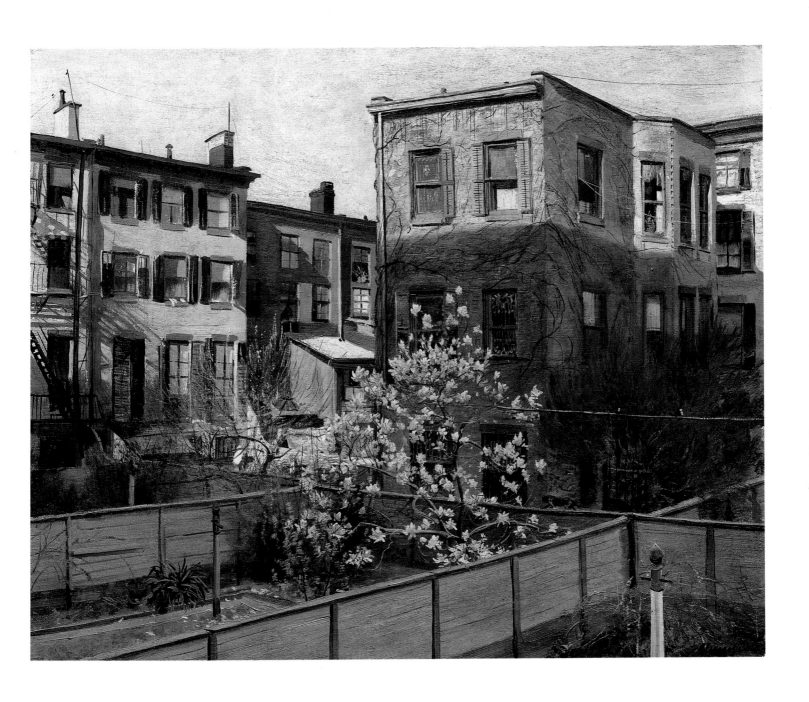

Backyards, Brooklyn, 1932
Oil on canvas
24 × 30⅛ in. (61.2 × 76.5 cm)
Arthur Hoppock Hearn Fund, 1932
32.80.2

16
DORIS EMRICK LEE
1904–1983

Seldom shown or discussed today, Doris Lee was a well-known and critically acclaimed figurative painter in the 1930s and 1940s. Born in Aldeo, Illinois, she graduated from Rockford College in 1927. In 1928 she went to Europe, where she studied in Paris with André Lhote, and traveled throughout Germany and Italy. Upon her return to the United States she studied with Ernest Lawson at the Kansas City Art Institute. In 1930, she went to the California School of Fine Arts in San Francisco (now the San Francisco Art Institute). There she studied under the painter Arnold Blanch, whom she married in 1939.

Lee made the transition from working abstractly to a more realistic style in the late 1930s. She cultivated a "primitive" quality in her art that reflected the contemporaneous interest of several American artists in folk art. She tempered this approach with her skillful manipulation of chiaroscuro modeling and perspective. It was this style of painting for which Lee first came to public attention. In 1935, the donor of the prestigious Logan Prize at The Art Institute of Chicago protested what she perceived to be the ugly, modern quality in Lee's winning entry *Thanksgiving*. The critics and public rallied to support the artist, and the Art Institute purchased the painting for its collection.

Although Lee was associated for the most part with the rural subjects that would seem natural given her Midwest farming upbringing, *Catastrophe* shows passengers parachuting from a flaming zeppelin over the Statue of Liberty in the Upper Bay in New York Harbor. The spectacular skyline of lower Manhattan rises in the distance, and at the lower edge of the painting rescue workers frantically guide survivors onto the New Jersey shore. Lee had a predilection for presenting scenes of turbulence and was attuned to the violence endemic to modern life. In many of her paintings, she appears to take the position of a cynical, detached spectator observing the frenzied daily activities of ordinary people. *Catastrophe* was conceived in the artist's imagination, predating the 1937 Hindenburg zeppelin fire and crash by one year. (However, there had been several other previous disasters involving airships in the United States in 1919, 1933, and 1935.)

In 1935 Lee was commissioned by the Treasury Department Section of Painting and Sculpture to execute the first of the major murals for the United States Post Office in Washington, D.C. She later worked extensively as a magazine illustrator. In the 1940s and early 1950s she traveled extensively throughout the United States, Central America, and North Africa. These adventures became the source of illustrations for *Life* magazine. She moved to Woodstock, New York, in 1931, where she lived and worked until her death in 1983.

L.S.S.

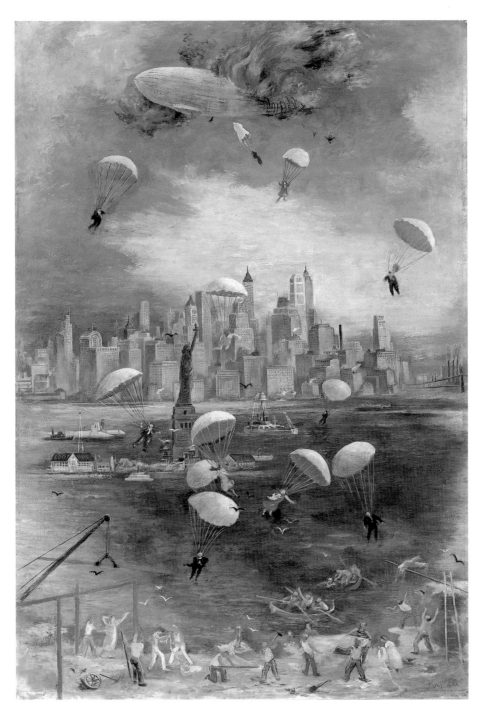

Catastrophe, 1936
Oil on canvas
40 × 28 in. (101.6 × 71.1 cm)
George A. Hearn Fund, 1937
37.43

Carey's Backyard, 1939
Oil on canvas
36 × 24 in. (91.4 × 61 cm)
Gift of New York City W.P.A., 1943
43.47.13

17
LOREN MacIVER
born 1909

Loren MacIver had her first art lessons in the Saturday children's classes at the Art Students League of New York when she was just ten years old. After about a year, these concluded her formal art training. As it matured, her style encompassed a wide range of tendencies ranging from "extreme realism to highly abstract designs."[1]

Carey's Backyard was painted while MacIver was employed by the Works Projects Administration Art Project. It is a view of a garden belonging to a friend of MacIver's—the Carey referred to in the title of the painting—who lived in Key West, Florida.[2] If we compare it to Ogden Pleissner's *Backyards, Brooklyn* (cat. no. 15), we see that MacIver's composition is characterized by a curiously dislocated space, while the Pleissner leads us logically through the layers of space in the enclave of residential backyards. MacIver's forms seem to float in a horizonless arena. She has rendered the plants, the garden chair, and other elements in a lively arabesque line that is laid over washes of color. The composition is divided in two: the lattice-like grid of the stairway and the shingles of the house contrast with the more curvilinear forms that abound in the garden area below. There is an intensely personal quality to this space. It may not be far-fetched to suggest that the quirkiness of the artist's rendering would seem to define a more idiosyncratic and individualistic attitude that might be analogous to MacIver's own position within the art world.

MacIver's work is certainly allied in sensibility to the anecdotal humanism that characterized much of American figurative art in the 1930s. But hers is not the sturdy, earth-toned commentary of the social realists, nor the formal rigor of the American scene painters. In her work, MacIver introduced elements of ambiguity and playfulness that seem more related to the work of Joan Miró, whose influence may also be discerned in the artist's adroit handling of soft areas of color that bleed into one another, often irrespective of the outlines of the forms. One also thinks of the sun-drenched "resort" view of Nice painted by Raoul Dufy during the 1920s.

In 1943, when the Works Projects Administration Art Project was terminated, certain American museums, the Metropolitan Museum included, were invited to accept gifts of paintings, sculpture, and prints. This project had been created to provide support for artists during the Depression. In exchange for a monthly stipend, artists were required to deposit a certain amount of their work with the project. Unfortunately, many of these works of art were lost with the dissolution of this program, so this and others like it remain unique records of that halcyon period of American creativity.

L.S.S.

NOTES
1. John I. H. Baur, ed., *New Art in America* (New York: New York Graphic Society and Frederick A. Praeger, 1957), 256.
2. Loren MacIver, conversation with author, 9 November 1989.

The Farm and the Field

In this nation of great regional diversity, one of the country's most notable features is its rich farmland and vast open spaces. Despite periods of economic hardship, our farms remain a source of national pride. In song and in art, they have inspired poetic sentiments that have looked beyond the harsh realities of long hours, hard work, and often poor crops, to portray a symbol of America's greatness. The words of "America the Beautiful" summarize these feelings: "O beautiful for spacious skies/For amber waves of grain/For purple mountain majesties/Above the fruited plain . . ."

Painters, too, have sought to capture the grandeur of the American farm and field in more specific images of particular places. In this selection of works from the mid-1910s to the 1980s, the geographic focus is primarily on the rural areas of the Northeast—Maine, Vermont, and parts of Long Island, New York—where New York City artists often went for summer vacations. Many, like Walt Kuhn, Jane Freilicher, Grace Hartigan, and Yvonne Jacquette, owned second homes in these locations, and therefore were able to paint familiar, local scenes over a period of several years. Others, like Thomas Hart Benton and John Steuart Curry, traveled throughout the South and Midwest and painted in different locales. Their images of and attitudes toward these landscapes, however, remained remarkably consistent. Their regionalist paintings elevated farms and laborers to the status of American icons.

America's pride in its work ethic comes across strongly in Frederic Grant's portrayal of rugged homesteaders (*The Homestead,* cat. no. 21) and in Benton's characterization of southern cotton pickers (*Cotton Pickers, Georgia,* cat. no. 20). Even in Curry's manicured and well-ordered Wisconsin farm (*Wisconsin Landscape,* cat. no. 22), where no figures appear, the labors of man are evident.

Human beings, often along with farm animals, are included in those works painted before 1950. Cows grazing lazily in the grassy fields or people attending to their chores seem to capture the tranquil

harmony expressed by the artists in these idyllic scenes. In the works done after 1950, all but the Altoon Sultan painting minimize or eliminate the human and animal presence. Here the artists convey a greater awe at the vastness of the natural landscape, painting panoramic vistas that often emphasize the sky as much as the land.

Within this section, one could also consider the paintings of Louis Eilshemius (see cat. no. 1), Eugene Speicher (see cat. no. 3), Gabor Peterdi (see cat. no. 8), and Paul Sample (see cat. no. 40), all of whom portrayed the American farm and field.

L.M.M.

18
GEORGE BELLOWS
1882–1925

George Bellows first visited Maine in 1911, staying with Robert Henri and his wife, Marjorie Organ, on Monhegan Island. Bellows returned to Monhegan with his wife, Emma, during the summers of 1913 and 1914, making excursions to the smaller island of Matinicus, some twenty miles northeast. He painted this Matinicus scene in September 1916, when he rented a house on the island for a month after having spent the summer in Camden, Maine. Bellows's own recollection of that early autumn best describes his attraction to Matinicus: "The trim little farms, hulled down against the wind, the big ledge behind the harbor piously called 'Mount Ararat,' the oxen toiling away from the pier—all these were daily noted as September turned the long grasses from green to gold, and sumach splashed the rocks and firs with red and orange."[1]

The space in *The Red Vine* is compressed against the picture plane with the half-foliated fir trees on the right-hand side partly obscuring the white house that sits just a short way down the hill. The road that would lead us to the mid-ground of the composition is off at the lower left, but it is unclear if we are meant to think we are on that road or looking down onto it. Just beyond the fence we see

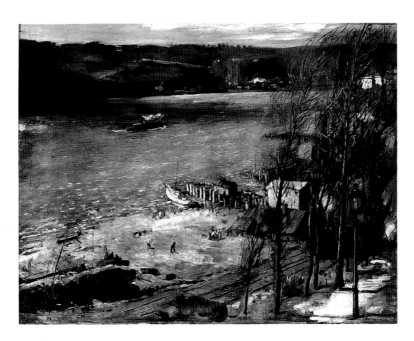

Figure 7
Up the Hudson, 1908
Oil on canvas, 35⅞ × 48⅛ in. (91.1 × 122.2 cm)
Gift of Hugo Reisinger, 1911
11.17

a figure tending to the laundry hung on the line. The light in the painting would seem to set the time at late afternoon, and perhaps the woman is testing whether the white sheets are dry enough to be taken in. The figure could almost be missed, but its presence brings an intimate quality to the scene which is quite distinctive from Bellows's usual practice of either focusing on the landscape without any figures, as in *Up the Hudson* (fig. 7), which is in the Metropolitan Museum's collection, or of relegating the figures to serve the overall spatial and formal organization of the painting.

In *Ox Team, Matinicus* (fig. 8), also in the collection of the Metropolitan Museum, we see the same vigorous brushstrokes that demonstrate the influence of Bellows's teacher, Robert Henri. Its composition also has been organized in the same sturdy, compact, compressed manner as *The Red Vine*. The emphasis is on the basic geometry of the form, as opposed to the more atmospheric and spacious

treatment of Bellows's earlier landscape paintings. It was Bellows's study of Jay Hambridge's system of Dynamic Symmetry that accounted for the change in the character of the artist's work between 1908 and 1916.[2]

Although Bellows's oeuvre consisted primarily of landscape depictions, he is perhaps best known for his sporting pictures, which celebrated stars of the tennis and boxing worlds, as well as well-known polo players. This might be expected of an artist whose first love was baseball, and who turned down a chance to play for the Cincinnati Reds, in spite of his father's strong objections to his pursuit of a career in art.

L.S.S.

NOTES
1. Charles H. Morgan, *George Bellows: Painter of America* (New York: Reynal and Company, 1965), 202.
2. Henry Geldzahler, *American Painting in the 20th Century* (New York: The Metropolitan Museum of Art, 1965), 40.

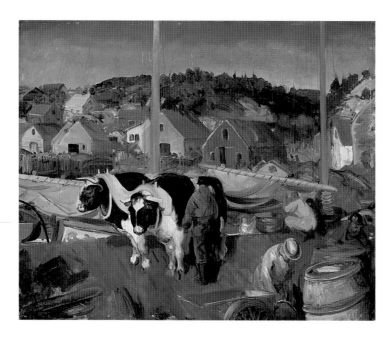

Figure 8
Ox Team, Matinicus, 1916
Oil on wood, 22 × 28 in. (55.9 × 71.1 cm)
Gift of Mr. and Mrs. Raymond J. Horowitz, 1974
1974.352

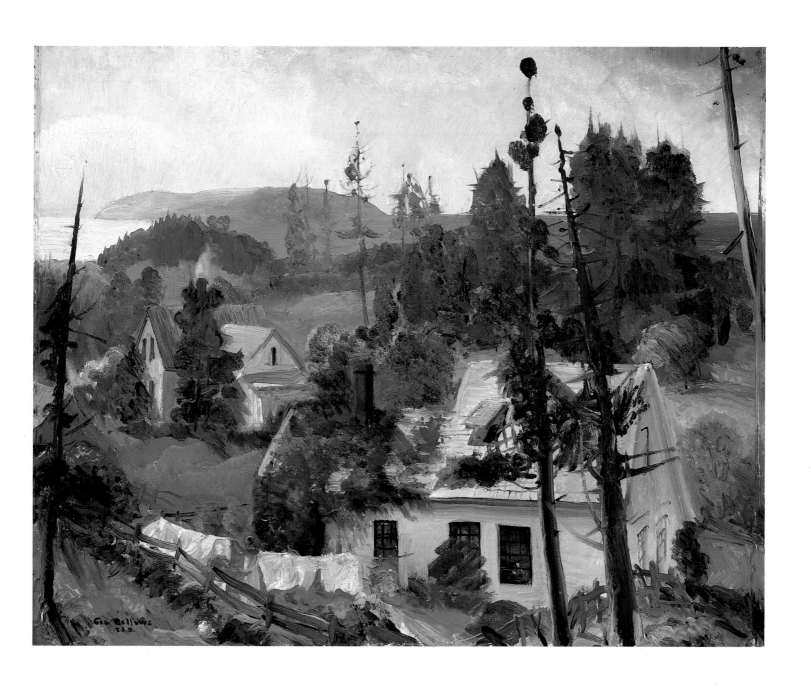

The Red Vine, 1916
Oil on wood
22 × 28¼ in. (55.9 × 71.8 cm)
Gift of The Chester Dale Collection, 1954
54.196.3

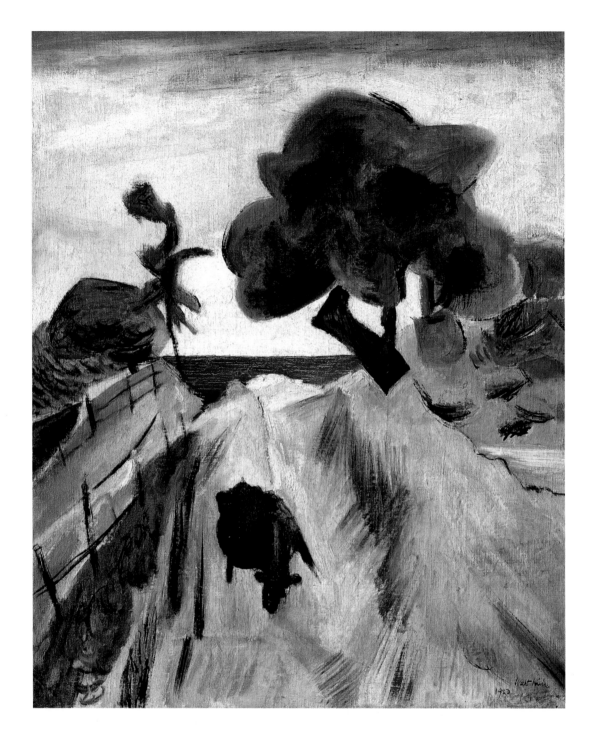

The Willow Tree and the Cow, 1923
Oil on canvas
30 × 25 in. (76.2 × 63.5 cm)
Lent by Dr. and Mrs. Robert E. Carroll

19
WALT KUHN
1877–1949

Like his friend Arthur B. Davies, Walt Kuhn's reputation as an artist is often overshadowed by his role as co-organizer of the 1913 International Exhibition of Modern Art (known as the Armory Show) in New York. Through Kuhn's efforts, this exhibition brought together more than 1,000 paintings, sculptures, drawings, and prints by some of the most avant-garde European and American artists.

Kuhn had begun his career as a magazine illustrator and cartoonist (1899–1914), as did several other artists discussed in this publication (such as George Bellows, Lyonel Feininger, and Edward Hopper). He studied art in Europe from 1901 to 1903. Thereafter, he worked primarily as a painter, although between 1915 and 1927 he produced a number of prints as well. Many of Kuhn's earliest works were destroyed over the years by the artist in a continuous process of self-evaluation, in the belief that only the best examples of his work should survive.

To support his family and his art, Kuhn spent half of each year working at various jobs unrelated to art; the rest of the year was devoted exclusively to painting. Kuhn contended that an artist should not depend upon the sale of his work for his income because the pressure might force him to compromise his ideals and to paint only safe, saleable pictures. To this end, Kuhn began to design and direct vaudeville and theater acts in 1922, a sideline that proved to be successful and fairly lucrative. His love of theater and circus performances continued throughout his life, and the paintings for which he is best known are portraits of circus performers done in the 1930s and 1940s. These seated and standing figures are usually silhouetted against solid, dark backgrounds, their intensely brooding expressions in contrast to their theatrical make-up and lavish costumes. Such portraits were the mainstay of Kuhn's oeuvre, although he also painted still lifes and landscapes.

The Willow Tree and the Cow is a rare example of Kuhn's early work. Painted in 1923, it is one of only five extant oil paintings from that year,[1] perhaps indicating the extent of the artist's involvement in designing and directing three theatrical productions—a pantomime show, a comedic act, and a musical review. In style it is very different from his clown paintings of only a few years later. This work reflects his admiration for Cézanne in its thin application of paint as short, jagged patches. It also suggests the influence of Matisse's paintings from about 1918–20 in Kuhn's use of dark outlines to define irregular and highly expressive shapes. In addition, it seems to anticipate the work of Milton Avery (see cat. no. 14).

The subject of *The Willow Tree and the Cow*—cows grazing in a landscape—appeared in Kuhn's painting in 1922, the previous year. This later work, however, reveals a more modern and dynamic approach to composition that suggests an affinity to the contemporaneous paintings of the Japanese-American artist Yasuo Kuniyoshi.[2] The number of elements in the scene has been greatly reduced, and the surface is divided into a few large areas of color. The wheat-colored ground moves swiftly backward into space until it is arrested by the stabilizing horizon line and strip of deep blue water. The location of this scene is unspecified, but it may depict a site in Ogunquit, Maine (along the state's southern coast), where Kuhn maintained a summer house from 1920 on.

L.M.M.

NOTES
1. See Philip Rhys Adams, *Walt Kuhn, Painter: His Life and Work* (Columbus, Ohio: Ohio State University Press, 1978), 246–47.
2. Kuhn met Kuniyoshi in New York in 1917 when both men were members of the Penguin Club, an informal group of artists that organized exhibitions and held discussions. Between 1920 and 1924, both artists spent their summers in Ogunquit, Maine.

20
THOMAS HART BENTON
1889–1975

With the exception of Norman Rockwell, perhaps no artist has been more closely associated in the public's mind with an art that epitomizes American values than Thomas Hart Benton. His preoccupation with the basic virtues of rural American life almost belies his elite background as the son of a member of the House of Representatives and grandnephew of a United States senator.

Benton was born in Neosho, Missouri. After pursuing his studies at The Art Institute of Chicago, he went to Paris in 1907, where for five years he was involved in the stylistic innovations of cubism and synchronism. After he returned to the United States in 1911, Benton took up residence in New York City in 1912 where he became acquainted with many figures in the art world, including Alfred Stieglitz, Walt Kuhn, Stuart Davis, and Thomas Craven. During this period, Benton came to reject abstract art and "internationalism" and concentrated on a realist style that would be put to service celebrating America.

Along with John Steuart Curry and Grant Wood, Benton is identified with the school of art known as regionalism, which celebrated—often romantically—the daily life and morality of Americans living beyond urban centers. This point of view is distinct from the work of his contemporaries such as Charles Sheeler, Georgia O'Keeffe, and Stuart Davis who also sought an American idiom in art, finding a medium for expression in the images of architecture, industry, and occasionally the landscape, but describing it within the formal language they had adapted from European avant-garde styles.

Although he is perhaps best known for his public murals, Benton was a prolific easel painter. *Cotton Pickers, Georgia,* which is one of two paintings by Benton in the collection of the Metropolitan Museum, illustrates the artist's rhythmic yet controlled expressionistic style. Rather than emphasizing the parallel rows of cotton, the composition is laid out in several looping bands that lead us through the scene, highlighting each detail. Benton creates several triangles—the mound of cotton in the foreground, the figure of the pipe-smoking man to the right, and the triangle formed by the woman with the small boy in a cap and the leafless tree to the upper left—that define both spatial and social relationships between the figures. The looping movement of the composition defies a perspectival system in creating space so that the figures, regardless of scale, seem to coexist within the same spatial quadrant. We are not sure of the identity of the large figure calmly smoking a pipe in the front. His bronze coloration would seem to indicate that he is one of the black workers, but the pipe and his size relative to the man bent over just to his right make it seem that he is the white sharecropper who owns the land.

This painting is based on a scene observed by Benton in central Georgia in the summer of 1928.[1] At this time he was traveling extensively throughout the South, Midwest, and West in search of subject matter. This type of rural Southern scene would be a theme that the artist repeatedly returned to during the 1930s. The depiction of the figures, however, often embroiled the artist in controversy. While Benton was largely sympathetic to blacks, the element of caricature present in his observation was viewed as insulting in its depiction. He decried the racism he observed in the South, but he was opposed to political elements in American society that led the fight against institutional racism in this country.[2]

L.S.S.

NOTES
1. See Henry Adams, *Thomas Hart Benton: An American Original* (New York: Alfred A. Knopf, 1989), 135.
2. Ibid., 248–51.

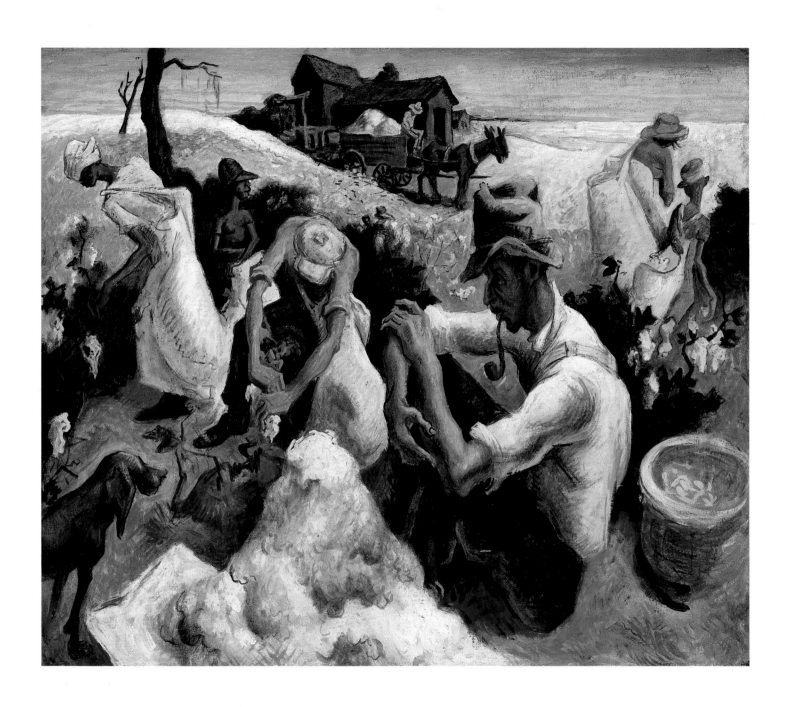

Cotton Pickers, Georgia, 1928–29
Tempera and oil on canvas
30 × 35¾ in. (76.2 × 90.8 cm)
George A. Hearn Fund, 1933
33.144.2

The Homestead, c. 1930
Oil on canvas
46 × 50⅛ in. (116.8 × 127.3 cm)
Gift of George D. Pratt, 1933
33.94

21
FREDERIC GRANT
1886–1959

Frederic Grant was born in Sibley, Iowa. He studied art at the Art Students League with such well-known artists as William Merritt Chase and Kenneth Hayes Miller. He also studied in France and Italy before settling in Chicago, where he became an influential member of the art community.

The Homestead is a dramatic painting, theatrically evoking the pioneer tradition that is so much a part of our national mythology. Grant has positioned the farmer-homesteader as the focal point of the composition, standing with a pitchfork in hand and gazing determinedly off into the distance. At his feet, a short distance away, his wife sits on the ground tenderly holding their child, like a latter-day Madonna. Thematically, the painting displays the same impulse to romanticize the peasant that French artists such as François Millet and Jules Breton demonstrated during the 1800s. The figure of the farmer exudes an optimistic confidence that belies the economic hardship that was a reality in America when this painting was executed. The empty basket next to the woman and child might allude to the hard times. Like the regionalist painters, Grant celebrates rural values, but unlike Thomas Hart Benton, John Steuart Curry, and Grant Wood, he largely eschewed anecdotal detail, focusing on the farm family group as a symbol rather than a signifier of values. The dramatic, even theatrical lighting of the composition enhances this impression. Despite the realist style, the painting appears to have been conceived in the artist's imagination rather than by reference to the natural world. The exact date when *The Homestead* was executed has also remained elusive. It certainly had been painted by the time Grant participated in the Thirty-fifth Annual exhibition of Chicago artists that opened at the Art Institute in January of 1931. *The Homestead* was prominently illustrated in a review of the exhibition by Eleanor Jewett in the *Chicago Sunday Tribune* of February 1, 1931.

Soon after World War II, Grant moved to Oakland, California. In his later work he often set his composition in exotic faraway locales—he did travel to Bali and Sicily—and these works were exceptional for their sumptuous use of color and romantic point of view.

L.S.S.

22
JOHN STEUART CURRY
1897–1946

John Steuart Curry's panoramic *Wisconsin Landscape* is one of the artist's most important and fully realized compositions. It is also one of the outstanding examples of regionalist art in the Metropolitan Museum's collection. Stretching seven feet in length, Curry's canvas eloquently adopts a narrow, horizontal shape to convey the vast openness of the Wisconsin farmland and the majestic presence of the changing sky.

Wisconsin Landscape was painted when Curry was the nation's first artist-in-residence at the College of Agriculture at the University of Wisconsin in Madison. It is an idealized composite of many farm scenes that Curry witnessed during his trips around Wisconsin, though it particularly recalls the landscape near Belleville, in the southern part of the state. Curry went to Belleville to sketch when the Alexander Legge Foundation commissioned him to paint a picture commemorating the philanthropist's hometown. It was originally intended to hang in Mr. Legge's office; however, after receiving first prize in the Artists for Victory exhibition at the Metropolitan Museum in 1942, the picture was purchased for the museum's own collection.

Curry's painting is gloriously colored like a patchwork quilt with bright yellows, greens, blues, and reds. Sunlight and shadow are distributed over the gently rolling countryside, creating a sense of undulating movement. Our eye meanders slowly back along the strategically placed diagonals, and across the succeeding, horizontal registers that structure the composition. In the immediate foreground a row of golden haystacks meets our gaze. Its jagged shape is echoed in the thicket of blue-green trees by the buildings, and in the formation of the gray-tinted clouds. Three clusters of barns and houses dot the landscape and, at the far left, a herd of cattle graze contentedly in the bucolic setting. Curry painted freely with large brushes, building up certain areas with heavy impasto. The final picture was the result of frequent reworking; *Wisconsin Landscape* underwent some revisions immediately after its exhibition in the Artists for Victory show.

The composition's design and the objects depicted in it were standard in Curry's art after 1930. Although they appear in numerous other paintings, some of which portray his home state of Kansas, none approaches the dramatic power, visual harmony, and completeness of *Wisconsin Landscape*. All aspects of this scene seem to suggest an idyllic existence led by the farmers of Wisconsin in the late 1930s, but the agricultural conditions in the Midwest were actually still feeling the effects of the Depression.

Curry's use of landscape as a tool for spiritual rejuvenation and as a symbol for American values brought him into the company of other regionalists, such as Grant Wood and Thomas Hart Benton (see cat. no. 20), who both celebrated the vision of what America once was, and what it could be again. In 1941 Benton, who was one of the jurors for the Artists for Victory show, wrote this assessment of *Wisconsin Landscape:* "It is immensely big and powerful. . . . It sticks in the memory as a grand sweeping exultant shout of 'yes' to the roll of the Earth. . . . It is likely to stand as a sort of unique performance in the history of American Art just as the Mont Sainte-Victoire series of Cézanne's stands in French Art."[1]

L.M.M.

NOTES

1. Thomas Hart Benton, "Wisconsin Landscapes," *Demcourier* XI, no. 2 (April 1941): 14.

Wisconsin Landscape, 1938–39
Oil on canvas
42 × 84 in. (106.7 × 213.4 cm)
George A. Hearn Fund, 1942
42.154

23
GRACE HARTIGAN
born 1922

Trained as a mechanical draftsman in the early 1940s, Grace Hartigan also developed an interest in painting. She studied painting part-time with an artist in Newark, New Jersey, from 1942 to 1945, and in 1946 decided to make what became an important move from New Jersey to New York City. That year she saw an exhibition of Jackson Pollock's paintings at the Betty Parsons Gallery that had a profound effect on her. Hartigan recalls: "I spent all day staring at these paintings, like something I'd never, ever seen in my life. I was astonished and stunned and couldn't understand. The allure was enormous."[1] The direction of her early work in New York was greatly influenced by the examples of Pollock and Willem de Kooning, the two leaders of the nascent abstract expressionist group, with whom she became friendly. Her own commitment to painting was strengthened by these associations, and she writes that "in 1947 I decided to devote my life to painting."[2]

Recognition by critics, galleries, and museums came early in Hartigan's career, beginning with her inclusion in the New Talent 1950 exhibition at Kootz Gallery in New York, curated by two champions of abstract expressionism, Clement Greenberg and Meyer Shapiro. Hartigan was then twenty-eight years old, and over the next nine years she was included in no less than fourteen group shows, six of them organized by the Museum of Modern Art in New York. The Modern acquired its first painting by Hartigan in 1953. Her first one-person exhibition was held in 1951 at the Tibor de Nagy Gallery, where her work had been recommended by Pollock and Greenberg. Under the direction of John Bernard Myers, the gallery represented some of the most important younger artists of the 1950s including Helen Frankenthaler, Jane Freilicher,

Alfred Leslie, and Larry Rivers. Hartigan's gender was always public knowledge, but she chose to exhibit under the name "George Hartigan" until 1953, perhaps, as one writer suggests, as an act of personal and professional liberation.[3]

In the 1940s and 1950s, New York City was the center of activity for the abstract expressionist group. Younger artists like Hartigan, who adapted a similarly vigorous brushwork and "action" style of painting, ignored abstract expressionism's original ties to surrealism and its mythical or unconscious subject matter. Instead, their paintings were generally based on tangible reality, that is, figures and landscapes. Hartigan became a leader of this group, known as the second-generation abstract expressionists. Like the work of their elders, the physical act of painting became a subject equal to the one being depicted. Hartigan wrote: "I do not wish to 'describe' my subject matter or to reflect upon it. I want to distill it until I have its essence, then the rawness must be resolved into form and unity."[4]

Southampton Fields reflects this distillation of images into an art that she called "not 'abstract' and not 'realistic.'"[5] It was painted during the summer of 1954 in Southampton, Long Island, New York, in a studio rented from the artist Fairfield Porter. The scene is of nearby Shinnecock Hills, dotted with sketchily painted houses and trees. Color is monochromatic with a range of light and dark, and pigments are applied in thin, washy layers that characterize the artist's style. Hartigan considers this painting rare in her body of work since "it is a landscape done directly from nature—I almost never have done or do that."[6] Instead, she usually creates a collective impression of a person or place culled from repeated observation. Like much of her

Southampton Fields, 1954
Oil on canvas
32 × 36 in. (81.3 × 91.4 cm)
Gift of Edmund E. Levin, 1982
1982.105

work, *Southampton Fields* imposes an overriding structure on the seemingly chaotic elements of the composition: "I feel that we are living a very fragmented life ... so I perceive the world in fragments. It is somewhat like being on a very fast train and getting glimpses of things in strange scales as you pass by. ... You see the corner of a house, or you see a bird fly by, and it's all fragmented. Somehow, in painting I try to make some logic out of the world that has been given to me in chaos. I have a very pretentious idea that I want to make life, I want to make sense out of it. The fact that I am doomed to failure—that doesn't deter me in the least."[7]

L.M.M.

NOTES

1. Grace Hartigan quoted in "Grace Hartigan: Painting Her Own History," by Robert S. Mattison, *Arts* (January 1985): 67, from a lecture delivered at Lafayette College on 26 April 1983.
2. Grace Hartigan, artist questionnaire in The Metropolitan Museum of Art, Department of 20th Century Art archives.
3. Ann Schoenfeld, "Grace Hartigan in the Early 1950s: Some Sources, Influences, and the Avant-Garde," *Arts* (September 1985): 85-86.
4. Grace Hartigan quoted in *Contemporary American Painting and Sculpture* (Urbana, Ill.: University of Illinois Press, 1967), 111.
5. Ibid.
6. Grace Hartigan, artist questionnaire in The Metropolitan Museum of Art, Department of 20th Century Art archives.
7. Grace Hartigan quoted in *Contemporary Artists,* ed. Colin Naylor (Chicago and London: St. James Press, 1989), 402.

24
JANE FREILICHER
born 1924

Georgia O'Keeffe's poetic description of New Mexico as a place where there is "more sky than earth" might also describe Jane Freilicher's depiction of Long Island, New York. In *Autumnal Landscape,* the hazy blue sky, streaked with soft pinks and yellows, occupies more than half of the large canvas. Its sparseness provides a restful backdrop for the more detailed rendering of grasses, houses, and trees in the landscape below.

The scene is one that Freilicher saw from her summer studio in Water Mill, a small town on the south shore of Long Island, near Southampton (the locale of Grace Hartigan's painting, cat. no. 23), where the artist has owned a house for more than

Figure 9
Bread and Bricks, 1984
Oil on canvas, 24 × 30 in. (61.2 × 76.2 cm)
Gift of Dr. and Mrs. Robert E. Carroll, 1986
1986.159.2

twenty years. "I like being near the ocean. The particular landscape around my studio is so flat and open—the sky out there seems to be endless. You feel you're in a universe of light, you feel the convexity of the earth, the horizons curving down at the periphery. I'm sort of depressed by mountains and lonely vast vistas. I like landscape on a human rather than a sublime scale. I enjoy the intimation of a human touch in the landscape as opposed to many painters who want to feel that man has never put his mark on it. I like to include something man-made like a house or maybe the line of a sailboat moored across the bay which will somehow seem very important to me."[1] Here, across the marshes we see a low, sprawling house nestled in the trees.

Until a few years ago, when developers dug up a portion of the nearby landscape, Freilicher's view remained a constant and ever-present source of inspiration. Other sections of this particular Long Island landscape, extending left and right, have appeared in her paintings over the years, just as the view outside her winter residence in New York City has become a recurrent motif. Freilicher explains her ability to find freshness in familiar subjects: "I work in the same places over and over again. I'm not much of an itinerant painter. But it's amazing how much things change in the same place. The weather, nature, and just the progression of things growing in season makes the subject matter different."[2]

"Somehow the paintings I do in the country are different in feeling from the ones I do in the city. They have a different kind of tonality and palette probably, because the difference in light is a crucial element to me."[3] A still life arrangement by Freilicher in the Metropolitan Museum's collection, with a view of New York through the windows, is painted in browns and grays (fig. 9). In paintings like *Autumnal Landscape,* Freilicher succeeds in capturing the clear light and fresh air of the beach environment. The time of year portrayed is early autumn, when the leaves on the trees are still quite green, and the underbrush is just starting to turn brown. Our eye easily takes in the whole vista, following the zigzag path of the grasses as they pass the water speckled with ducks, the houses in the distance, and the open sky. In the lower half of the canvas, which is predominantly green, the artist achieves remarkably subtle nuances of color that are blended together.

Freilicher's style of painting is similar to that of Fairfield Porter (see cat. no. 33), with whom she became acquainted in 1952, when he reviewed her first exhibition at the Tibor de Nagy Gallery for *Art News*. Ironically, Porter, then forty-five years old, had never exhibited his own paintings. On the recommendation of Freilicher and her fellow artists Larry Rivers, and Willem and Elaine de Kooning, Porter began to show at Tibor de Nagy. Aside from their mutual preference for landscape subjects, Freilicher says that they had a common "interest in an informal, fluid vernacular kind of painting."[4] She was particularly drawn to Porter's technique of constructing an intricately woven composition with both flat color areas and smaller, more broken passages. This style of painting—neither completely realistic, nor completely abstract—created a sense of having just caught a fleeting moment on canvas. Her aim is "to capture the poetry of the moment and yet make it stick. To give it gravity and weight without losing the spontaneity and informality."[5]

L.M.M.

NOTES

1. Jane Freilicher quoted in *Art of the Real*, ed. Mark Strand (New York: Clarkson N. Potter, 1983), 69.
2. Jane Freilicher quoted in *Real, Really Real, Super Real*, Boothe-Meredith, Sally Martin, and Alvin Martin (San Antonio, Texas: San Antonio Museum of Art, 1981), 45.
3. Ibid., 44.
4. Jane Freilicher quoted in *Jane Freilicher Paintings*, Robert Doty (New York: Taplinger Publishing Co., 1986), 49.
5. Jane Freilicher quoted in *Art of the Real,* ed. Mark Strand (New York: Clarkson N. Potter, 1983), 69.

Autumnal Landscape, 1976–77
Oil on canvas
80 × 70 in. (203 × 177.8 cm)
Gift of Dr. and Mrs. Robert E. Carroll, 1978
1978.225.4

Little River Farm, 1979
Oil on canvas
78 × 64 in. (198.1 × 162.6 cm)
Gift of Dr. and Mrs. Robert E. Carroll, 1982
1982.182.1

25
YVONNE JACQUETTE
born 1934

Since 1973, Yvonne Jacquette has painted a world seen from above, looked down upon from the height of an airplane or a tall skyscraper. Her pictures depict two very different types of landscapes: one completely urban—the congested streets, bridges, and buildings of New York City, where she lives during the winter; the other strictly rural—most often the lush farmland around her summer home in Searsmont, Maine. Earlier in the century, Jonas Lie conveyed a similar aerial viewpoint in his painting of the Panama Canal (cat. no. 2).

To achieve such an unusual perspective on her subjects, Jacquette came upon a working method that was equally inventive. During the making of a series of cloud pictures, she began to go up in an airplane to get a closer look, and discovered that landscapes could be painted from this height as well: "One day the clouds disappeared . . . and I saw the land down there and I said, 'I've only been hinting at that because I have centered on the clouds so much. Why not get into the land?' And the first reaction was, 'Oh God, that is going to just take me forever.' It is so complicated. Every time you fly ten miles more it is different. . . . But once I sort of proposed the challenge I wasn't going to be chicken. So I said, 'O.K., this is it. You are going to do this. You are going to do this whole landscape from the air.'"[1] Thereafter, she hired single-engine planes for the express purpose of circling around a selected site for an hour at a time, while she made small pastel sketches with color notes. Typically, she makes several of these sketching expeditions before putting paint to canvas. The final painting, done in her studio, is based directly on these sketches, which incorporate elements of what she has actually seen, what she remembers, and what she invents. The increase in size from sketch to painting allows for a greater clarity and specificity of the image. Because her time in the air is short, Jacquette must fix the images in her mind. Her impressions are quick, and that freshness is translated into her paintings.

The scene depicted in *Little River Farm* is one that she saw while flying over Belfast, Maine. The artist suggests perspective without the use of a horizon line and tips "the picture forward from top back, to avoid scale diminishment and aerial haze."[2] The visual weight of the composition is in the lower half of the canvas, where a large farm with several buildings sprawls across the land opposite a meandering body of water. Surrounding the buildings are the newly plowed fields, all fresh and green. Roadways, large and small, and clusters of trees divide the landscape into oddly shaped parcels, each one painted with a different pattern of brushstrokes. "I wanted to get away from vanishing point perspective and engage the viewer the way a map might, as a textured map might."[3]

Jacquette's palette is muted but cheerful. Her divisionist patterning is reminiscent of impressionism, while her sense of expressionist energy and scale comes out of abstract expressionism. Viewed up close, the surface vibrates with the different dabs and crosshatches of color. Looked at from a distance, however, these marks blend into subtle shadings, creating a cohesive whole like a woven tapestry.

L.M.M.

NOTES
1. Yvonne Jacquette quoted in *Profile: Yvonne Jacquette,* vol. 2, no. 6 (November 1982): 19.
2. Yvonne Jacquette, artist questionnaire in The Metropolitan Museum of Art, Department of 20th Century Art archives.
3. Yvonne Jacquette quoted in *New Vistas: Contemporary American Landscapes,* Janice C. Oresman (Yonkers, N.Y.: Hudson River Museum, 1984), 42.

26
MARJORIE PORTNOW
born 1942

Under the direct beams of the midday sun, a field of corn droops languidly with the heat. The sky is absolutely clear with the exception of a few wisps of clouds, and we can almost hear the low, steady hum of various insects harmonizing with one another in that uniform intensity that marks the height of the summer. Marjorie Portnow has been preoccupied with the open spaces of upper New York State and New England. "Each view suggests a real and different atmosphere and real and evolving sense of time's passage, so that one might attempt to gauge the temperature of hour[s] of daylight. Skies quietly display nuances of tone and hue, particularly at the distant horizons where a marvelous feel for the light refraction is handled with uncanny precision."[1]

Portnow favors a horizontal format for her paintings, which reinforces the particular interplay that she establishes between sky and ground. Rarely does she allow dramatic precipices or claustrophobic framing elements—such as great stooping trees or architecture—to distract us from the steady, panoramic unfolding of the scene she creates before us. We may be present but we maintain our distance, and rarely, if ever, is the presence of other figures or animals, birds, or insects observed. In *Cambridge Corn* we see Portnow's characteristic compositional organization: layers of space are defined by intersecting horizontal bands of plant life starting with Queen Anne's lace in the foreground, moving to the field of corn and the stretches of grass alternating with sections of shrubbery and trees, to a large forested area mid-ground at the right, and then onto the hills in the distance.

Portnow studied art history at Western Reserve University in Cleveland where she received her Bachelor of Arts. She studied fine arts at Pratt Institute, the Skowhegan School of Painting and Sculpture, and the Art Students League of New York, and she received her Master of Fine Arts in Painting from Brooklyn College, where her professors included Philip Pearlstein and Gabriel Laderman.

L.S.S.

NOTES
1. Allen Ellenzweig, "Reviews," *Arts* (November 1974): 11.

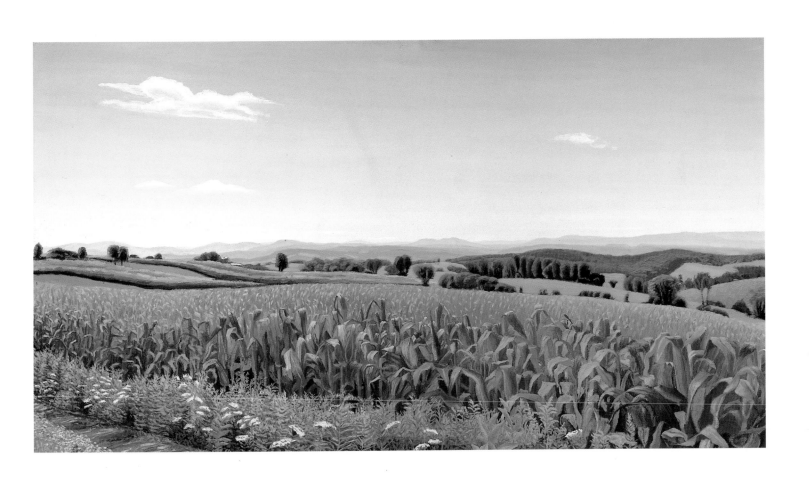

Cambridge Corn, 1981
Oil on canvas
16 × 30 in. (40.6 × 76.2 cm)
Gift of Dr. and Mrs. Robert E. Carroll, 1983
1983.191.2

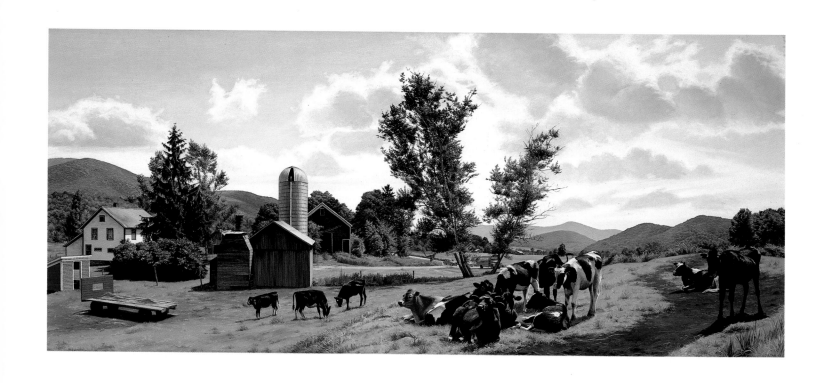

Heifers, Pawlet, Vermont, 1987
Oil on canvas
30 × 72 in. (76.2 × 182.9 cm)
Purchase, Lila Acheson Wallace Gift, 1988
1988.59

27
ALTOON SULTAN
born 1948

"Cows, for me, are a special presence in a landscape. They are life in an often empty space. The heifers of this painting remind me of the awkwardness of adolescence."[1] This observation by Altoon Sultan might explain the particular individuality exuded by each of the cows in the painting *Heifers, Pawlet, Vermont*. Bovine subjects have been a favorite in Western art at least since the seventeenth century. While this subject connotes more mythological and allegorical content in Dutch landscape painting, here they are merely props within a contemporary bucolic scene.

Although this painting exhibits a clarity of form and light that indicates an immediate experience of the scene, it was in fact executed in the artist's studio in New York City. It is based on black-and-white photographs and watercolor studies that Sultan made of such a scene on Route 3 in Pawlet, Vermont. The composition has a curiously choreographed arrangement. The trees in the center bend away from one another in a "V" formation that distinguishes the relatively unpopulated right-hand side of the composition from the left. On the left-hand side, the cubic geometry of the house, the barn and silo, and various other structures on the property arrange themselves in regimented horizontal, vertical, and diagonal positions. The pervasive yellow-green, which is almost blinding as illuminated by the early afternoon sun, is broken by touches of red that focus the movement of our eyes across the span of the painting: the shed and truck at the right, the red barn in the distance in the center, the touch of red on the foremost reclining black cow, and then what appears to be a red ball, which intersects with the ear of the reclining cow of the duo set apart at the left. Almost incidentally, a yellow school bus and two cars pass on the road behind the center cluster of trees. Beyond, the hills and expanse of sky complete our experience of the scene.

Altoon Sultan is a native of Brooklyn who received her Bachelor of Fine Arts and Master of Fine Arts from Brooklyn College, where she studied with Philip Pearlstein. She also studied with Gabriel Laderman at the Skowhegan School of Painting and Sculpture in Maine. Sultan has consistently displayed a distinct architectonic sensibility in her work: relatively contained spatial movements, sharply defined planar organization, and strong surface design. In spite of this analytical approach, however, she asserts her intention to "be emotional. I feel the paintings have different emotional qualities. Some of them are sadder, some . . . funnier, some have a tranquil feeling . . . they're not all the same."[2]

L.S.S.

NOTES
1. Altoon Sultan, artist questionnaire in The Metropolitan Museum of Art, Department of 20th Century Art archives.
2. Jane Cutter, "Altoon Sultan," *American Artist* (May 1983): 37–47.

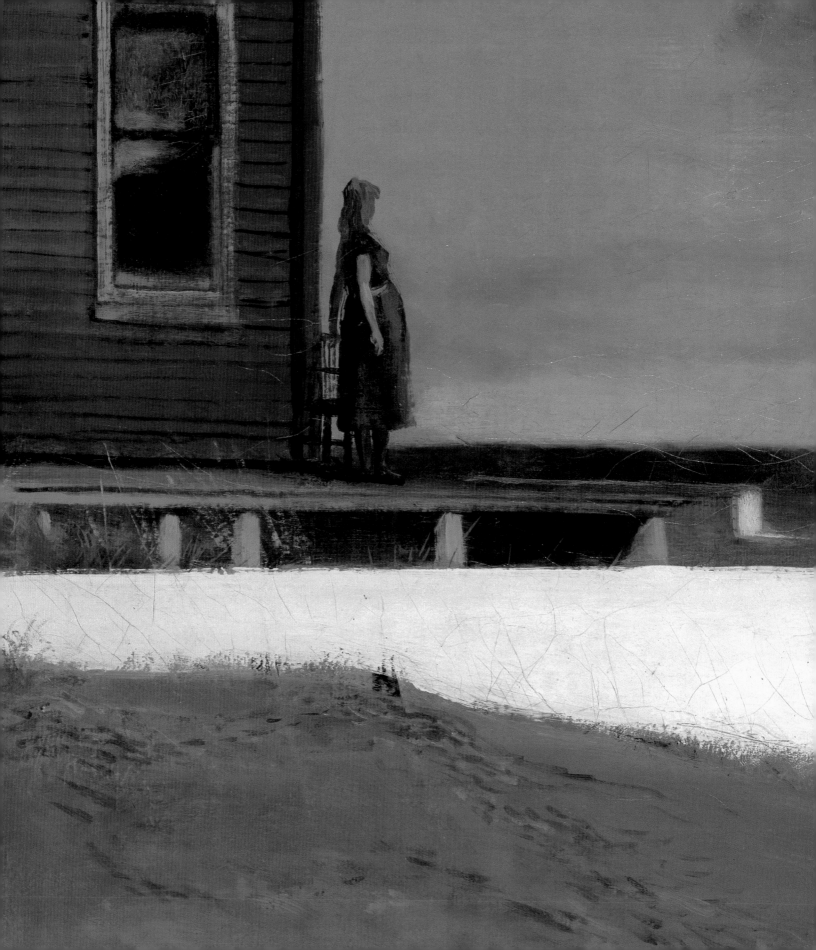

Currents, Tides, and Placid Pools

Detail from
Thunderstorm II
by Walter Stuempfig
(cat. no. 32)

The symbolic connotations of water—along with earth, wind, and fire one of the four elements of earthly existence—have had a long and rich tradition in numerous cultures during any number of historical eras. Whether a symbol of the original source of life and redemption, a metaphor for the various psychological and emotional states we experience throughout life, a surface upon which we could reflect on our spiritual as well as physical condition, or merely a component of the landscape, water continues to engage the artistic imagination and to reach the deepest recesses of our primordial memories.

The bodies of water in the paintings included in this publication may seem at times peripheral to the overall theme, but they have nonetheless a persistent presence. In John Kane's *The Monongahela River Valley* (cat. no. 30), the river is a crucial artery to and from an industrial complex. The panoramic view reminds us of nineteenth-century French paintings of industrial sites by artists such as François Bonhomme. These works chronicled the new elements in the landscape and testified to the prosperity of the owner. Richard Chiriani's *Morning in the Cleveland Flats* (cat. no. 34), although painted some fifty years later, seems in fact to be more kindred to a nineteenth-century sensibility. The artist has captured the now-abandoned factory site with a clarity of form and stillness of atmosphere that give a vintage air to the scene. The quaint addition of the garland at the lower edge and on the right- and left-hand sides would be the final touch to the ages-gone-by aspect of this painting. What a surprise it is to learn, then, that this decorative border is in fact a closely observed detail taken directly from nature, and that the passage of the freighter from the right-hand side occurred during the time the artist painted this work on site during the late spring and early summer of 1979.

Charles Sheeler's *Water* (cat. no. 31) is also an industrial scene, in this case focusing on the pristine, geometric forms of one section of the dams and generators that are part of the Tennessee Valley Authority. This painting clearly celebrates a man-made environment

and is an example of the industrial subjects that Sheeler executed in the 1930s and 1940s, often as commissions from *Fortune* magazine. Although there is no water in the scene, water is clearly the primary force behind the machines that provide both irrigation and electrical power. We rely on the painting's title to clarify water's key role in regard to the subject matter. It is almost as if the natural phenomenon has metamorphosed into a mechanical, architectonic surrogate.

Although Rafael Ferrer's *Merengue in Boca Chica* (cat. no. 37) is a beach scene, the painting is dominated by figures rather than water and sand. The beach thus acts as a stage that defines the relationship of figures to one another, rather than serving as just another vista.

A scenic spot is what we discern in Fairfield Porter's *The Kittiwake and The John Walton* (cat. no. 33). Here the focus is on water's recreational aspects as well as on the pleasurable views of vacation sites. In his similarly idyllic scene, *Out of Doors* (cat. no. 36), Duncan Hannah imbues this subject with a particularly poetic nuance. This painting resembles a souvenir postcard of a vacation site, but in reality it is a colored re-creation of a black-and-white photograph taken at a site in England that the artist never visited.

Rockwell Kent's *Winter—Monhegan Island* (cat. no. 29) depicts a site that was a favorite with New York City artists during the first two decades of this century. But instead of showing an idyllic summer day, Kent revels in the icy desolation of the island in winter, a weather condition that presents a particular challenge to those—like the artist—who dare to face the elements. Walter Stuempfig, on the other hand, loved the New Jersey coast. His haunting composition *Thunderstorm II* (cat. no. 32) of an approaching summer storm speaks to the psychological isolation that is conveyed not only by the disposition of the figures but also by the artist's considered organization of various elements in the composition. Gregory Gillespie gives us a similar view in his *Landscape with Islands and Sky* (cat. no. 35). Under closer scrutiny, however, the imagery soon reveals the presence of a plethora of spectral forms that haunt the environs.

Ultimately, it is John Marin who evokes nineteenth-century ideals of water imagery. While luxury crafts hover in *Off Cape Split, Maine* (cat. no. 28), the dynamic action and power of the waves crashing against the Maine shore dominate the foreground of the composition. Thus Marin brings us back to a sense of our primal relationship to water as depicted in the dramatic paintings of such nineteenth-century American artists as Thomas Cole and Winslow Homer.

L.S.S.

28
JOHN MARIN
1870–1953

Since the early part of this century, John Marin has been considered an important member of the group of modern artists who were associated with Alfred Stieglitz and his New York galleries. His fame was established early as one of America's premier watercolorists, and his preferred subjects were almost always landscapes. Most of these landscapes were done in Maine during the summer months; the rest of the year the artist lived in Cliffside, New Jersey, and made frequent trips to New York City.

Since 1914, Marin had been visiting Maine, but it was not until 1933 that he took up summer residence in the northeastern coastal town of Addison, Maine. The watercolors that he produced in the early 1910s frequently featured a rocky shoreline in the foreground, with the ocean and islands beyond, all painted in the fluid, atmospheric style that characterized his earliest work. Such subjects and compositions repeated themselves in his later paintings of Maine, although his style in the 1920s became progressively tighter and more linear, and his medium changed from watercolor to oil paint in the 1930s.

Marin painted in various Maine locations throughout the 1910s and 1920s. However, after 1933 he concentrated on the area around Addison, especially the remote point overlooking Pleasant Bay called Cape Split, where he had purchased a summer house on three acres in 1934. It was a site that Marin said "lay nearer to his heart then any place in the world."[1] In a letter to Alfred Stieglitz, Marin wrote: ". . . we have the house and grounds and in front of us the bay and islands and smooth water and rough water—and the porpoises a chasing after herring—the house is so close to the water I almost feel at times that I am on a boat. . . ."[2] Sometimes Marin did go out on his boat to sketch,

but in later years he tended to work from the shore while perched on the rocks.

Marin found the sea to be compelling, constantly shifting in motion. He expressed this energy in his work as bold, rhythmic splashes of line and color, with a calculated use of black. A similar sense of movement had inspired his dynamic studies of New York City in the 1910s and 1920s. However, his compositions also suggested that the opposing movements and tensions found in nature occur within an overall structure of order and harmony. "This picture must not make one feel that it burst its boundaries. . . . And—too—I am not to be destructive within. I can have things that clash. I can have a jolly good fight going on. There must always be a fight going on when there are living things. But I must be able to control this fight at will with a Blessed Equilibrium."[3]

The rugged character of the Maine landscape led Marin to work increasingly in oil, a medium whose opacity and thickness more faithfully reproduced the density and choppiness of rough waters and rocky ledges than did watercolor. In Marin's 1938 painting, *Off Cape Split, Maine,* the basic elements of the composition—water, sky, horizon line, rock ledges, and boats—are defined by dark outlines and spaces that are broadly painted in with quick, expressionistic brushstrokes.

The turbulent churning of the sea, and of the very paint itself, is contained in a state of "equilibrium" by the use of insistent horizontal lines, representing horizon and sky, and strong, diagonal black slashes, denoting rocks. The space within the composition is divided into layers and flattened with a minimal sense of three-dimensional recession. The water occupies about four-fifths of the canvas and rises up, rather than back, to meet the thin bands of sky at the top.

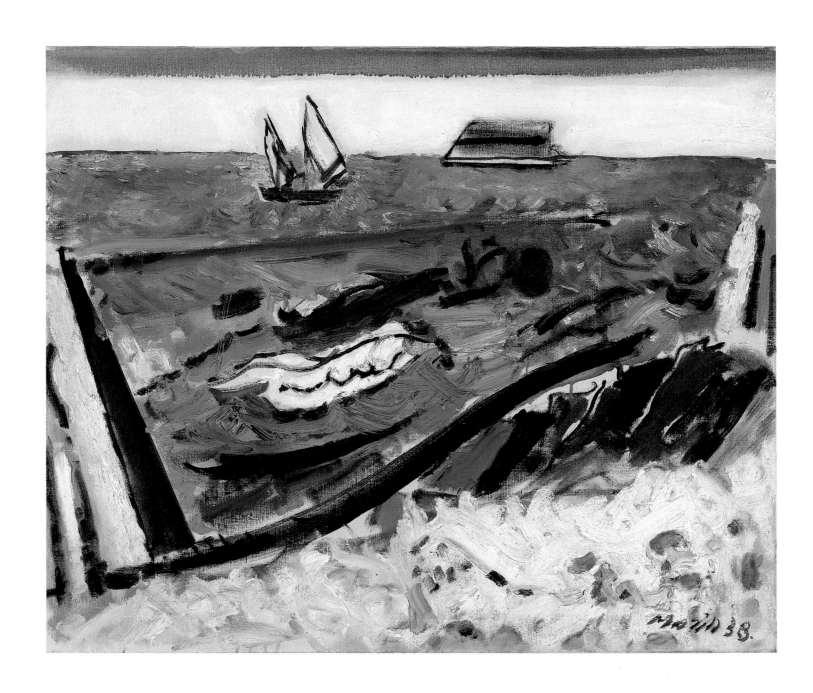

Off Cape Split, Maine, 1938
Oil on canvas
22⅛ × 28⅛ in. (56.2 × 71.4 cm)
George A. Hearn Fund, 1946
46.42

A similar subject, color scheme (blue, black, and white), and diagonal compositional line are found in Rockwell Kent's early modernist painting of Monhegan Island from 1907 (cat. no. 29). Like Marin, Kent focused on the ruggedly austere coastline of Maine and the broad expanse of ocean. Kent's work, however, maintains a fair separation between subject and viewer, while Marin's composition thrusts the viewer into close and immediate contact with the water.

Marin's handling of paint varies within the composition, depending upon what is painted. "In painting water, make the hand move the way the water moves."[4] Therefore, the paint is thick and raised in some places while in others we see the striations made by the bristles. Elsewhere, the paint is applied in thin washes that drip over or stain into the bare canvas. Interestingly, Marin's technique is similar to that of the abstract expressionists around the same time. Although Marin does not seem to have had direct contact with these younger artists, they all display a common desire to expand the expressive and tactile qualities of painting in the late 1930s and 1940s.

L.M.M.

NOTES
1. Mackinley Helm, *John Marin* (Boston: Institute of Contemporary Art, 1948), 70.
2. John Marin, letter to Alfred Stieglitz, 18 August 1935, published in *The Selected Writings of John Marin,* ed. Dorothy Norman (New York: Pellegrini & Cudahy, 1949), 167.
3. John Marin quoted in *John Marin by John Marin,* ed. Cleve Gray (New York: Holt, Rinehart, and Winston, n.d.), 156.
4. John Marin, letter to Alfred Stieglitz, 1932, published in *The Selected Writings of John Marin,* ed. Dorothy Norman (New York: Pellegrini & Cudahy, 1949), 149.

29
ROCKWELL KENT
1882–1971

Rockwell Kent first visited Monhegan Island in 1905 at the suggestion of his art teacher, Robert Henri. He returned the following year to build a cabin, and subsequently lived there for several years, supporting himself as a well-driller, lobster fisherman, and carpenter, painting all the while.

The role of great American outdoorsman was one Kent enjoyed playing throughout his life. In his art, it was reflected in his depiction of the harsh, barren, rugged side of nature as he found it, from Maine to Alaska, where he spent the winter between 1918 and 1919. He later journeyed to France, Ireland, Denmark, Greenland, the Straits of Magellan, and the Tierra del Fuego off South America. Each adventure resulted in yet another series of paintings, and another book on his experiences. By the mid-1920s, sales from his exhibitions and books afforded Kent acclaim and financial security.

We can almost feel the cold as we gaze at the pristine whites and clear blues in *Winter—Monhegan Island*. The snow-covered landscape is deserted except for two hardy souls rowing a boat in the inlet between the islands. We are looking at the upper end of Monhegan Harbor where Kent's studio was located. The large island farthest in the distance is known as Mananna, and the two islands in the mid-ground, which seem to be one, are named Smutty Nose and Little Smutty Nose, respectively.[1] Kent elegized the island in one chapter of his autobiography, *It's Me, O Lord:* "Monhegan: its rock-bound shores, its towering headlands, the thundering surf with gleaming crest and emerald eddies, its forest and its flowering meadowland; the village, quaint and picturesque; the fish-houses, evoking in their dilapidation those sad thoughts on the passage of time and the transitory nature of all things human so dear to the artistic soul; and the people, those hardy fisherfolk, those men garbed in their sea boots and their black or yellow oil skins, those horny-handed sons of toil—shall I go on? No, that's enough. . . . It was enough to start me off to such feverish activity in painting as I had never known."[2]

Kent's versatility included not only painting and writing, but also printmaking and illustration. During the last thirty years of his life, he continued to chronicle his infatuation with nature, mostly from his farm at Au Sable Fork in the Adirondack Mountains. Although his artistic achievement was overshadowed by the controversies engendered by his socialist leanings—particularly during the McCarthy era in the 1950s—Kent was one of the most popular American illustrators of this century. His work certainly confirms his philosophy as expressed in 1910 that art should be a record of an individual's life and experience yet still reach out to society in general, not just artists.[3]

L.S.S.

NOTES

1. Frederic B. Wright, Attorney, Washington, D.C., letter to the Metropolitan Museum, 4 March 1920, on file in The Metropolitan Museum of Art, Department of 20th Century Art archives.

2. Rockwell Kent, *It's Me, O Lord* (New York: Da Capo Press, 1977), 120.

3. William J. Spangler, "The Legacies of Rockwell Kent," *Print Review*, no. 14 (1981): 53–63.

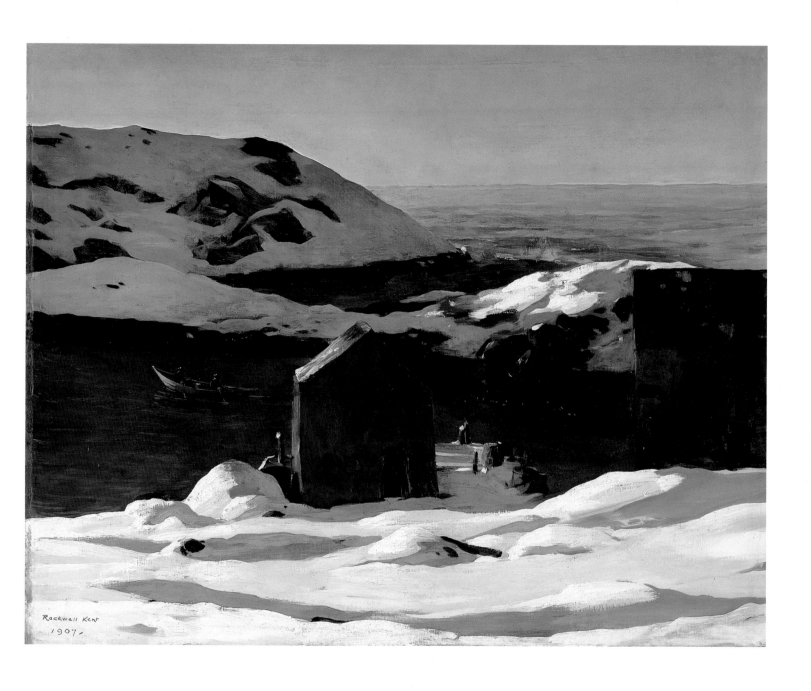

Winter—Monhegan Island, 1907
Oil on canvas
33⅞ × 44 in. (86 × 111.8 cm)
George A. Hearn Fund, 1917
17.48.2

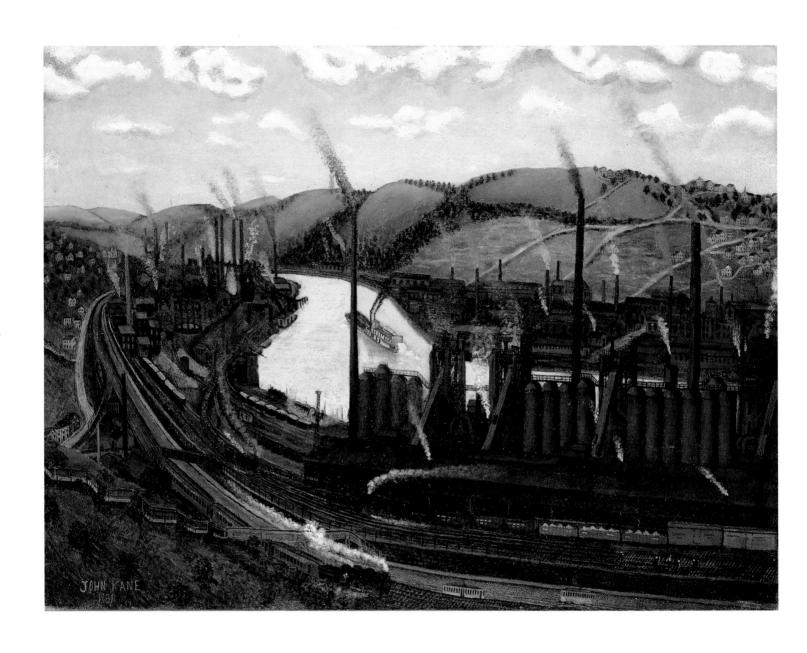

The Monongahela River Valley, 1931
Oil on canvas
28 × 38 in. (71.1 × 96.5 cm)
Bequest of Miss Adelaide Milton de Groot (1876–1967), 1967
67.187.165

30
JOHN KANE
1860–1934

John Kane was born of Irish parentage in West Calder, Scotland. At the age of nineteen he went to America, eventually taking up residence in Pittsburgh, Pennsylvania, a city famous for its steel refineries. Around 1897, while working as a laborer, Kane began to dabble in painting. Although he wanted to enter art school, he could not afford the expense. Kane was self-taught, and his style has been variously classified as "naive," "primitive," and "folk art," a genre that gained critical acceptance in the 1920s and 1930s. In 1927, one of his paintings was accepted for the Carnegie International exhibition upon the urging of artist Andrew Dasburg, who was one of the jurors. This exhibition brought Kane public recognition but few sales. In 1931, the year of his painting *The Monongahela River Valley,* Kane had his first one-man show at the Junior League in Pittsburgh and his first New York show at Contemporary Art Galleries.

The Monongahela River Valley is one of several paintings by Kane that celebrate the ever-growing industrialization of the American landscape during the 1930s. He was intimately acquainted with Pittsburgh's heavy industries, having worked for both the steel industry and the railroad (in fact, he lost part of his leg in a railroad-related accident). Despite this setback, his enthusiasm for Pittsburgh was never extinguished. He was forever fascinated by the city's "mills with their plumes of smoke, her high hills and deep valleys and winding rivers."[1] To Kane, Pittsburgh "represented both the promise and the fulfillment of the American dream."[2]

Based on pencil sketches, this canvas was painted in the artist's studio with painstaking detail and clarity of line.[3] The scene fairly hums with activity. Four railroad trains, one clearly marked with the name of the local rail line, Baltimore and Ohio, pass swiftly along an intricate maze of tracks, while nearby trolley cars and boxcars wait for clear passage. Echoing this movement is a large paddlewheel steamboat pushing a barge upriver. On either side of the meandering river, the dark buildings of the steel mills spread across the landscape, their billowing smokestacks lending vertical accents to the horizontal composition.

Although Kane is known for his portraits of both himself and others, people play a subordinate role in this particular landscape. Here a railroad crew is dwarfed by the enormous buildings and vast network of tracks. Only the serene rural landscape, seen in the background, maintains a sense of dignity against this industrial foil. Kane treats these divergent landscapes with equal admiration, finding beauty in both.

L.M.M.

NOTES
1. John Kane quoted in "John Kane exhibit evokes the beauty painter found in Pittsburgh," by Patricia Lowry, *Pittsburgh Press,* 28 February 1985, p. C8.
2. Jane Kallir, *John Kane: Modern America's First Folk Painter* (New York: Galerie St. Etienne, 1984), unpaginated.
3. Ibid., plate 29, and number 62 on separate, printed checklist for that exhibition (catalogue insert).

Water, 1945
Oil on canvas
24 × 29⅛ in. (61 × 74 cm)
Arthur Hoppock Hearn Fund, 1949
49.128

31
CHARLES SHEELER
1883–1965

America's industrial landscapes were a frequent theme in Charles Sheeler's precisionist paintings and photographs, both produced after 1927. That year Sheeler was commissioned to photograph the Ford Motor Company's new plant at River Rouge, outside of Detroit, Michigan, for an advertising campaign. He spent six weeks on the site and produced a series of stunning black-and-white photographs that depicted the "details of the plants and portraits of machinery."[1]

These factories and machines were the new icons of America's machine age. Sheeler wrote: "Every age manifests itself by some external evidence. In a period such as ours when only a comparatively few individuals seem to be given to religion, some form other than the Gothic cathedral must be found. Industry concerns the greatest numbers—it may be true, as has been said, that our factories are our substitute for religious expression."[2] Where earlier artists had turned to natural wonders like Niagara Falls and the Rocky Mountains for inspiration, Sheeler and his generation often looked to industrial subjects to epitomize America's great achievements.

Several years after producing the River Rouge photographs, Sheeler used these images as the source for a series of paintings, drawings, and watercolors (1928–35). This process was repeated in later works as well. In 1939, Sheeler received a commission from *Fortune* magazine to make a series of paintings based on the concept of industrial, mechanical, and technological power, which would be published in a special portfolio. During the year Sheeler traveled throughout the country with his camera, taking pictures of various images that conveyed this idea, such as Hoover Dam on the Arizona-Nevada border (formerly called Boulder Dam), large machinery, locomotive trains, and the structures built by the Tennessee Valley Authority (TVA).

These photographs inspired five oil paintings and one tempera, all published in the December 1940 issue of *Fortune*. Like many of Sheeler's themes, variations on these images reappeared in the artist's later paintings. *Water* seems to be one of those pictures based on the power series. During World War II, Sheeler worked as a staff photographer at The Metropolitan Museum of Art (1942–45).

Water was painted at Sheeler's home in Irvington-on-Hudson, New York, and depicts what the artist called an "element of [a] TVA project."[3] The scene contains no people or plants. Instead, Sheeler portrays the grandeur of America's technological powers in this man-made environment. The structure, probably part of a dam, is pristine and regal as it rises up to dominate the sky. The forms are geometric, the edges sharp and precise. One senses the artist's admiration for these symbols of modern society.

L.M.M.

NOTES

1. Charles Sheeler, letter to Walter Arensberg, 25 October 1927, published in *Charles Sheeler: The Photographs,* Theodore E. Stebbins, Jr., and Norman Keyes, Jr. (Boston: Museum of Fine Arts, 1988), 26.
2. Charles Sheeler quoted in *Charles Sheeler: Artist in the American Tradition,* Constance Rourke (New York: Harcourt, Brace and Company, 1938), 130.
3. Charles Sheeler, artist questionnaire in The Metropolitan Museum of Art, Department of 20th Century Art archives.

32
WALTER STUEMPFIG
1914–1970

After Walter Stuempfig died at the age of fifty-six, his obituary notice described his work as "meticulous, dreamlike still-lifes and landscapes . . . faintly tinged with Surrealism."[1] Stuempfig was raised in an affluent family on the outskirts of Philadelphia. He studied at the Pennsylvania Academy of Art and at age eighteen demonstrated a precocious talent when his work was included in the 1932 annual exhibition of the academy. He made frequent visits to Europe and drew his inspiration from masters as varied as Claude, Poussin, John Constable, and Thomas Eakins.

Stuempfig's aesthetic temperament favored a romantic approach. He once observed: "I hate most modern painting and Benton at the head of the list. You can quote me on that."[2] Recalling his days as a student at the Pennsylvania Academy of Art, he "tried to resist the tendency of the average art student to like the obvious—the obvious being Matisse and Picasso."[3] He sought instead to "create something that moves people."[4]

Thunderstorm II is one of Stuempfig's familiar beach scenes depicting Cape May and the New Jersey coast—a favorite summer retreat for the artist. In this painting, as in so many of Stuempfig's scenes, we sense an isolation reminiscent of Edward Hopper. The figures remain physically as well as psychologically removed from the viewer, except for the young boy in the foreground who stares out of the scene. At various points while spatially progressing into the composition, we encounter barriers: the rowboat, the horizontal line of the white retaining wall, even the house. The people portrayed are clearly not affluent summer visitors, but rather year-long residents who eke out a living. Long after we have walked away from this painting, we may be haunted by the lone figure of the pregnant woman standing in profile, gazing out to sea at the gathering thunderstorm clouds. She reminds us of those stoic fishermen's wives in the paintings of Winslow Homer who search the horizon for their husbands' fishing ships.

L.S.S.

NOTES

1. "Obituaries," *Art News* 69 (January 1971): 7.
2. "Stuempfig Remakes Nature," *Art News* 44 (December 15, 1945): 20.
3. Alexander Eliot, *300 Years of American Painting* (New York: Time Inc., 1957), 228.
4. Ibid.

Thunderstorm II, 1948
Oil on canvas
36 × 48 in. (91.5 × 121.9 cm)
George A. Hearn Fund, 1949
49.164

33
FAIRFIELD PORTER
1907–1975

Several of the artists whose work is included in this publication, including George Bellows, Yvonne Jacquette, Rockwell Kent, Walt Kuhn, John Marin, Fairfield Porter, and Neil Welliver, have captured the natural beauty of Maine in their paintings. These works span more than seventy years—from Kent's *Winter—Monhegan Island* (1907, cat. no. 29) to Jacquette's *Little River Farm* (1979, cat. no. 25)— but the images produced seem ageless, unaffected by the hands of time or man. Maine's appeal as a popular vacation spot rests with its widely varied and still unspoiled terrain that offers a range of experiences for all seasons.

The source of this particular scene is Great Spruce Head Island, located four miles off the coast in Penobscot Bay where Porter spent almost all his summer vacations between 1913 and 1975. In 1912, his father, James E. Porter, an architect in Illinois, purchased the island as a family retreat. Over the years, the elder Porter designed and built a farmhouse, a large cottage, and a barn. The artist's attachment to the place was rooted in his sense of self as well as family history: "Going to Maine always excites me as much as going to Europe. It has all kinds of emotions attached to it for me: the island stands for my personal golden age (my childhood) and in addition it is very beautiful."[1] "It's the place where most of all I feel myself to belong."[2] Porter's brother, the photographer Eliot Porter, has also recorded aspects of the island's life, producing color photographs of plants and birds.

From 1949 on, Fairfield Porter divided his time between the island in Maine and his home in Southampton, New York, on Long Island's south fork. In both locales, his compositions naturally incorporated water and beaches, although he also produced a large number of paintings featuring room interiors as well as portraits of family and friends. In each one, his approach is as gentle and unassuming as his subject matter. They are images of quiet ordinariness, in whose familiarity Porter found beauty. He believed that the painting itself "should be beautiful, not what the painting refers to."[3]

In its muted coloring and familial atmosphere, *The Kittiwake and The John Walton* reflects the influence of the early-twentieth-century French artist Edouard Vuillard on Porter. Although based on a specific scene, the focus of the painting seems to be as much on the harmonious arrangement of color and shape as on the narrative elements of boats in the bay; the title of the painting refers to the names of the two boats. Porter divides the square canvas into two large color areas representing sky and water. Within and around these subtly tinted blocks, Porter defines the configuration of the shore, the boats, and the other islands by using smaller, interlocking shapes. The reflections on the water made by land and boats create an intriguing mirroring of form. The lighting is diffuse and hazy, suggesting the "melancholy" that Porter felt was "inherent to the beauty of the island."[4]

L.M.M.

NOTES

1. Fairfield Porter quoted in *Fairfield Porter: A Catalogue Raisonné of his Prints,* Joan Ludman (Westbury, N.Y.: Highland House Publishing, 1981), 132.
2. Ibid., 131.
3. Fairfield Porter quoted in *A Sense of Place—The Artist and the American Land,* Alan Gussow (Friends of the Earth with The McCall Publishing Co., 1971), 145.
4. Fairfield Porter, "The Wave and the Leaf," quoted in *Fairfield Porter: A Catalogue Raisonné of his Prints,* Joan Ludman (Westbury, N.Y.: Highland House Publishing, 1981), 132.

The Kittiwake and The John Walton, 1962
Acrylic on canvas
36 × 36 in. (91.4 × 91.4 cm)
Gift of The Woodward Foundation, 1976
1976.250.4

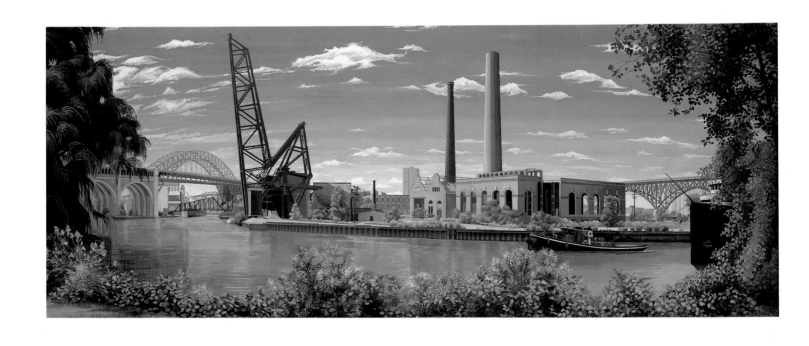

Morning in the Cleveland Flats, 1979
Alkyd on canvas mounted on composition board
41¼ × 107⅛ in. (104.8 × 272.1 cm)
Gift of Dr. and Mrs. Robert E. Carroll, 1985
1985.429

34
RICHARD CHIRIANI
born 1942

Richard Chiriani's painting has been described as combining "an esthetic and scientific perspective on nature we associate with certain of our nineteenth-century artists."[1] Indeed, *Morning in the Cleveland Flats,* a precisely rendered industrial scene located on the banks of a river and framed with an incongruous garland of trees and flowers seems to have been taken from a nineteenth-century panoramic view. The perspective ebbs and flows ever so imperceptibly out toward the spectator, setting up several points of focus over a 180-degree sweep.

In fact, Chiriani worked on the painting on site—in Cleveland, Ohio—for four months in the late spring and early summer of 1979. Chiriani's aim was to document one of the first major steel foundries built in the United States. A Dutch engineer responsible for the foundry's design left a vestige of his native architecture behind in the twin gables located just below the smaller smokestack. The complex also included one of the first electrical power plants, which was fed by a coal supply from Canada. On either side, we see at least four of the eight bridges that led into the complex, examples of almost every kind available in the late nineteenth century—including the swivel, cantilever, and span. Each one raises up to permit ships and tankers to pass through the Cuyahoga River, which flows before us just beyond the garlanded border at the bottom edge.

Although the floral details along the bottom edge would clearly seem to be a flight of fancy, the artist says that this is an observed detail.[2] At the left is the willow tree that, according to legend, marks the spot where Cleveland's founder first landed to initiate trade with the Indians. The scene has a strange stillness to it, leading one initially to view it as a composite of several sites or a more allegorical presentation. In contrast to this tranquillity, John Kane's *The Monongahela River Valley* (cat. no. 30) bustles with activity: trains passing through, smoke belching from smokestacks, and the steamboat bustling up the river. The tiny figures of workmen can be seen in the foreground: their toy-box homes dot the landscape on the left side. In *Morning in the Cleveland Flats* the smokestacks have stopped, the cranes clank no more, and the workers are gone. From the right-hand side of the painting emerges what was to be the last large ship to pass through the river, towed by a tugboat. Today all that remains of this site is one building that has been renovated as a shopping mall. Chiriani has presented us with the final epitaph for a now-vanished moment in America's industrial history.

L.S.S.

NOTES
1. Hilton Kramer, "Art: A Marriage of Freedom and Form," *New York Times,* 24 March 1978, p. C21.
2. Richard Chiriani, conversation with author, 10 August 1989.

35
GREGORY GILLESPIE
born 1936

Houses and boats of every style and economic taste crowd this scene of a series of islands in a bay or inlet viewed from the mainland. It is from all appearances a normal summer day in Newburyport, Massachusetts. Closer perusal of *Landscape with Islands and Sky,* however, reveals no human figures in spite of all the indications of recreational activity. Out of the rich, encrusted surface of the painting we do begin to discern a plethora of spectral figures, plant life, and so forth, that seem to form before our eyes in the foreground landscape. They call to mind the phantasmagorical forms of a Hieronymous Bosch and are meant to suggest that "everything is animate, overflowing with 'life' and changing continuously."[1] This is the quintessential Gregory Gillespie: an artist who glimpses the surreal, the unexpected, and the occult and brings it to the forefront of our consciousness.

Gillespie himself has ascribed this impulse to the lingering influence of a strict and repressed Catholic upbringing. Indeed, he spent eight years (1962–70) in Italy confronting this aspect of his life that finally found an outlet in his work. The artist professes his admiration for the works of fifteenth-century Italian artists such as Masaccio, Mantegna, and Crivelli. The last, in particular, matches Gillespie's own predilection for rendering forms in an obsessively precise way that often defies the reality it purports to evoke through the introduction of anomalous elements, out-scaled symbolic material, and bizarre points of view.

In spite of the dense details in this painting, the scale is relatively small, imbuing it with the preciousness of manuscript painting. Characteristically, Gillespie's paintings of the 1960s were rendered on a small scale, reflecting the artist's use of photographs. In this case, however, the source of the composition has been taken from a commercially produced scenic photograph on a laminated place mat that the artist found before him in a diner.[2] There seems to be a strange sense of perversity in Gillespie's world view that could accommodate such "kitsch" as sources for his art, but this is evidently a key component for comprehending the artist's approach to his work.

Gillespie currently lives not far from Amherst, Massachusetts. He first moved there in 1970, settling in Northampton when he returned from Europe. "I was fascinated by the local character and flavor of that part of America. It was very new and fresh to me. I loved the photographs of the local scene in the Northampton newspaper. I felt I was seeing the truly strange and bizarre in the ordinary and everyday photo."[3] In *Landscape with Islands and Sky,* Gillespie demonstrates his unique ability to share that vision with us.

L.S.S.

NOTES
1. Gregory Gillespie, artist questionnaire in The Metropolitan Museum of Art, Department of 20th Century Art archives.
2. Ibid.
3. Gregory Gillespie, interview by Howard Fox, in *Gregory Gillespie,* Abram Lerner (Washington, D.C.: Hirshhorn Museum and Sculpture Garden, Smithsonian Institution, 1977), 20.

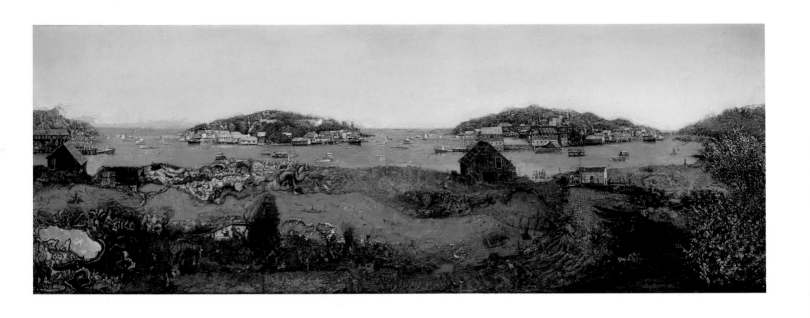

Landscape with Islands and Sky, 1979
Oil on particle board
12⅛ × 35⅞ in. (30.8 × 91.1 cm)
Gift of the family of Charles Wilmers, in his honor, 1982
1982.521

36
DUNCAN HANNAH
born 1952

Duncan Hannah's unabashedly romantic sensibility has alternately confounded and intrigued the critics who surveyed the 1980s art scene. He approaches his subject matter with an eye to the literary and film conventions that have fed his imagination since his youth. He writes: "I didn't feel allied with my times so I escaped into a kind of cultural time travel....The pluralism of the 1980s welcomed such a dark horse."[1] Hannah introduces a subtle, refined gentility to our sense of ourselves that constantly evolves as time and space alter all about us. At first glance, his straightforward presentations seem perfectly and completely perceptible, but we must not miss the intensity of the symbolism that smolders just beneath the surface, submerged before us.

The seemingly innocuous outdoor scene represented in *Out of Doors* appears to be a rendering of some vacation spot that the artist has visited. In fact, the composition is based on a black-and-white photograph from a 1949 issue of the *Illustrated London News*. It is a sketch of the Basingstoke Canal at Ash Vale, England.[2] Hannah was so taken with this photograph—particularly the large tree at the left which reminded him of Barbizon paintings—that this site has become associated for him with a mythic Hannah family ancestral property.[3] Hannah engages the thirst for historical pedigree that has obsessed the immigrant population of this country. His assumption is that a sense of historical connectedness may be achieved by appropriating the accoutrements of a past existence to approximate the substance of tradition.

Hannah also makes us reflect on the peculiar way that late-twentieth-century cultures prefer to validate reality. Does colorization of old black-and-white films really make the content and characters more real? Or is this a delusion as we seek more and better ways to escape the stridency of our contemporary reality? The title of the painting refers to Aldous Huxley's *Doors of Perception*[4] and perhaps, for us and the artist, this painting may be a link to some other existence or state of being.

L.S.S.

NOTES
1. Duncan Hannah, artist questionnaire in The Metropolitan Museum of Art, Department of 20th Century Art archives.
2. Duncan Hannah, letter to author, 22 August 1989, on file in The Metropolitan Museum of Art, Department of 20th Century Art archives.
3. Duncan Hannah, conversation with author, 15 August 1989.
4. Duncan Hannah, letter to author, 27 August 1989, on file in The Metropolitan Museum of Art, Department of 20th Century Art archives.

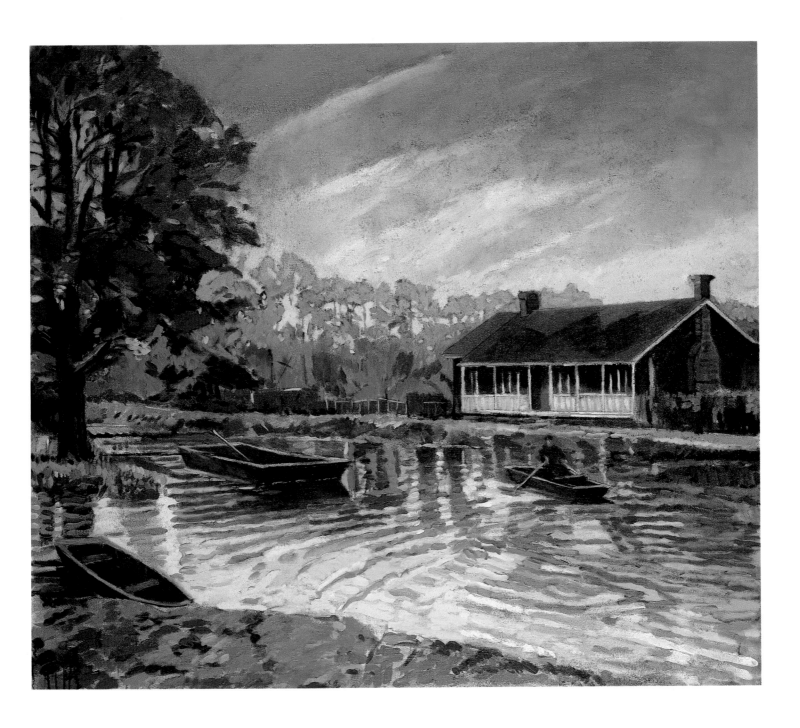

Out of Doors, 1987
Oil on canvas
54 × 64 in. (137.2 × 162.6 cm)
Purchase, Mr. and Mrs. Milton Petrie Gift, 1988
1988.209

37
RAFAEL FERRER
born 1933

Painter and sculptor Rafael Ferrer was born in San-turce, Puerto Rico. Ferrer established his reputation in the art world on the United States mainland during the mid-1960s as a conceptual artist who specialized in ephemeral works with a political but poetic nuance and installations that celebrated his Puerto Rican heritage. In the 1980s, Ferrer returned more or less exclusively to easel painting and has produced a body of work that not only serves as an effusive homage to the people and places of the Caribbean but also reminds us of the intricate dynamics of the sometimes contentious relationship that exists between the United States and Europe and the tourism economies of the Caribbean.

At first glance Ferrer has presented a pleasant beachside resort scene in *Merengue in Boca Chica.*

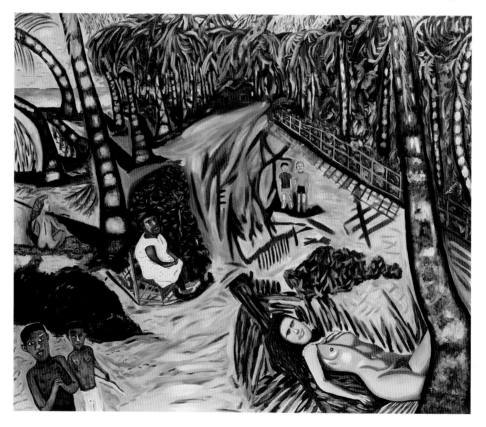

Figure 10
Remembrance of an Afternoon on the Way, 1983
Oil on canvas, 64 × 78 in. (162.6 × 198.1 cm)
George A. Hearn Fund, 1983
1983.253

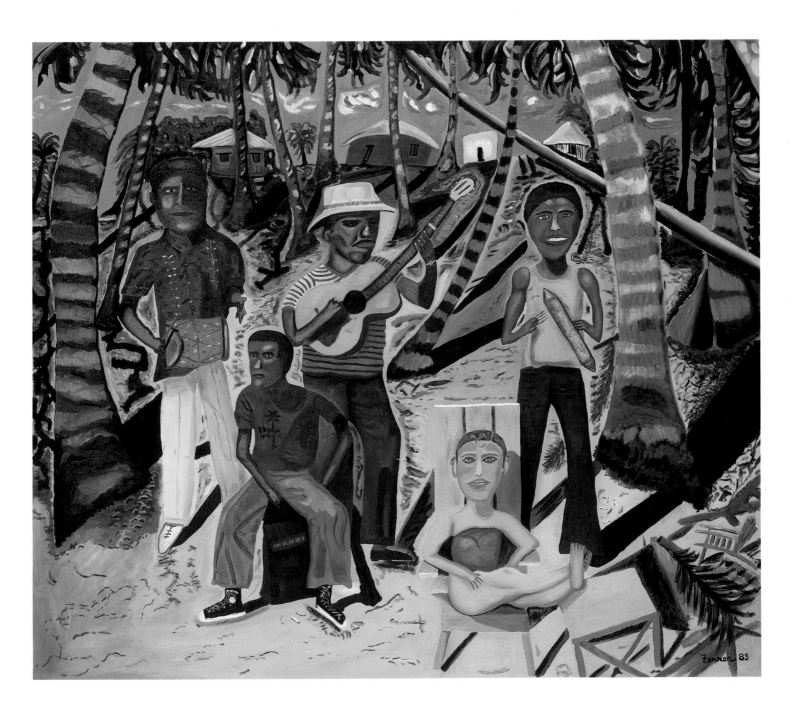

Merengue in Boca Chica, 1983
Oil on canvas
60 × 72 in. (152.4 × 182.9 cm)
Purchase, Anonymous Gift, 1984
1984.2

Three musicians, playing—from left to right—a drum, a guitar, and a güiro (gourd scraper), serenade a blond woman seated in front at the lower right. To her left, a sullen male figure—also seated—looks away from the scene. Ferrer has skillfully affected a "primitive" or "naive" style that approximates the conventions of folk art, which has a rich and flourishing tradition on many Caribbean islands. The distortions in representation constantly shift our perception of scale and proportion so that all the elements of the painting serve the overall design of the composition. For example, the palm trees consistently move in a contorted fashion toward the middle of the composition, thus helping to focus our attention on various areas in the painting. The artist also uses bright, exuberant color and insistently repeats decorative elements that serve to distract us temporarily from contemplating the relationships among the figures.

From the composition's arrangement, it is clear the blond woman has control, seated, as she is, in graceful leisure on a wooden chair. She personifies the American tourists who dominate the economy and even the culture of the Caribbean. The musicians behind her would be playing for tips, an economic reality underlying the illusion of a sensuous, pleasure-oriented paradise society. It is only the small, seated man who introduces a note of discord as he scowls out over the scene. By his positioning he seems to be one of the musicians, and the division of figures by sex and nationality indicates the social barrier between the man and the woman, although they are both seated. Ferrer has tackled the economic, social, and political tensions of his dual existence as a Puerto Rican and a resident of the United States in another composition in the Metropolitan Museum's collection, *Remembrance of an Afternoon on the Way* (fig. 10), also done in 1983. Here, pairs of figures delineate the phases of the artist's life and his relationships with various individuals both on the island and in the States.

Since the title of the painting mentions the merengue,[1] it is likely that the locale in the painting represents the Dominican Republic where Ferrer now has a home. Indeed, it was during a visit to the Dominican Republic that Ferrer first produced the watercolors and photographs that form the basis of his tropical paintings. According to the artist, these are the "geographic locales that have the most intensely erotic connotations from my childhood. . . . If there is a fundamental sustaining emotion in all the work, it's a kind of irony that comes from the knowledge that I am pursuing something that I will never really be able to get a hold of. . . . It's the fact that you love the place that no longer exists and the memory of that place makes you continue to search for it."[2]

L.S.S.

NOTES
1. The merengue may be considered the national dance of the Dominican Republic where it was first choreographed.
2. Marie-Rose Charite Velásquez, "Diamonds on the Street: Rafael Ferrer's New York," *Arts* (February 1984): 70–73.

The Great Outdoors

Perhaps the American preoccupation with the pursuit of outdoor pleasures can be seen as a lingering expression of the pioneering impulse that inspired settlers to traverse the three-thousand-mile expanse of this country in search of a better life. Certainly, for some, the out-of-doors provides an antidote to what is seen as the liabilities of urbanization, and we go in search of a better life-style—even if only for a week or a month each year—in what is left of our wilderness. Once there, we seek to possess, to conquer, to tame nature, much like David Bates's determined hunter, who struggles unperturbed to navigate his canoe through a seemingly impassable cypress swamp in *The Long Cypress* (cat. no. 43). Bates has reinforced the physicality of the situation by visually crowding all the elements in the composition to the foreground. The hunter's arms, the paddle he wields, and the overgrown vegetation all unite to create a web through which our eyes must push to comprehend the scene. In Willard Dixon's *Fair Hills* (cat. no. 45), a woman and her dog have chosen a more leisurely manner in which to enjoy nature. How disarming it is to see this same act of walking interpreted within the formal dictates of cubism seventy years earlier in Lyonel Feininger's 1915 *Road of Trees* (cat. no. 38). The dramatic, diagonal spatial shifts and the densely applied paint surface contrast with the atmospheric, almost photorealist style of Dixon's work.

Carroll Cloar's melodramatic *The Lightning that Struck Rufo Barcliff* (cat. no. 41) demonstrates the hazard of outdoor activities. His bewildered protagonist was clearly taken by surprise as the bolt of lightning reached down from the sky to strike the top of his head. The janitor in Paul Sample's *Janitor's Holiday* (cat. no. 40) seems to be in an equally dazed state as he pauses to enjoy his pipe beneath a denuded tree. Both Sample and Cloar paint in a quasi-folk art style that seems suited to the character of the tales that unfold before us. Horace Pippin was a self-taught folk artist. In his surprisingly sly composi-

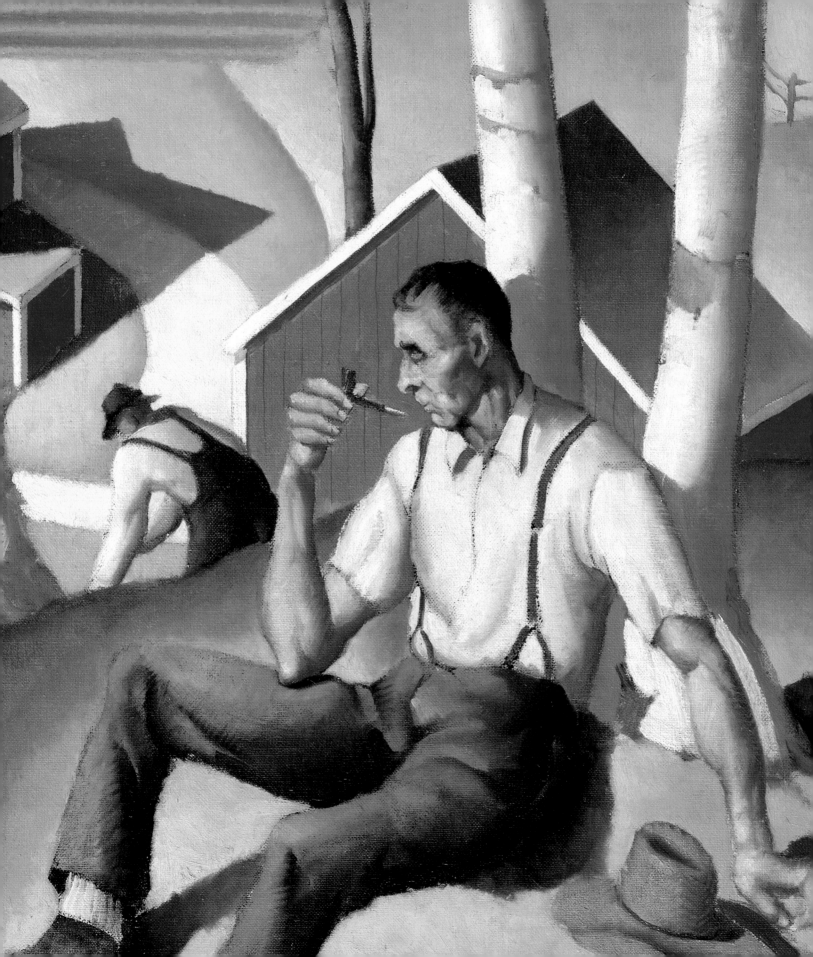

tion, *Lady of the Lake* (cat. no. 39), done the same year as Sample's *Janitor's Holiday*, 1936, Pippin casts us in the role of voyeur as we spy his heroine sunbathing. Our vicarious enjoyment of the scene is enhanced by the presence of the quaint and cozy log cabin, the lush forest surrounding a cool, clear lake, and the plush, vibrantly decorated blanket on which the figure reclines.

Dennis Smith's voracious picnickers in *Corn Eaters* (cat. no. 44) add a note of surreal buffoonery to this group of paintings. Their bizarre outdoor repast is missing the expected accoutrements, and rather seems to be some weird enactment of an eating ritual. What makes this painting all the more disconcerting is the fact that we associate corn so intensely with summer enjoyments, thus causing this particular episode to seem even more out of the ordinary. By contrast, Louis Bouché engages us in an amateur baseball game, like those we expect to come upon in any number of vacant lots, parks, and stadia in towns and cities all across America. The rather ragtag arrangements in *Baseball Game, Long Island* (cat. no. 42) contrast with the highly commercialized character that our national pastime has assumed and remind us of the fabled innocence that baseball has always symbolized in American life.

L.S.S.

38
LYONEL FEININGER
1871–1956

Born in New York City, Lyonel Feininger was sixteen years old when he went to study music in Germany. Once there, however, he decided to study art instead at the School of Applied Arts in Hamburg (1887) and at the Art Academy in Berlin (1888–92). Over the next forty-nine years, Feininger worked in Europe (primarily in Germany), first as an illustrator and cartoonist for magazines and newspapers, then, after 1907, as a painter and draftsman. His work was included in many important exhibitions in the early part of the twentieth century—the Berlin Secession (1910) and the Salon des Indépendants in Paris (1911), as well as those exhibitions featuring Die Brücke (The Bridge) and Der Blaue Reiter (Blue Rider) groups in Germany, with whom he was associated. In 1917 he had his first one-man exhibition at Der Sturm Gallery in Berlin.

Throughout his long career, Feininger's art reflected the early influence of cubism, which he first saw around 1911. That year six of his paintings were displayed in the Salon des Indépendants, along with those of the cubists. His friendship at this time with Robert Delaunay, leader of orphism (an offshoot of cubism that focused on the refractive effects of colored light) also had a long-lasting effect on his work. Feininger, however, did not consider himself a cubist. While he adopted the cubist analysis of form into geometric planes, he used the method to achieve a very different effect. Where the cubists "pluck to pieces . . . I strain in the opposite direction—concentration, monumentality."[1] In Feininger's work the broken planes of color did not dematerialize the subject but rather sharpened and clarified its form. Painted in 1915 while the artist was living in Berlin, *Road of Trees* reflects Feininger's full assimilation of these ideas.

Feininger often spoke about art in terms of musical analogies. He lauded Bach as the role model for his own compositions: "It seems to me of the utmost importance to become more simple. Again and again I realize this when I come to Bach. His art is incomparably terse, and that is one of the reasons that it is so mightily and eternally alive. I must avoid becoming entangled and fettered in complexities."[2] *Road of Trees* is one of Feininger's most architectonic compositions. The park landscape is arranged along a grid diagonal to the picture's plane. The tall, dark trees are aligned in three neat, parallel rows, slanting precariously to the left. The trees are leafless and monolithic, with sharp V-shaped branches. A lone male figure dressed in coat and hat is entrapped within two diagonal lines that echo the shape and angle of the surrounding tree trunks. This use of repetitive overlapping of lines and planes to suggest motion is similar to techniques devised by the Italian futurists at around this time. Here, man and nature merge completely into a single rhythm. This feeling of spiritual unity is found in many of Feininger's landscapes.

Between 1919 and 1932, Feininger was an important teacher at the Bauhaus School in Weimar and Dessau, Germany, where the visual arts were integrated with architecture and design. In 1936, Feininger returned to America for a short visit after forty-nine years abroad. After his paintings in Germany were confiscated by the Nazis and declared "degenerate art," Feininger moved permanently to New York where he continued to work until his death in 1956.

L.M.M.

NOTES
1. Lyonel Feininger quoted in *20th Century Masters from The Metropolitan Museum of Art, New York* (Canberra: Australian National Gallery, 1986), 58.
2. Lyonel Feininger quoted in "Lyonel Feininger and German Romanticism," by Alfred Werner, *Art in America* (Fall 1956): 59.

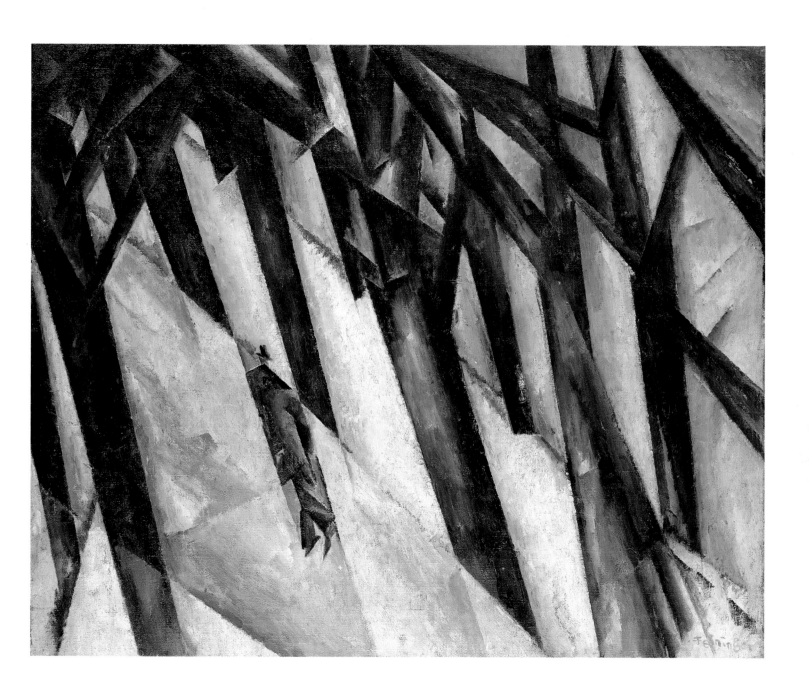

Road of Trees, 1915
Oil on canvas
31¾ × 39¾ in. (80 × 100 cm)
Anonymous Loan

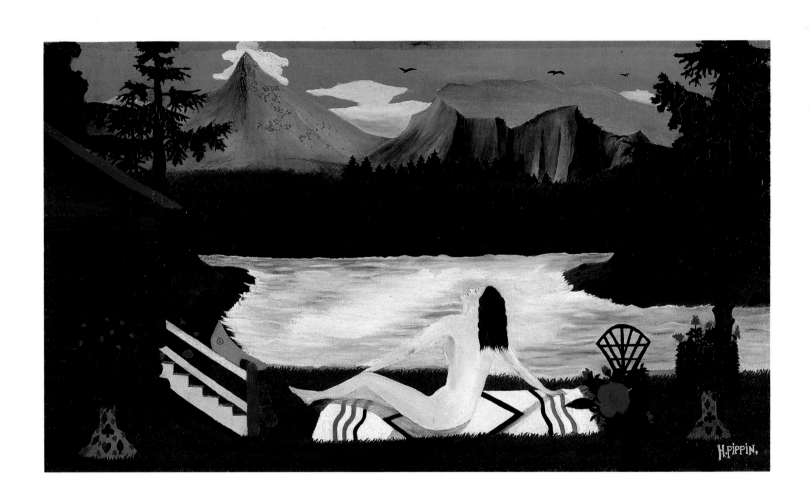

Lady of the Lake, 1936
Oil on canvas
20½ × 36 in. (52.1 × 91.4 cm)
Bequest of Jane Kendall Gingrich, 1982
1982.55.1

39
HORACE PIPPIN
1888–1946

Horace Pippin is one of America's best-known folk or self-taught artists. His paintings deal with historical subjects, various religious themes, and interior scenes depicting the life and activities of families, both black and white, in and around West Chester, Pennsylvania, where he spent most of his life. Pippin was a methodical worker who produced only a few paintings each year during the two decades of his creative work. Typically, the work reveals an intuitive sense of design and expresses a personal creed of peace and justice for all humanity.

Pippin demonstrated a love of art as a child. He did not pursue painting until he was in his forties, after having been disabled during World War I. He found his first subject matter in his experiences as a soldier in France. His arm had been wounded during his tour of duty, and as a result, he had to support his limp right hand with his left in order to draw. He devised a method of gouging the outlines of his compositions on wooden panels with a hot iron poker. He then filled the areas in with color, thus creating a rich, textural surface. Eventually he learned to draw on canvas with greater ease, and most of his later work was executed on this surface.

Within Pippin's oeuvre, *Lady of the Lake* is distinctive for its concentration on a landscape setting. The title alludes to a literary subject, the Arthurian tales. Instead of depicting stalwart knights in search of an enchanted sword in the care of the mysterious lady who resides in the lake, Pippin presents a nude sunbather at the edge of a lake, stretched out on a blanket adorned with a Native American design. She is clearly the sovereign lady of this realm and sits serenely with her face turned to the sun, in front of a cabin that seems too small to accommodate her height. Behind her we see the lake, a meadow and forest on the opposite shore, and mountains rising in the distance. Pippin's inclination for symmetrical design can be observed in the two bushes in planters at each side of the composition, decorated with the four symbols of playing cards. Farther in the distance, two fir trees echo this placement. The symmetry of the composition is broken only by the trellis with a single, prominent rose at the lower right. The artist's use of bright, intense reds and greens is typical of his palette during this period.

Lady of the Lake entered the Metropolitan Museum's collection as part of a bequest of seven paintings and drawings by Pippin from Jane Kendall Gingrich, who met the artist when she vacationed in the West Chester area during the 1940s. This painting was done at the end of Pippin's career, when his work had attracted the attention and support of Dr. Albert C. Barnes, whose pioneering collection of European and American modern art now forms the Barnes Foundation in Merion, Pennsylvania.

L.S.S.

40
PAUL STARRETT SAMPLE
1896–1974

Paul Sample regarded Brueghel as the greatest painter of all time. We recognize an affinity with Brueghel's work in Sample's own painting, especially in the detailing of anecdotal episodes that cater to our taste for narrative detail. Philosophically, Sample celebrates the "plain, unvarnished facts of American life plus a strong, even sentimental love for the facts that finally emerge."[1]

Although Sample's work has been described as a phenomenon of the Midwest, *Janitor's Holiday* actually depicts a New England scene. It was probably executed just after Sample returned from a European trip during which he had an opportunity to study Flemish and Italian masters firsthand. The artist has provided us with the details: "I did this painting last fall and winter in Montpelier, Vermont. It was suggested from a two-fold source . . . : the beauty of the rural Vermont landscape in Autumn . . . near the hamlet of Shady Rill . . . [and] . . . figures from various sources apart from this scene. I had seen a small girl on a huge horse during the past summer. . . . I decided to use my friend Henry Davidson for the model for the male foreground figure. Henry was the janitor of the building [National Life Building] . . . I put him there with the little girl on a horse and called it 'Janitor's Holiday'. . . . His wife recently made a trip to New York and saw the picture . . . in the Metropolitan Museum."[2] Like Thomas Hart Benton and the other regionalist artists with whom he is often compared, Sample strongly responded to the social conditions of the Depression era. However, his work has always emphasized harmonious compositions that contrast with the cultivation of an anti-aesthetic point of view by many of his peers.

Paul Sample was born in Louisville, Kentucky, and part of his childhood was spent in Winnetka, Illinois. In 1916 he went to Dartmouth College where his studies were interrupted by a year's service in the Navy during World War I. In college Sample was primarily interested in boxing, football, and the saxophone, which he played in the student jazz band. In 1925, when he was almost thirty years old, he decided to pursue a career in painting. He studied with Jonas Lie (see cat. no. 2) and spent a year working at the Otis Art Institute in Los Angeles. For the next thirteen years he divided his time between the coasts, teaching at the University of Southern California in the winter and painting in Vermont and Maine during the summer. In 1938 he was named Artist-in-Residence at Dartmouth College, one of the first to hold such a post in an American educational institution.

Sample also worked as an artist-reporter for *Life* magazine during World War II, "painting the war as he saw it from an aircraft-carrier, a submarine base and on a submarine patrol mission in the Pacific."[3] In his later career, Sample was known for his landscape studies and portraits of friends and prominent personages.

L.S.S.

NOTES
1. Alfred Frankenstein, "Paul Sample," *Magazine of Art* 31 (July 1938): 387–91.
2. Paul Sample Papers, Archives of American Art, roll 335.
3. Paul Sample's obituary, *New York Times,* 27 February 1974.

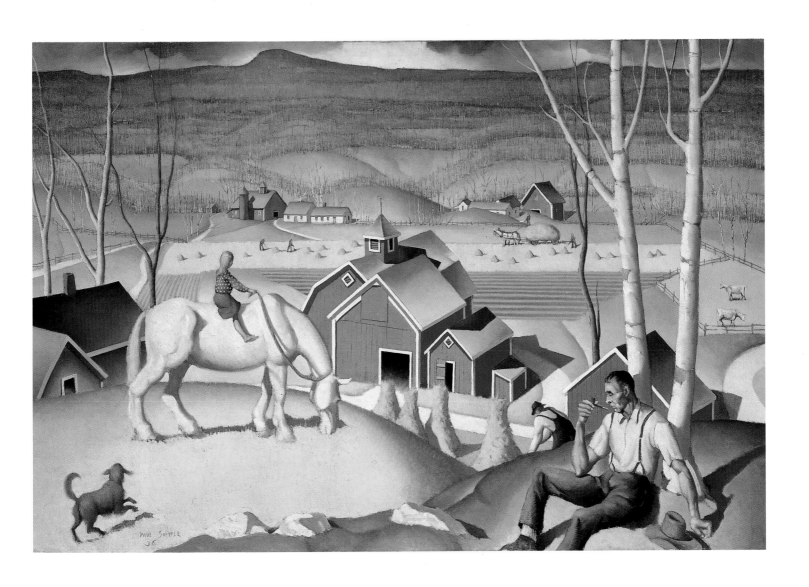

Janitor's Holiday, 1936
Oil on canvas
26 × 40 in. (66 × 101.6 cm)
Arthur Hoppock Hearn Fund, 1937
37.60.1

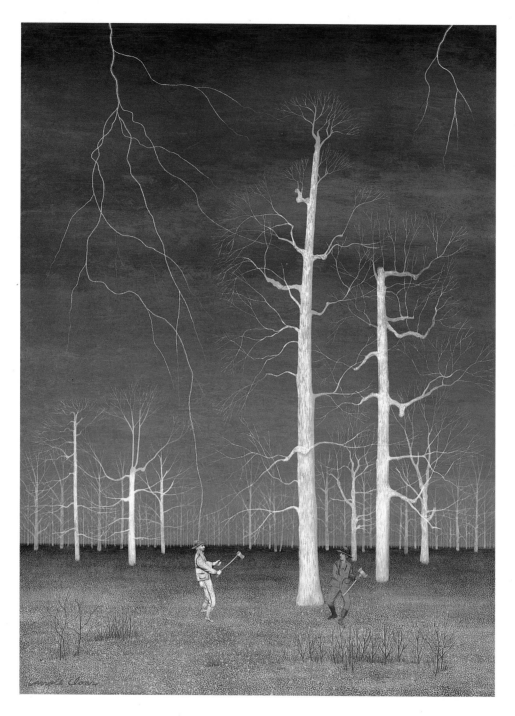

The Lightning that Struck Rufo Barcliff, 1955
Tempera on composition board
31 × 23 in. (78.7 × 58.5 cm)
George A. Hearn Fund, 1956
56.40

41
CARROLL CLOAR
born 1913

Carroll Cloar was born and raised in Earle, Arkansas, near Gibson Bayou. He grew up on a cotton plantation, and as a youth was intensely impressed by the evangelical religious beliefs and superstitions that governed daily life. Cloar studied at the Memphis Academy of Art and the Art Students League of New York, and received a Bachelor of Arts from Southwestern College, in Memphis, Tennessee.

In spite of his artistic training, Cloar has described himself as an intuitive painter: "I cannot explain my work in terms of art. . . . I simply try to paint the thing as I have seen it in my mind's eye or in my daytime dreams. . . . I paint the way I do because I am intensely interested in the life around me. Form and color are endless excitement, but I cannot slight the man sitting by the side of the road. He is important to me and he must come alive before I can quit the painting."[1] The artist's work does exhibit a certain surreal literalness that we might associate with a "folk" or "self-taught" artist. This effect is enhanced by working in tempera. In age and artistic predilection, Cloar would be compatible with such artists as Andrew Wyeth and Robert Vickery.

The Lightning that Struck Rufo Barcliff is based on the artist's childhood memory of the death of a friend who was struck by lightning while chopping wood in a forest. In this painting, Rufo Barcliff seems to have been taken by surprise as the bolt of lightning strikes the top of his head. The only indication of a reaction is his opened mouth and outstretched gesture. His companion seems equally nonplussed as he observes the event. Cloar has painted the branches of the bare trees—suggesting that the scene is taking place in late fall or winter—so that they mimic, even extend, the "spidery" lines of the lightning emanating out of the dominant sky. In fact there is such a proliferation of linear play that we might almost miss the point of the tragedy being played out for us.

L.S.S.

NOTES
1. *Contemporary American Painting and Sculpture,* vol. 1 (Urbana, Ill.: University of Illinois Press, 1963), 206.

42
LOUIS BOUCHÉ
1896–1969

Louis Bouché was born in New York of French parents. He was the progeny of artists—his grandfather, Ernst, was associated with the Barbizon school of painters and his father was an interior architect who worked with Stanford White. When

Bouché was about thirteen years old, his family returned to Paris and stayed for about four years. During this time, Bouché studied art at two well-known if conservative academies—La Grande Chaumière and the École des Beaux Arts. When he

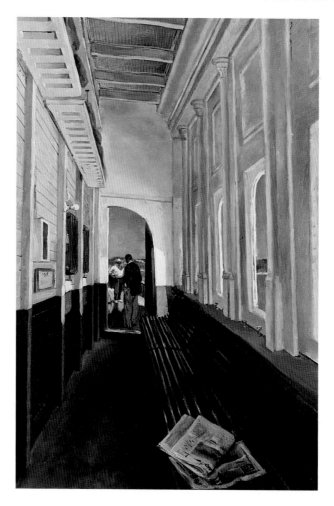

Figure 11
Ten Cents a Ride, 1942
Oil on canvas, 45 × 30 in. (114.3 × 76.2 cm)
George A. Hearn Fund, 1942
42.157

Baseball Game, Long Island, 1939
Oil on canvas
20 × 25½ in. (50.8 × 64.8 cm)
George A. Hearn Fund, 1940
40.48.2

returned to New York in 1915 he studied at the Art Students League where he met artists such as Alexander Brook and made contact with other artists working in realist styles. While pursuing his painting, Bouché supported himself in the 1920s by managing an art gallery. He was able to secure several mural commissions, one for the Hall of Justice in Washington, D.C., and another for the Men's Lounge in Radio City Music Hall in New York, which are still on view.

While Bouché was working on *Baseball Game, Long Island,* some of the boys who were playing ball came over to see what he was doing. "One asked, 'Watcha's doin' that pitcher fur, the newspaper?' 'No,' replied Bouché, 'I'm doing it for the Metropolitan Museum of Art.'" A few months later it was purchased by the museum.[1] The subject may be considered a typical one for the artist, who was described as having an "eye for contemporary scenes and events," and as "being vitally interested in every phase of big city life. He rides ferry boats [see fig. 11], visits bowling alleys and pool rooms, explores the city's outskirts for . . . scenes."[2] The painting itself has the quality of a quickly observed sketch. The figures literally seem in motion as Bouché has captured their actions with swift, light movements of the paintbrush. The scene is an open expanse of sky and land, with water seen beyond.

There is no clear indication of where Bouché observed this game. It could have been in any number of parks in Brooklyn or Queens, or even farther out on Long Island in Nassau or Suffolk counties. Perhaps the sign on the shelter under the tree in the center of the composition provides a clue: Bay Building Materials. This scene not only encapsulates the spirit of that uniquely American sport but also demonstrates how the landscape is an integral part of our experience of baseball, whether on a diamond in a park or field, or in the open stadia that crop up within the skylines of our major urban centers.

L.S.S.

NOTES
1. "Louis Bouché" *American Artist* 8 (April 1944): 17.
2. "Bouché Holds Best Show of Career at Kraushaar Gallery," *Art Digest* 16 (April 1, 1942): 16.

43
DAVID BATES
born 1952

Like fellow artist John Alexander (see cat. no. 52), who is also Texas-born and raised, David Bates finds the inspiration for many of his paintings in the primeval swamps around east Texas. Bates, however, relies not on memory, as Alexander does, but on color notes and small pencil-and-ink sketches made directly at the site to make his paintings (fig. 12). With these small sketches Bates returns to his Dallas studio where he works out the compositions in black and white, and then makes small color studies before translating the images onto large canvases.

Figure 12
Study for *The Long Cypress,* 1983
Pencil on paper, 14 × 11 in. (35.6 × 27.9 cm)
Gift of the artist, 1984
1984.529.1

The Long Cypress, 1983
Oil on canvas
90 × 67 in. (228.6 × 170.2 cm)
Purchase, Anonymous Gift, 1984
1984.12

The Long Cypress is an early work in a large series of paintings, dating from 1982 to the present, that focus on the landscape and wildlife of Grassy Lake in western Arkansas. An avid hunter and fisherman, Bates was already familiar with such swamps, which are a haven for birds, ducks, and fish (in addition to alligators), but he had not yet used this subject matter in his painting. Upon the recommendation of his friend Claude Albritton, whose figure is portrayed in this painting, Bates went on a fishing expedition to Grassy Lake for the first time in the summer of 1982. He was immediately astounded by the location's natural beauty and realized that he had found a new and engrossing subject: "On my first visit to Grassy Lake I was rendered speechless, which is no easy chore. It was like a dream, a place of strange beauty and complex compositions that changes completely from sunrise to noon. I knew I found something I couldn't learn in school or from other art and artists."[1]

During the 1980s, Bates returned several times to Grassy Lake. The works produced after these trips focused either on the wildlife in the swamp—both serene and predatory—or on portraits of his fellow boaters, navigating their way through the dangerous swamp waters in narrow canoes. Here, Claude Albritton seems trapped within the dense mesh of bald cypress trees that tower above him like a cathedral arch. Their crossing branches and buttressed trunks create a visual barricade that blocks his progress toward the open waters of the lake, colored red by the setting winter sun. Man and landscape are joined in an adversarial drama. The plane of the composition is tilted sharply toward the viewer, accentuating Albritton's precarious situation. The artist writes that the figure "frantically attempts to follow the sun before it disappears. These swampy landscapes are not easily mapped so the possibility of getting lost is an ever present reality. . . . The weather, the fading light, the greenery, and the air keep you out longer than is safe, like a diver mesmerized by the deep."[2]

The overall effect of the painting is that of a patchwork quilt made up of many interlocking and repeating colors and patterns. Bates's naïve style of painting is reminiscent of that by such earlier, self-taught artists as John Kane (see cat. no. 30) and Horace Pippin (see cat. no. 39), although here, the evocation of folk art is deliberate and studied.

<div align="right">L.M.M.</div>

NOTES

1. David Bates quoted in *David Bates: Forty Paintings,* Marla Price (Fort Worth, Texas: Modern Art Museum of Fort Worth, 1988), 10.
2. David Bates, artist questionnaire in The Metropolitan Museum of Art, Department of 20th Century Art archives.

44
DENNIS SMITH
1951–1983

With the untimely death of Dennis Smith at the age of thirty-two, the American art community lost a visual satirist and social commentator of great perception, wit, and verve. Smith completed only forty paintings between 1977 and 1983. They demonstrate his affinity with the moralizing surrealism of Hieronymous Bosch, the social commentary of Honoré Daumier, and the Gothic romanticism of American artists Peter Blume, Ivan Albright, and George Tooker. *Corn Eaters* seems to come out of the pages of a Shirley Jackson short story. Smith finds the buffo and the macabre even in such a seemingly innocuous activity as savoring summer corn on the cob. The three figures—a woman and two males, one rather effete-looking—lounge under a spreading tree, adjacent to a picturesque scene of a mill and waterfall, with a glimpse of the landscape extending to the horizon. We can only guess they are a family.

Figure 13
Corn Eaters, 1980
Graphite on paper, 5¼ × 6¾ in. (13.3 × 17.1 cm)
Gift of Ellen and Spencer Smith, 1985
1985.184.1

Summer corn is one of the signs of the season. It is associated with picnics, family outings, vacation stops, county fairs, roadside food stands, and other events of summer. Smith has presented us with what seems to be a picnic scene, but upon closer scrutiny the vision is an odd one. There is no other food evident aside from the ears of corn that the figures grasp in both hands, grimacing as they prepare to bite into them. Their consumption seems to have been synchronized: they all look out at us with the same wide-mouthed pose. With the exception of the man in the center of the composition—who wears cut-off denim jeans—their dress is hardly archetypical American summer leisure wear. The woman wears an Oriental-style jacket and short skirt with ankle boots. The younger man sports a frilly ensemble with shorts. Have we come upon some weird local ritual? The almost indistinct form of the squirrel warily watching the scene from behind the tree at the left of the painting would seem to be a warning to us to venture no further into this situation.

In creating this composition, Smith also has indulged in several interesting formal devices that can be more readily discerned in the drawing he made as a study for the piece (fig. 13). We see in the drawing that the torso of the man in the center serves almost as the focus of energy from which the other forms develop. The woman's left leg fits snugly under and beneath his girth, and the elbow of the younger male forms a triangular shape that notches into the line created between the calves of the older man's legs. Even the hands on the three figures echo with meaning; they are shaped like animal silhouettes we might play with in front of a light. Indeed, in their positioning they enhance the figures' voracious act of devouring the corn.

L.S.S.

Corn Eaters, 1980
Oil on canvas
45¼ × 60 in. (114.9 × 152.4 cm)
Anonymous Loan

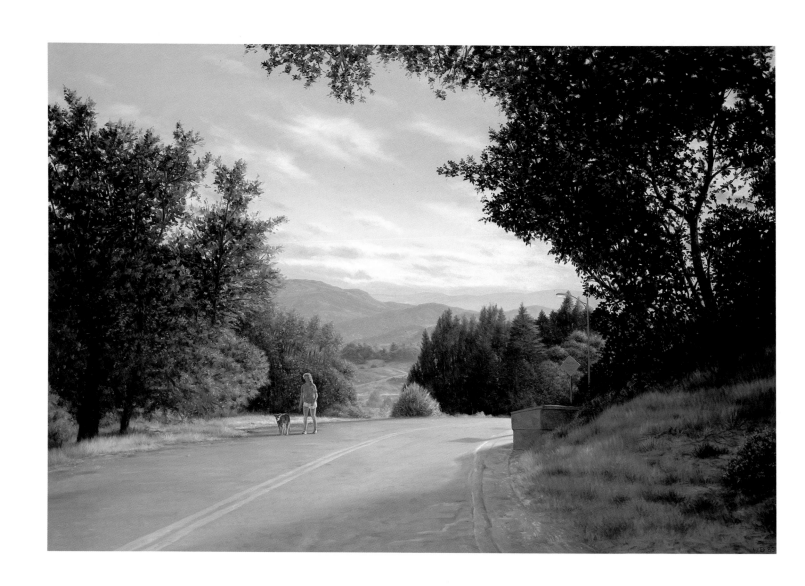

Fair Hills, 1985
Oil on canvas
72 × 108 in. (182.9 × 274.3 cm)
Gift of Dr. and Mrs. Robert E. Carroll, 1987
1987.460.1

45
WILLARD DIXON
born 1942

The painting *Fair Hills* is the kind of idyllic scene associated with the best aspects of living in America: a woman and her dog set out for a walk along a deserted highway. Lush foliage and unlittered stretches of grass hug the road as it curves gently up into the hills. In the center of the composition, a valley opens the vista to the rolling hills beyond and then to the sky. The location is in Marin County, California, just across the valley from San Rafael, where Willard Dixon lives. It is late in the afternoon during the spring or summer and, it would seem, all is well with the world.

In the 1980s, we came to expect that such a scene would include some element, some nuance—large or small, evident or barely perceptible—that would undermine the sense of euphoric well-being that Dixon has presented. But, happily, we can enjoy the relaxed air of the figure and her companion, and the clear, cool weather that is characteristic of northern California. Even the incursions of modern society are kept to a minimum, consisting only of the paved road and the street lamp almost hidden among the trees at the right of the painting. Dixon bases his compositions on his own slides taken at various sites. As he projects the image, he begins to make choices about what to delete and what to add. In this particular painting he has presented the scene practically as it was, a fascinating approach, given the overall idealistic quality of the composition.

Willard Dixon was born in Kansas City, Missouri. He studied art at the Art Students League of New York, the Brooklyn Museum School, Cornell University, and the San Francisco Art Institute where he received his Master of Fine Arts in 1969. He has taught in several art institutions in California and has executed a number of mural projects in both Texas and California.

L.S.S.

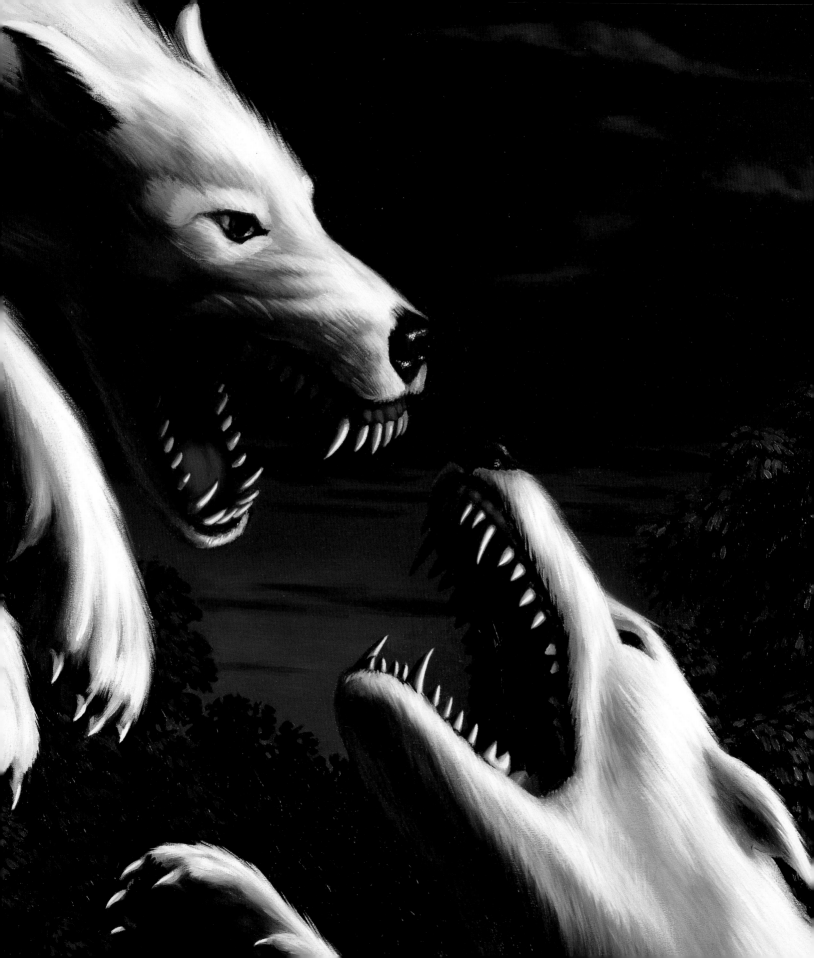

Landscape as Allegory

Detail from *Wild Dogs*
by Leonard Koscianski
(cat. no. 51)

Webster's dictionary defines "allegory" as a "narrative in which abstract ideas are personified; a description to convey a different meaning from that which is expressed."[1] This narrative can be expressed in either written, oral, or artistic form.

In this section, the earliest painting was begun in 1943 and completed a decade later; the other works range in date from 1954 to 1983. All eight are united by their artistic attempt to suggest feelings or ideas beyond the literal scene depicted. Early in the twentieth century, such an approach informed the work of Italian metaphysical painter Giorgio de Chirico. During the 1920s, his ideas exerted a direct influence on the development of the surrealist group in Europe. Through unusual juxtapositions of imagery and unconscious improvisation of color, form, and composition, they sought to explore the realm of the subconscious—the painted dream.

Artists like Yves Tanguy and Kay Sage became surrealists before they worked in America, and their later paintings from the 1950s continue to reflect this style. Psychological implications can be read into their enigmatic imagery, as it can in the more contemporary paintings of James McGarrell, John Alexander, and Louisa Chase from the 1980s. These psychological concerns are often triggered by world events. The erosion of political, social, and environmental order underlies the thematic message in the paintings of Edwin Dickinson, John Tweddle, and Leonard Koscianski. In all, landscape imagery—whether real or imagined—has been used as the means by which personal emotions and universal truths are expressed.

L.M.M.

NOTES
1. *Webster's Dictionary for Everyday Use* (Baltimore: Ottenheimer Publishers, 1986), 14–15.

EDWIN DICKINSON
1891–1978

The creation of *Ruin at Daphne* took almost ten years in two locations (Wellfleet, Massachusetts, and New York City). Even then, the artist did not consider it finished. Dickinson's artistic process was slow and methodical, with many revisions occurring as the painting evolved. The changes reflected the artist's rethinking of the composition: "If a painting takes many years, one hasn't stood still from the beginning to the end. As time goes on, one starts to disapprove of the earlier work. But even so, I prefer doing long ones to short ones."[1] Each change was scraped off completely with a knife before a new passage was painted in, so that there is no perceptible accumulation of paint. Around the edges of the canvas, the red underdrawing that laid out the composition is still visible.

Ruin at Daphne was exhibited at various stages during its ten-year period of creation, and a series of photographs documents its transformations. The subject of the painting—ancient ruins in a state of constant decay—could be a metaphor for the artist's method of working, in which images are invented and partially or completely destroyed.

Ruin at Daphne is a study in shifting perspectives. Like many of Dickinson's canvases, this one presents objects seen from unusual vantage points. The tilting of even the most familiar images forces the viewer to stop and study the elements of the painting in order to fully understand them. Here, Dickinson shifts the direction of his vision three times. Along the top portion of the composition, the architectural features are painted as if we are looking up at them, so that we see the underside of the rounded arch. In the midsection of the painting we see the fountain with the perched bird and flying horse head-on. Along the bottom register we view the understructure of the staircase labyrinth.

The painting also vacillates between highly realistic representation and passages of pure abstraction, as if the image is going in and out of focus—half reality, half hallucination. Color is not an issue here, but strong tonal values of light and dark are used to punctuate the composition. Elaine de Kooning said of Dickinson's work that "light becomes a means to disguise, not to describe the subject,"[2] and that the artist is "a master of off-tones and narrow ranges."[3]

The idea for *Ruin at Daphne* grew out of Dickinson's earlier interest in Roman architecture. Although most writers have assumed that the scene is a figment of Dickinson's vivid imagination, there is reason to believe that some of the buildings are based on actual sites, perhaps seen in illustration. For example, the round temple with curved entablature (to the left of the three arches) is closely modeled after the Temple of Venus at Baalbek in Syria and corresponds to Dickinson's mention of a "Roman ruin in Syria, built 40 A.D."[4] The three arches themselves can be found in the Basilica of Constantine in the Roman Forum. Dickinson may have also incorporated images from Leonardo da Vinci's painting *The Adoration of the Magi* (before 1482, Collection Uffizi, Florence). "There is the same ambiguous merging of complex architectural forms and living trees, and even a small Leonardesque horse. . . . The mood of ruined grandeur is unmistakable."[5]

L.M.M.

NOTES
1. Edwin Dickinson quoted in *The Artist's Voice*, Katharine Kuh (New York: Harper & Row Publishers, 1962), 73.
2. Elaine de Kooning, "The Modern Museum's Fifteen: Dickinson and Kiesler," *Art News* 51, no. 2 (April 1952): 67.
3. Elaine de Kooning, "Edwin Dickinson Paints a Picture," *Art News* 48, no. 5 (September 1949): 50.
4. Edwin Dickinson quoted in Ibid., 51.
5. Edward B. Henning, *Fifty Years of Modern Art: 1916–1966* (Cleveland, Ohio: The Cleveland Museum of Art, 1966).

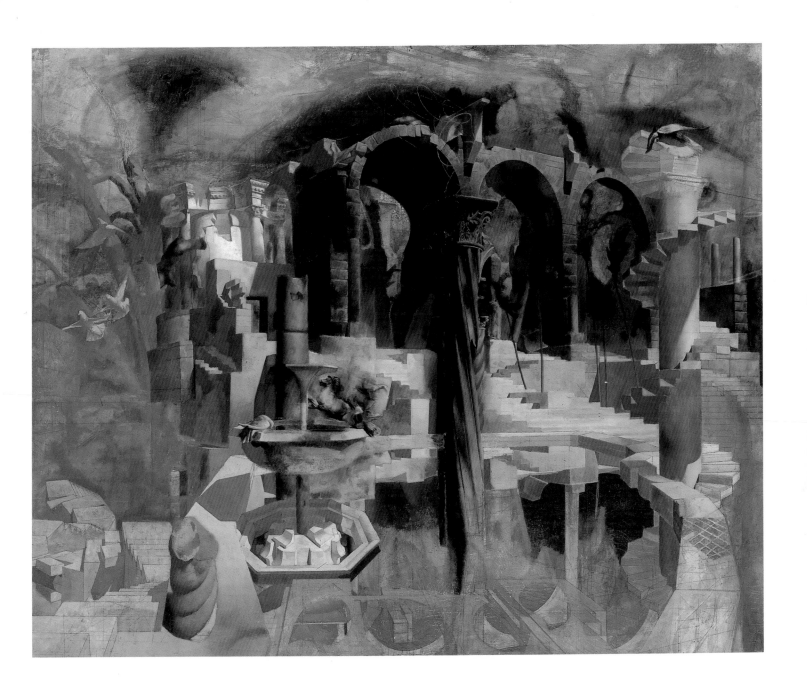

Ruin at Daphne, 1943–53
Oil on canvas
48 × 60¼ in. (121.9 × 153 cm)
The Edward Joseph Gallagher III Memorial Collection
Gift of Edward J. Gallagher, Jr., 1955
55.13.1

The Mirage of Time, 1954
Oil on canvas
39 × 32 in. (99.1 × 81.3 cm)
George A. Hearn Fund, 1955
55.95

47

YVES TANGUY
1900–1955

Like his American wife, the artist Kay Sage (see cat. no. 48), Yves Tanguy was greatly influenced by the metaphysical paintings of Giorgio de Chirico. As a result of seeing de Chirico's work in 1923 at a Paris gallery, Tanguy decided to devote himself to oil painting, and as an artist was completely self-taught. In 1925 he met the French poet André Breton who urged him to join his new surrealist group, which he did in 1926. The following year he held his first exhibition at the Galerie Surréaliste in Paris.

Tanguy painted without sketches, and his images developed on the canvas without forethought. "The element of surprise in the creation of a work of art is, to me, the most important factor—the surprise to the artist as well as to others. . . ."[1] His paintings are dreamscapes of gaseous skies and low horizons, barren vistas containing piles of geomorphic formations. Although these landscapes are imaginary, they may have been suggested by his early experiences as a child in France, living on the coast of Brittany. His friend Roland Penrose, a writer, artist, and fellow surrealist, described "the wild shores of Brittany" as being "the hallucinatory wonder of tides, winds, clouds, sand and rocks on the Atlantic coast. The weather-beaten granite of prehistoric standing stones and menhirs, linked mysteriously to cosmic movement impressed him."[2] Thus inspired, Tanguy's disturbing vision of the world was obsessively recorded in numerous paintings.

In 1940 Tanguy married Sage, and the couple settled in Woodbury, Connecticut; in 1948 he became an American citizen. During World War II, their home was a haven for many of the European artists who came to the United States. *The Mirage of Time* was painted in Tanguy's Woodbury studio a few months before his death in January 1955. In style, subject, and composition it is characteristic of the work he had produced since the 1930s. Like many of the later paintings, the foreground here is densely congested with rocklike images of varying size and shape that crowd to the very edge of the picture plane. In contrast, the background area that occupies two-thirds of the canvas is left empty, producing a sense of infinite space. Sky and ground fuse at the juncture of an ambiguous horizon.

The forms in Tanguy's compositions are articulated with great clarity and detail; yet this illusion of realism does nothing to elucidate their actual geological identity. He uses stark dark and light contrasts to enhance the impression of three-dimensionality. Among the smaller bits of rock, Tanguy intersperses flat planes of solid color to relieve the intense congestion. His palette is essentially monochromatic, heavily reliant on steel grays and blues, which reinforces the impression that all life has vanished from the world depicted. Only an occasional accent of red, yellow, or brown appears, as in the red sphere at the extreme right that eerily resembles a detached eye. As in all his later paintings, this work registers a pervasive sense of anxiety.

L.M.M.

NOTES
1. Yves Tanguy quoted in *Contemporary American Painting and Sculpture* (Urbana, Ill.: University of Illinois Press, 1955).
2. Roland Penrose, *Yves Tanguy: A Retrospective* (New York: Solomon R. Guggenheim Museum, 1983), 4.

48
KAY SAGE
1898–1963

Kay Sage's work is too often considered a footnote to that of her more famous husband, the surrealist painter Yves Tanguy (see cat. no. 47), although her adoption of surrealism occurred before they met. In their mature works there are similarities in their subject matter—imaginary landscapes painted in a realistic fashion—but their sense of space and vocabulary of images are very different. Tanguy created carefully delineated environments with bizarre rocklike formations that recede deeply into space. On the other hand, Sage's paintings after the mid-1940s, like *Tomorrow is Never,* locate architectural structures within rather unspecified, amorphous spaces.

Born in Albany, New York, to a wealthy family, Sage spent most of her early years in Italy and France. After a brief time in New York during World War I, she returned to Italy in 1919 at the age of twenty-one, where she stayed until 1937. The following two years she spent in Paris. During these years in Europe, Sage drew and painted and constantly wrote. Although primarily a self-taught artist, she did study briefly at the Corcoran Art School in Washington, D.C., and attended life drawing classes for a few months in 1924 at the Scuola Liberale delle Belle Arti in Milan.

Sage's first exhibition, in Milan in 1936, contained mainly abstract paintings. The following year her style changed considerably after she saw the metaphysical paintings of the Italian artist Giorgio de Chirico in Paris, who was an important influence on many surrealist painters. Sage was particularly impressed by his ability to endow ordinary architectural subjects with a dreamlike intensity of feeling, and this idea influenced her subsequent subject matter.

In 1938, Sage's new work was exhibited in the Salon des Surindépendants where it attracted the attention of both Tanguy and André Breton, the writer and spiritual leader of the surrealists. Sage was immediately invited to exhibit with the surrealists, and she later participated in the International Surrealist Exhibition in New York in 1942. Sage and Tanguy were married in 1940 and, the following year, settled in Woodbury, Connecticut, where she lived until her death. Their home became a meeting place for artists displaced by World War II, among them Peter Blume and Hans Richter, both associated with surrealism, and Naum Gabo, the constructivist sculptor.

Tomorrow is Never is an example of Sage's mature style that combines boundless uninhabited space with meticulously rendered unpeopled buildings. In this painting, the buildings seem to be grounded somewhere below the canvas, emerging mysteriously from the nebulous surrounds. They are what James Thrall Soby called "pavilions of dreaming."[1] In this case, the dreams are ominous and haunting, suggesting loneliness and death. Within three of the structures, Sage has painted long folds of cloth that resemble shrouded figures in mourning. The air is still and heavy with a sense of impending doom.

Tomorrow is Never was painted in 1955 after Tanguy had died suddenly at the age of fifty-five in January of that year. His death had a profound effect on Sage and she spent the last eight years of her life as a recluse, partially blind and often depressed. Unable to paint after 1958, she worked instead with collage. Four years after an unsuccessful suicide attempt, the artist killed herself with a gunshot in 1963.

L.M.M.

NOTES
1. James Thrall Soby, in foreword to Kay Sage catalogue, Galleria dell'Obelisco, Rome, March 1953.

Tomorrow is Never, 1955
Oil on canvas
37⅞ × 53⅞ in. (96.2 × 136.8 cm)
Arthur Hoppock Hearn Fund, 1955
55.179

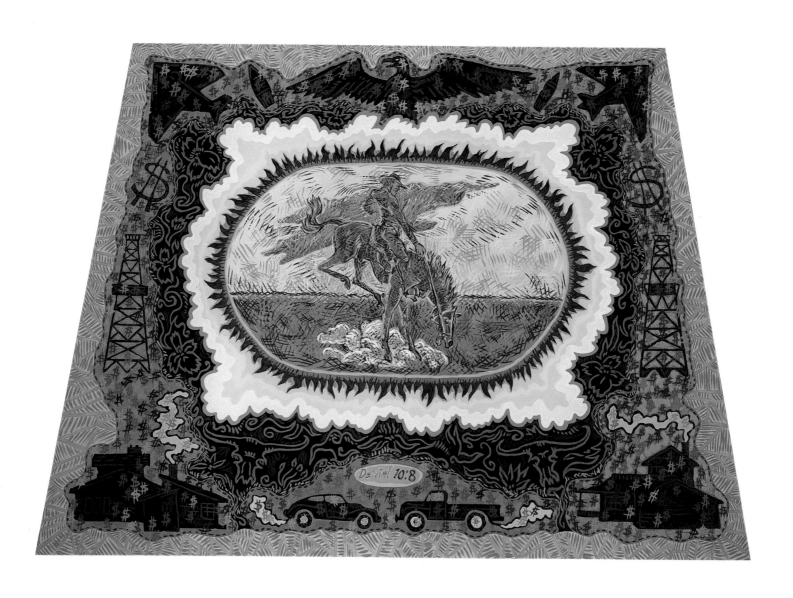

Vision from Oklahoma, 1981
Oil on canvas
66¼ × 96¾ in. (168.3 × 245.7 cm)
Edith C. Blum Fund, 1983
1983.358

49
JOHN TWEDDLE
born 1938

In 1989, the state of Oklahoma celebrated its centennial anniversary. The official commemoration of the free-wheeling stake-out of the territory by the so-called "sooners" who rushed in to take possession of unclaimed land in 1889 did not progress without controversy. Various representatives of Native American peoples, whose "reserved" areas were seized during the land rush, staged counter-demonstrations that brought to light the other side of our romantic image of the Wild West.

John Tweddle's *Vision from Oklahoma* deals with the conflicting aspects of America's Western myths. The painting is dominated by a virile cowboy astride a bucking horse, confident in his ability to tame the beast to do his bidding. Similarly, nineteenth-century pioneers advanced across this country to the Pacific coast, defying nature, mankind, and any other force that might have challenged their presumption. But eventually the unrestrained exploitation of the land, fueled by the insistence on a rugged, individualist capitalism, created an environmental crisis that Tweddle alludes to in the decorative border of this painting. At the bottom, we see trucks, boom towns, and cars emitting dollar signs in their exhaust; up the sides, oil wells and dollar signs; and at the top, military aircraft and bombs that add a rather apocalyptic tone to the painting.

Tweddle deployed the rhomboid shape utilized here in several allegorical paintings produced at about the same time. All shared more or less the same dimensions. The artist has also created a cross-hatched pattern in his application of the paint that suggests woven carpets laid down and viewed in perspective.[1] This pattern, in addition to the florid (and occasionally floral) designs that serve to delineate the different spatial arenas in the paintings, results in a dense composition that conveys the hallucinatory edge of the biblical warning from the Book of Daniel, which is referred to in the inscription at the center of the composition on the bottom edge: "Therefore I was left alone and saw this great vision, and there remained no strength in me: for my comeliness was turned in me into corruption, and I retained no strength" (Daniel 10:8).

L.S.S.

NOTES
1. William S. Lieberman, *New Narrative Painting: Selections from The Metropolitan Museum of Art* (Fort Lauderdale: Museum of Art, 1984), unpaginated.

50
JAMES McGARRELL
born 1930

In his paintings, James McGarrell combines the disciplines of figure study, landscape painting, and still life. Each element is painted in a representational way, but the juxtapositions within the composition are fanciful and dreamlike, leading viewers to make their own associations. Some of his images are based on actual people or places. Sometimes they are derived from paintings done by other artists. Other times they are a product of what he calls "invention." "One of the reasons that I paint is to be able to see things which otherwise I couldn't, and to be able to see them, furthermore, in my own 'handwriting' or to make a believable event which otherwise doesn't exist."[1]

Time and space have little reality in a painting like *Crossing Move*. We drift across and into the picture, surveying the figures in the foreground and the intricate landscape some distance away. The landscape is based on an Umbrian village in Italy, in the foothills of the Apennine Mountains. In the lower portion, the figures and fruit seem to spill into the viewer's space. The horizontal band of patterned pink cloth suggests that the objects are in an interior space, but the setting quickly shifts to an outdoor scene. With vertical stripes of blue and green on either side of the canvas acting like an inner frame, McGarrell seems to imply that this may be a painting within a painting, but the boundaries are ambiguous and constantly shifting.

The figures of the man and woman are considerably larger than the objects around them. This pair is also oddly separated from one another as they lean away in opposite directions. The man, nattily dressed in tuxedo and red bow tie, faces front—a hat in one hand; a bolt of cloth in the other. The woman, dressed in a strapless gown, stands with her back to the viewer, one side of her face totally hidden in shadow. In the mirror that she holds in her left hand—a gesture that echoes her partner's—we catch a reflected glimpse of her face. Both figures quote, in style, gesture, and dress, paintings of the 1920s by the German artist Max Beckmann, whom McGarrell admires.[2] The pouncing cat at the bottom right is a more animated version of the cats that inhabit Balthus's paintings. McGarrell readily acknowledges his debt to these artists as well as his interest in the work of Giorgio de Chirico and René Magritte, but his use of such imagery is totally his own.

Crossing Move and its companion piece, *Drifting Move* (private collection, New York), were painted between 1981 and 1982 in St. Louis, Missouri, when McGarrell first accepted a teaching position at Washington University's School of Fine Arts. In describing the two paintings, he wrote that they "were made after I had gone through a period of moving in and out of Bloomington (Indiana), New York City (where I lived for four months in early 1981), Italy and St. Louis. I was thinking not only about literal moves—at one time I thought of one as moving in and the other as moving out—packing, unpacking, etc., but in a larger sense of changing places, changing life: manner, growth, transition, throwing off old encumbrances but assuming new ones."[3]

L.M.M.

NOTES

1. James McGarrell quoted in *James McGarrell, Recent Work,* Edward Bryant (Albuquerque, N.M.: University of New Mexico Art Museum, 1981).

2. See Max Beckmann's paintings: *Family Picture,* 1920, The Museum of Modern Art, New York, for source of the woman with mirror; and *Self-Portrait in Tuxedo,* 1927, Busch-Reisinger Museum, Harvard University, Cambridge, Mass., for inspiration for the man.

3. James McGarrell quoted in "The Recent Paintings of James McGarrell," by Edward Bryant, *Arts* (February 1984): 144.

Crossing Move, 1981–82
Oil on canvas
78 × 59 in. (198.1 × 149.9 cm)
Kathryn E. Hurd Fund, 1984
1984.109

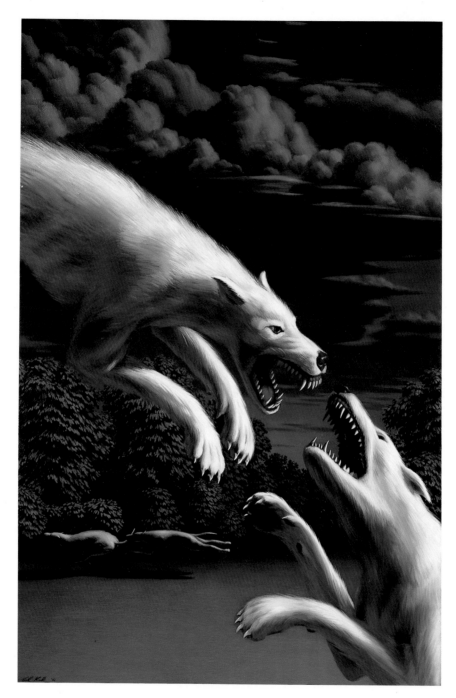

Wild Dogs, 1982
Oil on canvas
72 × 48 in. (182.9 × 121.9 cm)
Gift of Karl Bornstein, 1984
1984.222

51
LEONARD KOSCIANSKI
born 1952

In the eerie stillness of a moonlit night, a startling confrontation unfolds on a manicured lawn. This scene of fighting dogs evokes the raw, primitive power of nature gone awry. But the chaos implied by the situation is offset by the artist's careful exploitation of a tightly controlled painterly technique and compositional format.

Koscianski has positioned the dogs so that they come at each other in a dramatic diagonal movement. They seem to defy the laws of gravity as they leap and attack. The diagonal is framed by the horizontal movement of the clouds above and the secondary chase of two dogs below in the background. The artist has established a nocturnal setting, cast in cool, dark shades of blue and green. He has carefully built up the surface of his painting by applying layers of paint, progressing from a dark ground to lighter values, similar to an Old-Master glazing technique. Clearly, it is this contrast between the unabashedly violent movements of the animals and the pristine surroundings within which this confrontation takes place that renders the scene even more terrifying.

In similar compositions done at about the same time, Koscianski added enclaves of neat little suburban houses lined up in a row. The artist strikes an allegorical chord casting pigs, stags, and dogs as surrogates for human beings, serving as "metaphors of a primordial nature that lurks below the surface of our fragile social organization."[1] During the 1980s, several artists turned to animal imagery to postulate an apocalyptic destiny for mankind, as a consequence of our unfettered pollution of the environment and disruption of the natural balance of ecology. Aesop and H.G. Wells are some of the literary sources that inform this work. As such, Koscianski's paintings transcend the personal realm of psychological terror to political musings on the future of civilization.

L.S.S.

NOTES

1. Press release, Karl Bornstein Gallery, Santa Monica, CA, 21 May 1985.

52
JOHN ALEXANDER
born 1945

John Alexander's imagery is based on his memories of the landscape around Beaumont, Texas, where the artist lived until the age of twenty-three. Located in southeastern Texas, near the Louisiana border and the Gulf of Mexico, Beaumont is surrounded by oil refineries and bayous. Alexander's familiarity with the bayous is firsthand, gathered from his brief residence on a houseboat in the Neches River, and from his many photographs of the region, taken over several years. The unusual features of this environment—its swampy areas, dense vegetation, and varied wildlife—have continued to fuel his imagination even after 1979, when he moved to New York City.

Although drawn from actual experience, Alexander's paintings should not be viewed as descriptions of particular places, but rather as general allegories of the human condition dealing with emotional distress, political turmoil, and environmental abuse. "I work with landscape imagery not as an end itself, but to exorcise the violence and psychosis that have become basic to the human experience."[1] Life and death, growth and decay, good and evil—all find their parallels in the specific environment that he portrays.

In paintings like *Red Goat,* we feel the artist's intimate knowledge of his subject—his awareness of both the darkness and imminent danger of the swamp as well as the unexpected flashes of color, life, and beauty that can be found there. The artist says that he sees himself "painting from inside the landscape, where instinct and intuition rather than detached observation and perception are critical faculties."[2] His paintings combine passages of abstraction and representation, both equally descriptive, so that we can gather information from both the slashing, jagged lines that explode across the canvas, as well as from narrative details, such as the cowering posture and frightened expression of the animals.

Red Goat was painted in New York City and is typical of what the artist calls his "dark ominous landscapes with startled, half-crazed, frightened animals."[3] In the center of the composition is a ghostly, black-and-white-striped animal with short antlers, trapped in a pool of water. She does indeed seem startled by the sudden exposure and turns quickly toward the intruder with an uncertain gaze, her eyes flashing red in the light. Immediately behind her stands a larger and darker animal with enormous branching antlers, and around them lurk disembodied eyes and bodies in the shadows. The painting seems spontaneous and emotionally charged by the gestural brushwork, but the composition is carefully organized and deliberately colored for maximum effect.

Although a strong sense of time and place are established in Alexander's work, his paintings do not adhere to a traditional landscape format. There are no distinct horizon lines to separate land from sky, no sense of objects receding into space. Rather, Alexander effects a murky, claustrophobic denseness that suggests further space but forbids penetration. We, the viewers, are trapped in the painting much as the painted animals are trapped in their setting.

L.M.M.

NOTES
1. John Alexander quoted in "John Alexander," by John Beardsley, *Art International* 26 (July–August 1983): 39.
2. Ibid., 39.
3. John Alexander, artist questionnaire in The Metropolitan Museum of Art, Department of 20th Century Art archives.

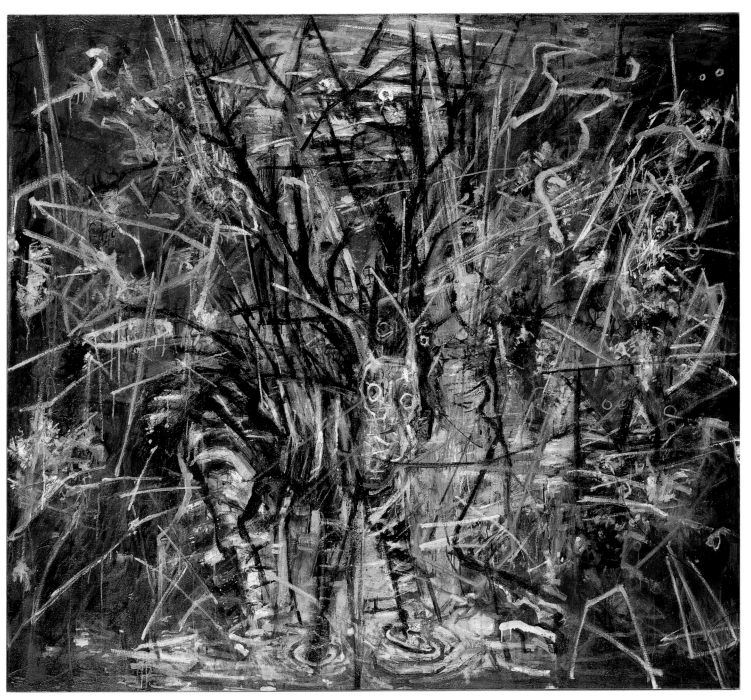

Red Goat, 1983
Oil on canvas
74 × 84 in. (188 × 213.4 cm)
Purchase, Anonymous Gift, 1983
1983.256

53
LOUISA CHASE
born 1951

In 1980, Louisa Chase began a series of paintings that depicted isolated geological formations—mountains, lakes, rocks, and caves. These landscapes, creations of the artist's imagination, are charged with emotion and symbolic meaning. Although the images themselves are recognizable, they are placed in such unfamiliar situations and juxtapositions that they assume a surreal and often romantic presence.

In *Pink Cave,* the placement of four round rocks at the bottom of the canvas leads our eye to the mouth of a large, encrusted cave. There is no clear sense of proportion, and these stones could be either pebbles or boulders. In the lower section, we appear to be inside the cave looking out at an unnaturally colored pink sky. Near the top left, the perspective is reversed, as the rocks now lie outside the threshold of the darkened cave. Elsewhere, the motif of arched cave opening and rock is reduced to a simplified hieroglyphic, incised on the wall of the cave, that is suggestively at once phallic and vaginal in shape. The thickly painted, impastoed surface of the picture re-creates the tactile inner and outer surfaces of the cave.

The insistent, often garish pink color that dominates the picture expresses the intense, conflicting emotions felt by the artist at the time she created this painting. Chase writes that *Pink Cave* was made "during a transitional time when I felt I was inside and outside the cave at the same time. Gradually I left the cave (the internal symbolic imagery) and went outside where the language of painting became less about memory (bracketed by symbol) and more about immediate response—immediate being in the world."[1]

L.M.M.

NOTES

1. Louisa Chase, artist questionnaire in The Metropolitan Museum of Art, Department of 20th Century Art archives.

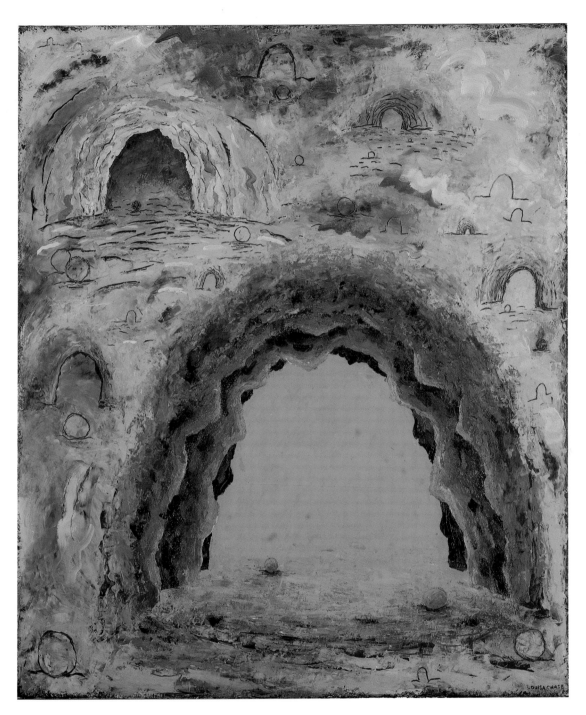

Pink Cave, 1983
Oil on canvas
84 × 72 in. (213.4 × 182.9 cm)
Edith C. Blum Fund, 1983
1983.173

Nature Transformed

Detail from *Susan at Black Lake* by Jack Beal (cat. no. 58)

The peculiar manner in which natural visual phenomena can be representative of the more exclusively formal concerns of abstraction in art—the arrangement of color, line, and shape, for example—has long been recognized. In turn, works of art that have been conceived as purely abstract can call to mind certain images, forms, and even atmospheric events that occur in nature. For example, Clyfford Still's untitled composition of 1946 (cat. no. 57) is intended to be perceived as devoid of anecdotal nuances. Evidence, however, is to the contrary. The composition suggests a cartographic rendering of canyons such as those that exist in the western United States where Still grew up. As the artist's habit was to trowel his paint onto the canvas with a palette knife, the resulting texture only enhances this association. David Smith's *Seashell and Map* (cat. no. 54) achieves a similar uniting of technique and imagery. Here, memories of a Caribbean sojourn have been encapsulated in forms that approximate a seashell and a map of some land mass. Despite the associative nature of these forms, it is the artist's aggressive handling of his pigment that is paramount.

Leon Kelly's approach in *Vista at the Edge of the Sea* (cat. no. 56) has been informed by the surrealists' interest in cultivating associative imagery through such techniques as automatic writing and the analysis of dreams. In this instance, the artist—like his contemporaries William Baziotes and Barnett Newman—finds inspiration in various biological life forms, many of them microscopic. In this case, insects form the basis of this seascape. Tod Wizon presents another approach to abstracted nature in *Above (for Steven Schmidt)* (cat. no. 60), executed in 1986. Here the artist self-consciously cultivates referential elements. For example, the colors themselves are meant to convey a specific emotional state relative to a particular incident in the artist's life. In another vein, Jack Beal's *Susan at Black Lake* (cat. no. 58) is painted in a pristine, hyperrealist style suggestive of the type of

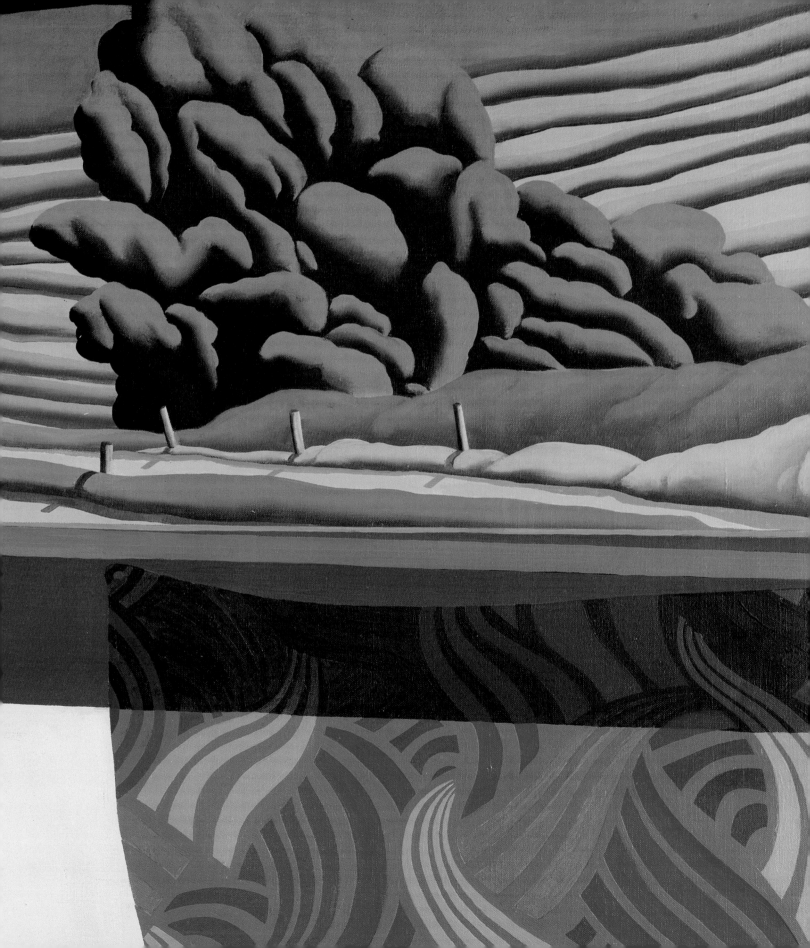

narrative we have come to associate with the spatial disjuncture of surrealism as seen, for example, in the work of Salvador Dali.

Marsden Hartley's expressionistic interpretation of the northern New Mexico landscape in *Cemetery, New Mexico* (cat. no. 55) is the earliest painting in this section. The roll of the mountains, the small houses, cacti, and clouds in Hartley's painting are rendered in an all-over textural impasto. It is a view of a Native American burial ground, which provides a fascinating contrast with Ernest Blumenschein's *Taos Valley* (cat. no. 5). Blumenschein's atmospheric depiction of the mesa-dotted landscape bathed in the warm red-orange of late afternoon displays a more direct involvement with the environment than does the Hartley. The shapes of the various elements in Hartley's composition have been disciplined to conform to the repetitive patterns in the overall design of the painting. It may not come as a surprise that the Hartley was done in Paris, far away from the site which inspired its subject matter. Ronnie Landfield similarly presents an image primarily achieved through a textural manipulation of paint in gel medium in his 1982 composition *From Portal to Paradise* (cat. no. 59). Despite our initial impression that the physical act of painting, rather than anecdotal nuance, is what interests Hartley and Landfield, it should be noted that both paintings present the artists' ideas of utopia. For Hartley, such an idyllic refuge is specific to the southwestern United States; for Landfield, it is less exact, a poetic evocation of a place of pure enjoyment—be it the Garden of Eden, Arcadia, or the South Seas.

L.S.S.

54
DAVID SMITH
1906–1965

Although David Smith is known as one of the preeminent American sculptors of the twentieth century, he began his artistic career in the 1920s and 1930s as a painter. *Seashell and Map* was inspired by an eight-month sojourn on Saint Thomas in the Virgin Islands in 1931 and 1932. During this time Smith produced a body of work that indicated his evolution from painter to sculptor. Art historian Edward Fry has suggested that this sojourn was a crucial event in Smith's life, during which he "clari-

fied [his] previously tentative efforts to translate European modernism into the vernacular of American experience; it also marked a first loosening of the bonds imposed upon Smith by his own Calvinist, Anglo-American and positivist heritage."[1]

In this painting, the artist has presented what seems to be a large seashell—perhaps the conch shell so prevalent in the Caribbean—against some kind of cartographic rendering. The seemingly random assembly and ambiguous quality of the

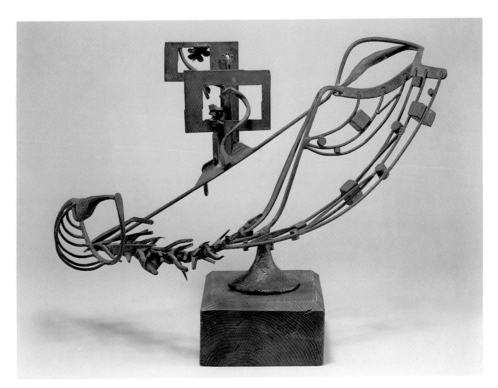

Figure 14
Song of the Landscape, 1950
Iron and bronze, 19 × 32 × 19½ in. (48.3 × 81.3 × 49.5 cm)
Promised gift of Muriel Kallis Newman
The Muriel Kallis Steinberg Newman Collection

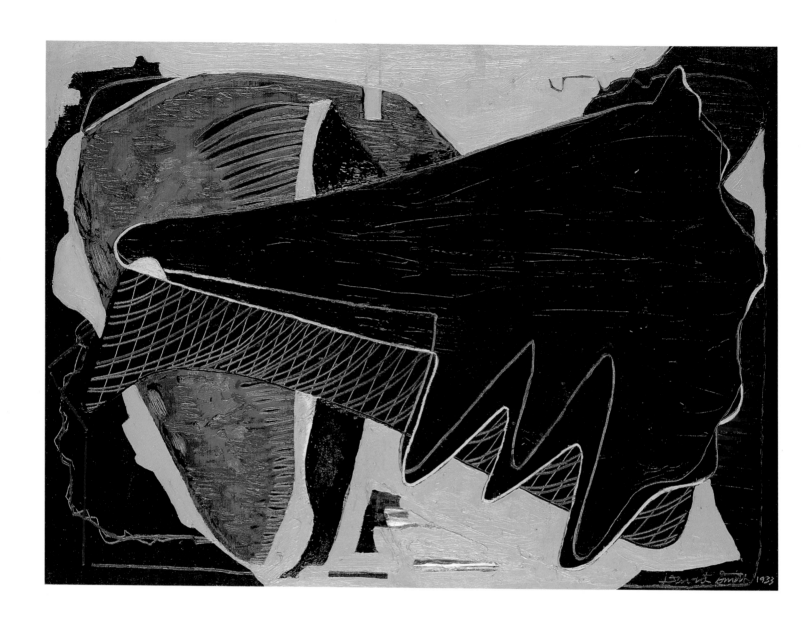

Seashell and Map, 1933
Oil on canvas
26 × 36 in. (66 × 91.4 cm)
Purchase, Lila Acheson Wallace Gift, 1983
1983.438

shapes as well as the patterning and texturizing in this work seem to merge Smith's interest in cubism, constructivism, and surrealism, and to foreshadow his approach to sculpture by welding unrelated elements together. Even the color indicates the influences of these varied styles; one is reminded of the yellows, browns, greens, and salmon colors seen in Braque's work during the 1920s. Smith has incised lines into the thick surface of the paint. This gestural quality is similar to his later sculptural surfaces—a harbinger of abstract expressionism, which would emerge almost a decade later.

In 1947, David Smith published this observation in the artistic journal *Possibilities:*

I HAVE NEVER LOOKED AT A LANDSCAPE
without seeing other landscapes
I have never seen a landscape without visions of things
 I desire and despise
The separate lines of salt errors
The balance of stone—with gestures to grow
A landscape is a still life of Chaldean history

it is bags of melons and prickle pears
its woods are sawed to boards
it is colored by Indiana gas green
it is steeped in Indian yellow
it is the place I've travelled to and never found
in the distance it seems threatened ↯ by
the destruction of gold.[2]

Smith's enumeration of the evocative elements in this poem distinguish his approach from the more panoramic views usually associated with landscape painting; it also seems quite compatible with his approach to form in this painting. In his later landscape sculptures, such as *Song of the Landscape* of 1950 (fig. 14), Smith similarly devises a landscape, this time defying our usual expectations about volume and mass in sculpture.

L.S.S.

NOTES
1. Edward Fry, "David Smith, An Appreciation," in *David Smith* (New York: Solomon R. Guggenheim Museum, 1969): 10.
2. David Smith, "I Have Never Looked at a Landscape," *Possibilities,* (Winter 1947/48): 25.

Cemetery, New Mexico, 1924
Oil on canvas
31⅝ × 39¼ in. (80.3 × 99.7 cm)
Alfred Stieglitz Collection, 1949
49.70.49

55
MARSDEN HARTLEY
1877–1943

In an unpublished essay, Marsden Hartley wrote that "mountains are...entities of a grandiose character, and the one who understands them best is the one who can suffer them best and respect their profound loneliness."[1] This subjective reading of landscape imagery characterized Hartley's landscape paintings from 1906 to 1943. Such works often reflected the artist's sense of personal loneliness which resulted in frequent bouts of depression and feelings of alienation.

In Hartley's *Cemetery, New Mexico*, an enormous mountain range takes center stage. It rises up in the middle of the composition and spreads to the foreground in successive layers of graduated mounds. Its contours are boldly outlined with thick black lines, as are both bulbous trees that frame the foreground and the graceful arrangement of elongated clouds in the deep blue sky. Hartley's colors are somber and muted—browns, earth reds, greens, and dark blues—with bright flashes of white paint. Throughout, his strokes are broad and roughly applied.

There is no sign of human life in this scene, save for a small house located to the left of the hulking mountains. In the center of the foremost hill, Hartley has prominently painted a small, fenced-in cemetery with crosses. Although the painting seems to depict a specific place, it is actually a "recollection" based on Hartley's trips to New Mexico in 1918 and 1919. During these initial visits, he produced a number of oil paintings and pastel drawings of the landscape that are much lighter in color and tone and more compositionally disjointed. With time and distance, Hartley has crystallized the essential character of this landscape.

Living in Berlin and Paris between 1923 and 1924, Hartley painted about twenty-five "recollections" of the Southwest, among them *Cemetery, New Mexico* (painted in Paris in late 1924). His interest in American subject matter was nostalgic. Soon after leaving Paris, he wrote from Provence: "I miss the call of the coyote among the sage brush in the prairies of New Mexico, the soft voices of the American Indians and the Spanish songs of the Mexicans under the tamarisk trees in the moonlight, for it is the Spanish language one hears in New Mexico along with the English of the whites. I miss the great folk dances of the American Indians, their religious summer dances and winter dances—all of which have to do with the symbolic phases of their ancient religious rites."[2]

These sentiments, however, must be tempered by the reality of Hartley's self-imposed exile. The anguish conveyed in the bold images of this time can be attributed to Hartley's troubled emotional state, caused in part by his lack of recognition in the States. Despite years of support from Alfred Stieglitz, and his early, pioneering accomplishments as an American modernist in the 1910s, Hartley lived on the brink of financial disaster, largely unappreciated in his native country until the very end of his life.

L.M.M.

NOTES
1. Marsden Hartley, "On the Subject of Mountains," in *Marsden Hartley,* Barbara Haskell (New York: Whitney Museum of American Art in association with New York University Press, 1980), 17.
2. Marsden Hartley, "Impressions of Provence from an American's Point of View," in *On Art by Marsden Hartley,* ed. Gail R. Scott (New York: Horizon Press, 1982), 144.

56
LEON KELLY
1901–1982

Leon Kelly was born in France and raised in Philadelphia, where he studied art at the Pennsylvania Academy of the Fine Arts. In 1924, he won a Cresson Traveling Scholarship from the school which enabled him to go to Paris, where he stayed until 1930. Thereafter he lived in Philadelphia and New Jersey, working periodically in France, Spain, Portugal, and North Africa.

Kelly's first one-man show was held in Paris in 1926 at the Galerie du Printemps. During the 1940s, his work was included in a series of exhibitions at the Julien Levy Gallery in New York City. Julien Levy, along with Peggy Guggenheim, was one of the prominent art dealers who showed the work of both young American painters and older European surrealists who had come to America in the 1930s and 1940s. Among the surrealist refugees in New York at the time were such noted artists as André Breton, Matta, Salvador Dali, Max Ernst, Kurt Seligmann, and André Masson. The few surrealists who remained abroad, like Joan Miró, were equally familiar to American audiences through gallery and museum exhibitions. The Museum of Modern Art, for example, presented an important retrospective of Miró's work in 1941. From this influx of new ideas, a hybrid American style of art developed that combined surrealist form and exploration of the subconscious with cubist structure and abstraction. The result was the birth of abstract expressionism in the mid- to late 1940s.

Kelly's large canvas *Vista at the Edge of the Sea* emerges from this milieu as a pioneering accomplishment, fully realized, and painted earlier than most such works. The advanced biomorphic abstraction that Kelly employs predates, by several years, the mature work of Arshile Gorky, who was similarly influenced by Miró's paintings of the late 1920s and 1930s. Gorky had begun to develop a biomorphic vocabulary of shapes and lines in his *Garden of Sochi* series in 1940, the same date as Kelly's picture, but it was several years before he was able to refine this style. For Kelly, however, biomorphic abstraction represented only a brief interlude in his search for an individual expression. By 1942, he had developed a tighter linear style that utilized insect imagery.

Despite its poetic title, *Vista at the Edge of the Sea* is a menacing seascape where myriad flamelike forms rise up to simulate the tumultuous unrest of the deep. Kelly wrote of this painting that he intended "to depict the many phases of the sea."[1] Under the sharply defined perimeter that separates sea from sky, the sinuous elements coalesce into fierce, often unimaginable, sea creatures. Several detached eyes peer at us from among the interlocking forms, and a few identifiable figures, like the small black octopus in the lower right (surrounded by white paint), emerge intact. Flying above this seething mass, like a large pirate flag, is a ferocious red shark head, jaws open and teeth sharp. The unsettling effect created by this picture is heightened by Kelly's dramatic use of black and deep red to articulate an otherwise somber color scheme.

L.M.M.

NOTES
1. Leon Kelly, artist questionnaire in The Metropolitan Museum of Art, Department of 20th Century Art archives.

Vista at the Edge of the Sea, 1940
Oil on canvas
51 × 80 in. (129.5 × 203.2 cm)
Arthur Hoppock Hearn Fund, 1981
1981.190

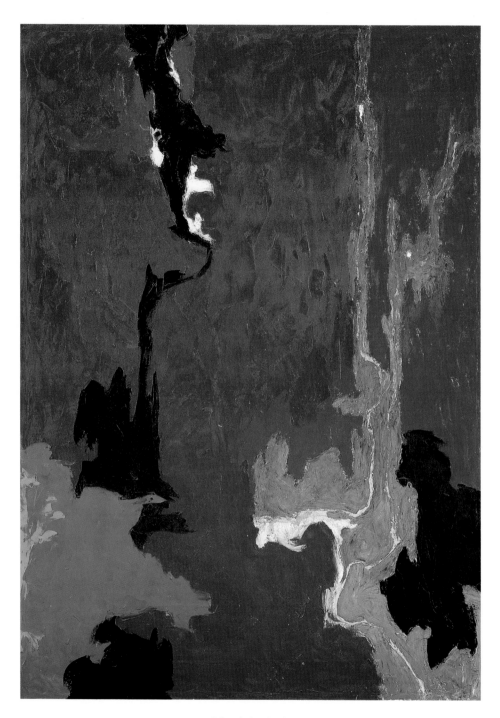

Untitled, 1946
Oil on canvas
61¾ × 44½ in. (156.8 × 113 cm)
George A. Hearn and Arthur Hoppock Hearn Fund, 1977
1977.174

CLYFFORD STILL
1904–1980

Clyfford Still, born in Grandin, North Dakota, spent most of his youth in Spokane, Washington, where his family moved shortly after his birth. From an early age, he demonstrated an interest in art and studied the subject at Spokane University from which he graduated in 1933. Although Still's first trip to New York City in 1925 was brief and disillusioning, he returned to the city twenty years later when he had a one-man exhibition at Peggy Guggenheim's Art of This Century Gallery in 1945.

At this time Still met and became friends with many of the artists who would become known as abstract expressionists. Although Still moved to San Francisco in 1946 to teach at the California School of Fine Arts (now the San Francisco Art Institute), he returned to New York in 1950 and taught at both Hunter and Brooklyn colleges and exhibited at the Betty Parsons Gallery. Still continued to work in New York until 1961 when he moved to Maryland, eventually settling in the town of New Windsor, where he continued to paint until his death in 1980.

As can be seen in this painting, Clyfford Still was in the process of resolving the amorphous, jagged shapes that were to become his hallmark. The different areas of color are set up against one another like interlocking puzzle pieces. Instead of a centralized orientation, the focus of the composition has been distributed for a more "all-over" approach. Still's colors are rich and deep-hued. By utilizing hues close in value, Still has achieved the visual impression that space has been compressed to the surface of the painting. He reinforces the feeling of a unified surface through the textural effects achieved by applying dense, viscous pigment with a palette knife.

Many proponents and historians of abstract expressionism have proposed that the work of artists such as Jackson Pollock, Mark Rothko, and Clyfford Still may be seen as having landscape references in spite of their determination to pursue complete abstraction.[1] Still's work, in particular, has been read as a romantic vision of the Western landscape. The artist, however, consistently rejected such references, declaring his work free of recognizable symbols or forms. During the mid-1940s though (when this painting was executed), Still gave his works mythic titles, which he soon rejected "for his intention had become more universal—create visual metaphors of the sublime."[2]

L.S.S.

NOTES
1. See the work of Thomas B. Hess, Robert Rosenblum, Irving Sandler, and Anne Chaves.
2. Irving Sandler, *The Triumph of American Painting* (New York: Praeger Publishers, 1970), 167, 170.

JACK BEAL
born 1931

Jack Beal is a highly original, if idiosyncratic, realist painter of the same generation as Philip Pearlstein and Alex Katz. Each of these painters, in his individual way, defied the color field and minimalist aesthetic of the 1960s to inject new life into realist painting. What has consistently distinguished Beal's vision from that of Pearlstein or Katz is his cumulative interest in investing his work with allegorical content as well as his use of art historical sources to create compositional devices that express such content. To this end, Beal has looked for inspiration to artists such as Caravaggio, Fantin-Latour, and de Chirico. Like the painter Alfred Leslie, he has couched the compositional preoccupations of these artists in a contemporary context.

Susan at Black Lake is a fascinating "composite" scene of a young woman seated with her back to us, looking out a window at the landscape beyond. Beal has collapsed the expected physical boundaries between exterior and interior in this view, which was painted in his barn at Black Lake, New York. The barlike form bisecting the composition in the upper third quadrant may be the lower edge of the window frame through which the young woman gazes. The nature of this architectural detail is reinforced by the presence of a swatch of fabric on the left, which signifies a gauzy patterned curtain waving in the breeze. The large empty space in the middle of the composition is a bright lime-green, like the color of a newly sprouted lawn. Just to its right is a more ambiguously de-scribed area which may be the pattern for another curtain or a stylized landscape that echoes the curvilinear designs of the windrows of hay seen at the top section of the painting. The intense, dense, bright hues of the painting have been a hallmark of Beal's work since the mid-1960s, when his realist style first found resolution after his earlier experimentation with gestural abstraction.

In the late 1960s, Beal executed several compositions of women seated in chairs with their backs to us and gazing out to a landscape beyond. One, entitled *Peace* (1969–70), shows a similar serpentine movement in the landscaping patterns while the deck space on which the woman sits and the landscape are more clearly delineated. The model for the female figure in these paintings is usually the artist's wife, the painter Sondra Freckelton.[1] In this case, however, the young woman is Susan Kate Dow, the daughter of two of Beal's closest friends from college.[2] Beal and Freckelton became surrogate parents to the young woman who spent several summers with them at Black Lake. At the time this painting was done, Susan Kate Dow was twelve or thirteen years old.

L.S.S.

NOTES
1. John Arthur, *Realists at Work* (New York: Watson-Guptill Publications, 1983), 19.
2. Jack Beal, letter to author, received in The Metropolitan Museum of Art, Department of 20th Century Art archives on 9 November 1989.

Susan at Black Lake, 1969
Acrylic on canvas
48 × 48 in. (121.9 × 121.9 cm)
Gift of Dr. Wesley Halpert and Carolyn M. Halpert, 1987
1987.365

From Portal to Paradise, 1982
Acrylic on canvas
107 × 78 in. (271.8 × 198.1 cm)
Gift of Charles Cowles, in memory of Nancy Hanks, 1983
1983.78.1

RONNIE LANDFIELD
born 1947

Born in New York City, Ronnie Landfield studied art as a young teenager at the Art Students League of New York between 1962 and 1963. After further study at the Kansas City Art Institute, Missouri, in 1963 and the San Francisco Art Institute between 1964 and 1965, he had his first one-man show in New York in 1969 at the age of twenty-two. Landfield was initially attracted to abstract painting by the example of such abstract expressionists as Franz Kline, Willem de Kooning, and Jackson Pollock, whose work he had seen in New York galleries and museums. His own commitment to abstraction has not waivered in almost three decades, although during the 1960s he did experiment with various idioms, including minimalism, before arriving at the mature style that he calls "the marriage between Matisse the Fauvist and Modernist painting."[1]

Landscape—without figures—became his chosen subject and his sense of color was increasingly influenced by the natural environment. In the painting *From Portal to Paradise* (part of a large series of landscapes that he made between 1981 and 1985), Landfield places four dark tree trunks (like prison bars) on the very surface of the picture to create a middle ground. The immediate foreground is implied by an unspecified, but clearly felt space in front of these trees where the viewer stands, looking through the barrier to the landscape beyond. Mountains, water, ground, and sky are generally delineated as color shapes and broadly painted without any interior modeling or detailing. Despite the painting's sense of deep space, the individual elements of the landscape remain totally flat.

The images in Landfield's landscapes are not painted directly from nature but are based on places seen earlier by the artist. Here, the subject was "inspired by the striking image of distant mountains seen through ponderosa pines in the Chiracaua Mountains"[2] along "a particularly beautiful stretch of highway in southeastern Arizona between the town of Portal and the town of Paradise."[3] Landfield's artistic interpretation of this scene was realized in his New York studio in October 1982. Characteristic of the works in this series, the acrylic paint was roughly applied "with large blades, trowels, palette knives, etc."[4] and heavily glazed. In both style and composition, the painting quotes Henri Matisse's *View of Collioure* (1907–8)[5] "and yet it reads not as an easel painting but as a physical presence, more related to American Abstract Expressionism."[6]

Landfield's poetic title, *From Portal to Paradise,* is both literal and suggestive. It literally locates the scene en route between two towns and suggests a play on words. The "portal" is the realm in which we stand gazing through the barricade of trees to the "idyllic beautiful wilderness, which represents paradise and freedom; the unbounded reign of nature and its wild state. . . . In this modern, technical, complex society we are all spectators. Very few of us ever experience the freedom of our true spirits. We are always bounded by societies' restrictions. Landscape in this painting is a metaphor for the free unbounded spirit."[7]

L.M.M.

NOTES
1. Ronnie Landfield, artist questionnaire in The Metropolitan Museum of Art, Department of 20th Century Art archives.
2. Ibid.
3. Ibid.
4. Ibid.
5. See Henri Matisse's painting, *View of Collioure* (1907–8), Collection Jacques and Natasha Gelman.
6. Ronnie Landfield, artist questionnaire in The Metropolitan Museum of Art, Department of 20th Century Art archives.
7. Ibid.

60
TOD WIZON
born 1952

Tod Wizon's approach to landscape is more metaphorical than empirical. He is heir to the visual systems codified in the 1940s by such artists as the surrealist Matta and the abstract expressionist Clyfford Still (see cat. no. 57). In the work of these artists, the search for abstract form suffused with emotional and psychological portent more often than not resulted in suggestions of nature. Wizon traces the impetus for his approach to a 1980 visit to a desert site near the Joshua Tree National Monument in California. The colors and inhabitants—both plant and animal—of this desert space made a great impression on him and he notes that: "After this revelatory trek my work began to evoke primordial spaces—timeless and ambiguous—where microscopic detail is interchangeable with

Figure 15
Points of Release, 1983
Acrylic on canvas, 68¼ × 71½ in. (173.4 × 181.6 cm)
Edith C. Blum Fund, 1984
1984.111

Above (for Steven Schmidt), 1986
Acrylic on canvas
84 × 98¼ in. (213.4 × 249.6 cm)
Denise and Andrew Saul Fund, 1987
1987.110

panorama and there are only hints of foliage."[1]

Above (for Steven Schmidt) is a tantalizing picture. The viewpoint is dizzying. We seem to be atop a promontory overlooking a turbulent eddy as water rushes in and around a cluster of rocks. The smaller biomorphic details could be either rocks or small marine entities that have washed up with the tide. Wizon courts this ambiguity in his work with the intention of "preserv[ing] the illusive nature and feelings of first seeing a place fresh, uninhabited— those inspirational moments when cognition and assimilation begin—when things are . . . still new in a child's mind."[2]

The artist has dedicated this painting to his sculptor friend Steven Schmidt. It commemorates a plane ride taken with Schmidt during the summer of 1986 when the sculptor was experiencing personal tragedy.[3] Wizon uses the transcendency of the experience of flight as a metaphor for experiencing an escape from the cares of everyday life. The blue in the painting represents a melancholic emotion that weaves in and out of the turbulent emotions represented by the whirls and swirls of white paint. The artist has eliminated any sense of horizon line so that our sense of space in the painting is correspondingly shifting. In other compositions, such as *Points of Release* (fig. 15), Wizon succumbs to a more traditional use of perspective and the space seems to be clearly defined although no less turbulent. Tod Wizon has been working as an artist since 1974. He was born in Newark, New Jersey, and studied English literature at Temple University in Philadelphia, and then at Drew University in New Jersey. He pursued his Bachelor of Fine Arts and Painting at the School of Visual Arts in New York City.

L.S.S.

NOTES

1. Tod Wizon, artist questionnaire in The Metropolitan Museum of Art, Department of 20th Century Art archives.
2. Janice C. Oresman in *New Vistas: Contemporary American Landscapes* (Yonkers, N.Y.: Hudson River Museum, 1984), 39.
3. Tod Wizon, artist questionnaire in The Metropolitan Museum of Art, Department of 20th Century Art archives.

INDEX OF ARTISTS

Numbers listed below refer to catalogue entries.

THE AMERICAN FEDERATION OF ARTS

Mrs. Gardner Cowles
Mr. & Mrs. John Cowles III
Mr. & Mrs. Donald M. Cox
Mr. & Mrs. Earl M. Craig, Jr.
Mr. & Mrs. James Crumpacker
Mrs. Catherine G. Curran
Mr. David L. Davies
Dr. & Mrs. David R. Davis
Mrs. Julius E. Davis
Mr. & Mrs. Walter Davis
Mr. & Mrs. Kenneth N. Dayton
Mrs. John de Menil
Mr. & Mrs. James De Woody
Mr. & Mrs. Robert Henry Dedman
Mr. & Mrs. Charles M. Diker
Mr. & Mrs. C. Douglas Dillon
Mr. & Mrs. Herbert Doan
Mr. & Mrs. Robert B. Dootson
Mr. & Mrs. Kirk Douglas
Mr. & Mrs. W. John Driscoll
Mr. & Mrs. Gilbert S. Edelson
Mr. & Mrs. Maurits E. Edersheim
Mr. William S. Ehrlich
Mrs. Lester B. Eisner
Mr. & Mrs. Edward E. Elson
Mr. & Mrs. Arthur D. Emil
Mrs. Madeleine Feher
Mr. & Mrs. David Fogelson
Mrs. Pati H. Gerber
Ms. Sondra Gilman
Mrs. Priscilla Grace
Mr. Leo S. Guthman
Mr. & Mrs. John H. Hauberg
Mr. & Mrs. Wellington S.
 Henderson
Mr. & Mrs. Henry Hillman
Mr. & Mrs. Lee Hills
Mr. & Mrs. Theodore S. Hochstim
Ronna and Eric Hoffman
Mr. & Mrs. William Hokin
Mr. & Mrs. James L. Holland
Mrs. Eunice W. Johnson
Mrs. Samuel K. Ketcham
Mr. & Mrs. Peter Kimmelman
Mr. & Mrs. Gilbert H. Kinney
Mr. & Mrs. C. Calvert Knudsen
Mr. & Mrs. Robert P. Kogod
Mr. & Mrs. Oscar Kolin
Mr. & Mrs. Anthony M. Lamport

Mrs. Emily Fisher Landau
Mr. & Mrs. A.R. Landsman
Mr. & Mrs. Richard S. Lane
Natalie Ann Lansburgh
Mr. & Mrs. Leonard A. Lauder
Mr. & Mrs. Edward H. Leede
Mr. & Mrs. Albert Levinson
Mr. & Mrs. Richard Levitt
Mr. Irvin L. Levy
Mrs. Ellen Liman
Mr. & Mrs. Joseph Linhart
Mr. & Mrs. Robert E. Linton
Dick and Mimi Livingston
Mr. & Mrs. Lester B. Loo
Mrs. C. Blake McDowell, Jr.
Mr. Roderick A. McManigal
Mr. & Mrs. David B. Magee
Mr. & Mrs. James H. Manges
Mr. & Mrs. Melvin Mark, Jr.
Mrs. Samuel H. Maslon
Mr. & Mrs. Irving Mathews
Mr. & Mrs. Frederick R. Mayer
Mrs. Robert B. Mayer
Mrs. Walter Maynard
Mr. & Mrs. Paul Mellon
Meryl and Robert M. Meltzer
Mr. & Mrs. Robert Menschel
Mr. & Mrs. William D. Miller
Barbara Babcock Millhouse
Mr. & Mrs. Roy R. Neuberger
Mrs. Peter Roussel Norman
Mrs. John W. O'Boyle
Mr. & Mrs. Peter O'Donnell, Jr.
Mr. & Mrs. George O'Leary
Mrs. Robert Olnick
Mr. & Mrs. Dean Pape
Mr. & Mrs. Robert L. Peterson
Mr. & Mrs. Donald A. Petrie
Mr. & Mrs. Nicholas R. Petry
Mr. & Mrs. Charles J. Petschek
Mr. & Mrs. John W. Pitts
Mr. & Mrs. Lawrence S. Pollock, Jr.
Mr. & Mrs. Peter O. Price
Mr. & Mrs. Jerome Pustilnik
Aileen Roberts
Mr. & Mrs. Edward W. Rose III
Mr. & Mrs. Walter S. Rosenberry III
Mr. & Mrs. Milton F. Rosenthal
Richard and Hinda Rosenthal

Mr. & Mrs. Lawrence Ruben
Dr. & Mrs. Raymond R. Sackler
Mr. & Mrs. Douglas R. Scheumann
Mrs. Marlene Schiff
Mrs. Marcia Schloss
Mr. & Mrs. Mort Schrader
Mr. & Mrs. Douglas A. Schubot
Mr. & Mrs. Rudolph B. Schulhof
Mr. & Mrs. Joseph Sevirolli
Rev. & Mrs. Alfred R. Shands III
Jan Shrem
Mr. & Mrs. George A. Shutt
Mr. & Mrs. Herbert M. Singer
Barbara Slifka
Mr. & Mrs. Nathan Smooke
Mr. & Mrs. David M. Solinger
Anne C. Stephens
Mr. & Mrs. James C. Stevens
Mr. & Mrs. W. T. C. Stevens
Mrs. Martha B. Stimpson
Mr. & Mrs. John W. Straus
Rosalie Taubman
Mrs. Norman Tishman
Mrs. George W. Ullman
Mr. & Mrs. Michael J. Waldman
Mr. & Mrs. Robert C. Warren
Mr. & Mrs. John R. Watson
Mrs. Paul L. Wattis
Mrs. Nancy Wellin
Mr. & Mrs. Dave Williams
Enid Silver Winslow
Mr. & Mrs. Bagley Wright
Mr. & Mrs. Howard S. Wright
Mr. & Mrs. C. Angus Wurtele
Mr. & Mrs. T. Evans Wyckoff
One anonymous patron

Staff

Serena Rattazzi, *Director*
Barbara Poska, *Executive Assistant
 to the Director*
Sheila Look, *Office Assistant*

Exhibition Department

J. David Farmer, *Director of
 Exhibitions*
Robert Workman, *Administrator for
 Exhibitions*
Marie-Thérèse Brincard, *Senior
 Exhibition Coordinator*

P. Andrew Spahr, *Senior Exhibition Coordinator*
Donna Gustafson, *Exhibition Coordinator*
Michaelyn Mitchell, *Head of Publications*
Carol S. Farra, *Registrar*
Andrea Farnick, *Associate Registrar*
Kathleen Flynn, *Assistant Registrar*
Deborah Notkin, *Exhibition Assistant*
Julie Min, *Exhibition Assistant*
Annie E. Raulerson, *Exhibition Assistant*

Media Arts
Sam McElfresh, *Director of Media Arts*
Tom Smith, *Assistant Director of Media Arts*
Thomas Smith, *Media Arts Assistant*
Kari Olson, *Media Arts Assistant*

Development, Membership, and Public Information
Susan J. Brady, *Director of Development and Public Affairs*
Gretchen MacKenzie, *Director of Membership and Events*
Phillip Ambrosino, *Membership Assistant*
Jillian W. Slonim, *Director of Public Information*
Jim Gaffey, *Grants Writer*

Museum Services
Ricki Lederman, *Professional Training Director and MMI Administrative Coordinator*
Penne Smith, *Museum Services Assistant*
Mary Dalton, *MMI Administrative Assistant*

Finance and Administration
Mark Gotlob, *Director of Finance and Administration*
Jim Finch, *Controller*
Patricia Holquist, *Senior Bookkeeper*
Yewsheva Wilder, *Accounting Clerk*

Jane Marvin, *Office Manager/ Personnel Coordinator*
Sabina Moss, *Receptionist*

Building
Marcos Laspina, *Superintendent*
Alfredo Caliba, *Custodian*

GOVERNMENT SUPPORT
National Endowment for the Arts
National Endowment for the Humanities
New York State Council on the Arts
California Arts Council

CORPORATE AND FOUNDATION PATRONS

Benefactors
Eastman Kodak Company
Exxon Corporation
The Horace W. Goldsmith Foundation
The Jewish Communal Fund
The Knight Foundation
Metropolitan Life Foundation
Philip Morris Companies, Inc.
The Rockefeller Foundation
Samuel & May Rudin Foundation, Inc.
U.S. West
Lila Wallace–Reader's Digest Fund

Patrons
Drexel Burnham Lambert Inc.
Gorham, Inc.
Samuel H. Kress Foundation
Sacred Circles Foundation
The Andy Warhol Foundation for the Visual Arts, Inc.

Sponsors
Chemical Bank
Cosmair, Inc.
The Cowles Charitable Trust
The Graham Foundation
IBM Corporation
The Interpublic Group of Companies, Inc.

The J.M. Kaplan Fund, Inc.
Lowe Marschalk Inc.
McCann-Erickson Worldwide
The New York Times Company Foundation, Inc.
Paramount Communications
PepsiCo Foundation, Inc.
R.J. Reynolds, Inc.
Sony Corporation
Warner Communications
Wells, Rich, Greene, Inc.

Associates
Arco Foundation
The Laura Bolton Foundation
Chevron Corporation
Donaldson, Lufkin & Jenrette
Fried, Frank & Harris
Generale Bank
Manufacturers Hanover Trust Company

Donors
The Bank of New York
BellSouth Corporation
Champion International Corporation
Compton Foundation, Inc.
Consolidated Edison Company of New York
Heublein, Inc.
KMPG Peat Marwick
Kraft Foundation
Lannan Foundation
Estee Lauder, Inc.
Mercedes-Benz of North America, Inc.
Mobil Foundation, Inc.
The J.C. Penney Company, Inc.
Pfizer, Inc.
Price Waterhouse Company
Reynolds Metal Company Foundation
Rothschild, Inc.
Martin E. Segal Co.
Syntex Corporation
Tandy Corporation
Times Mirror
The Xerox Foundation

Friends
Harry N. Abrams, Inc.
Backer Spielvogel Bates

Ernst & Young
James Felt Realty
General Motors Corporation

Ogilvy Group
Phillips Petroleum Foundation, Inc.